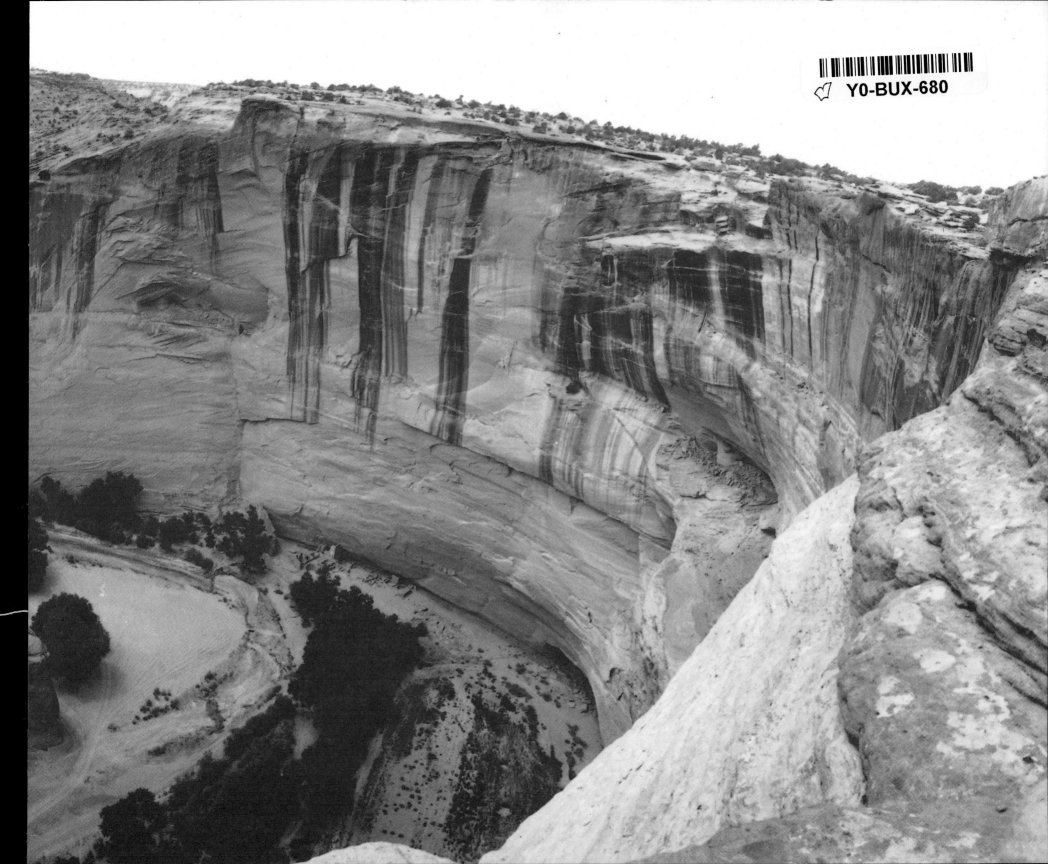

THE ANCIENT ONES

KURAQ AKULLIPAQ

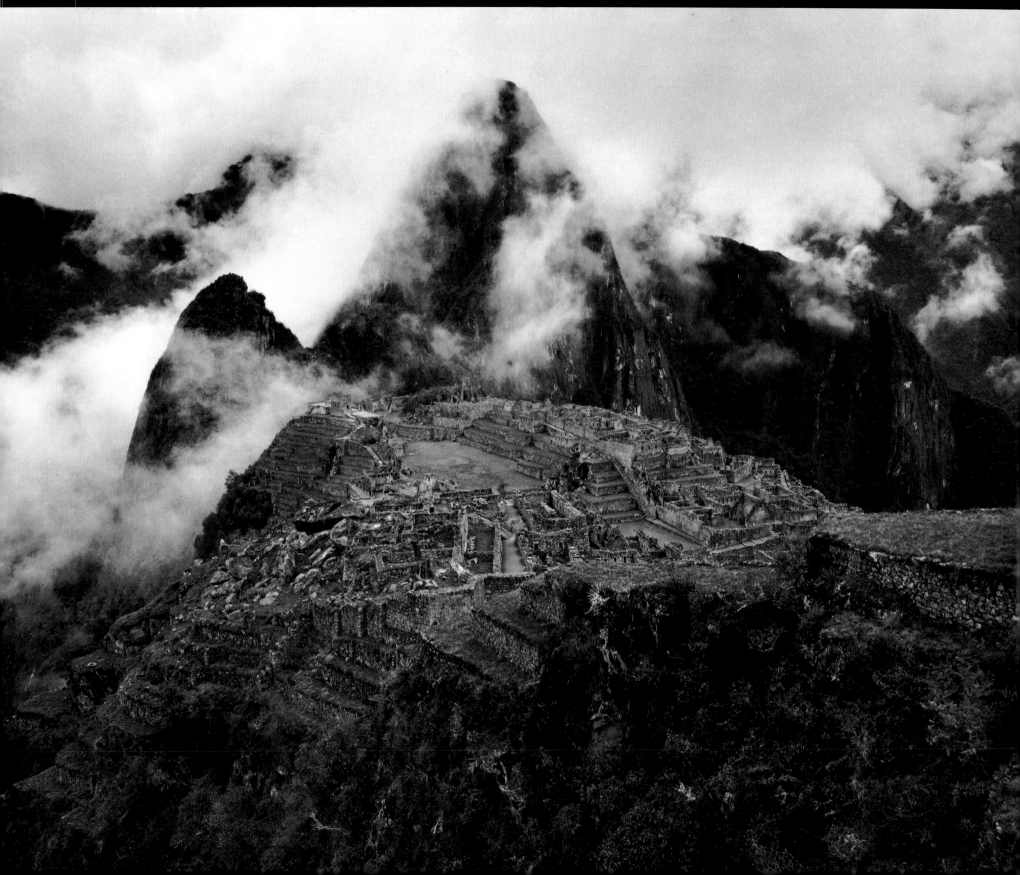

THE ANCIENT ONES

Sacred Monuments of the Inka, Maya & Cliffdweller

MYTHS RETOLD AND PHOTOGRAPHS BY HANS LI

CITY OF LIGHT EDITIONS NEW YORK, NEW YORK

First Published in 1994 by City of Light Editions, New York City

Available through D.A.P./Distributed Art Publishers
636 Broadway, 12th floor, New York, N.Y. 10012 (212) 473-5119, fax: 673-2887

p.51— excerpts from *The Book of Counsel: The Popol Vuh of the Quiché Maya of Gautemala*, Publication 35,
Middle American Research Institute, Tulane University. Lines 5163-5176 in *Quiché Maya* reprinted by kind
permission of Dr. Munro S. Edmonson. Copyright © 1971 by Munro S. Edmonson.

pp.56-72— excerpts from *The Popol Vuh, The Mayan Book of the Dawn of Life*, are reprinted by permission of
Simon & Schuster, Inc. Copyright © 1985 by Dennis Tedlock.

p.95— excerpts from *The Indians' Book, Songs and Legends of the American Indians*, recorded and edited by
Natalie Curtis, Dover Publications, 1968, p.487, *Hevebe* song in Hopi. Contents of the book are in public domain.

p.116— Researchers have not been able to locate Chief Seattle's supposed letter to President Pierce, there is no
record of it in the National Archives. This impressive document which exists in many versions, functions more
as a myth than as history.

ISBN: 0-89923-942-5 Library of Congress Catalogue Card Number: 92-70770

First Edition

Designed by Joseph Guglietti
Printed and bound in Italy by EBS, Verona

CONTENTS

PREFACE

I have conceived *The Ancient Ones* as a bridge across time to recover the visible and the invisible worlds of the Inka, the Maya, and the Cliffdweller. The visible are captured in the photographs of their monuments, and the invisible in the essence of their myths. These three cultures have been selected for their architectural distinction and the richness of their mythology.

The photographs in this volume direct the audience to those moments in our reality that are not bound by our perception of the present and the consequences of history. To the extent achievable by photography as a medium, I rely on the collaboration of the wind, the suspension of the sun in the clouds, the casting of shadows, the falling of rain or snow, and the rising of fog to produce images that are forever true.

The myths in this book, whenever possible, are told in the voices of the ancient ones themselves, thereby approximating the practice of the oral tradition in these cultures. The legends retold are supported by available historical documents.

In 1987, during an anthropological journey to Peru with Dr. Alberto Villoldo, I had the opportunity to participate in nighttime ceremonies along spectacular Nazca lines, between the temples of the sun and moon in the desert of Trujillo, and among the architectural wonders of Machu Pijchu. These magical experiences prompted eight subsequent trips to Peru and Bolivia to study with shamans and Altomesayoq, the Andean high priests, and to explore the sacred sites photographed in this book.

Five hundred years after the conquest, this exploration grants me an understanding of the relationship between the structure of ritual and the programming of sacred architecture. Ceremony, most certainly, was essential to the building of empire.

The Inka civilization flourished along the Andes, in present-day Peru, Ecuador, Bolivia, and parts of Colombia. The name "Inka" was intended for a very privileged class of people who claimed their divine origin from the Sun. The Inka built temples and cast golden images of the sun in order to reinforce their claim to divinity. Thus, the Inka convinced their subjects to collaborate in imperial enterprises: the building of temples, palaces, administrative settlements, agricultural terraces, fortifications, and "highways" that connect over 1000 miles of territory.

For the Inka text, I have consulted three chroniclers who recorded both myths and historical events: Pedro Cieza de Leon (1520-1554), Father Barnabe

Cobo (1580-1657), and Garcilaso de la Vega (1539-1616). I have made a compilation of these texts and, in some places, have added other scholars' opinions on the subject.

While the Inka lived vertically along the hillsides of the Andes, the Maya lived in the dense jungles of present-day Mexico, Belize, Guatemala, Honduras, and El Salvador. Their pyramids towered above the jungle so they could greet the Morning Star as it rose above the eastern horizon; thus, they could relive part of their creation story each day. It was told that all living beings awaited in the darkness for the first light.

The Maya myths were passed on orally in the form of poetry. This was a powerful tool used to invoke a deep feeling for the birth of their people. Their architecture and the decorative arts, however, expressed the rich symbolism of their religion.

The story of creation is told in the *Popol Vuh*, the community history book from the Guatemala highlands. I have consulted the translations of Adrian Recinos (1950), Munro Edmonson (1971), and Dennis Tedlock (1985). As for the legend of the Toltec hero Quetzalcoatl, whose image appears so often in Maya buildings, I have incorporated Lopez-Portillo y Pacheco's rendition of the story, as no original text has been preserved.

Even less is known about the Cliffdweller, the so-called Anasazi of the American South-West. Aside from their rock art, there is neither written nor oral history passed on to us. We know little about their myths, except as they are reflected by the legends of their descendants in the oral tradition of the Hopi, Zuni, Tiwa, and the Keresan. By looking at the Anasazi rock art and architecture, especially the Kiva, we see references to their ancestors' emergence from the underworld.

During my last visit to Qosqo (Cusco), the Altomesayoq of the Andes asked me to tell my people in North America that the practice of the old ways did not die upon the arrival of Christianity, but had merely been submerged into the realm of the invisible. I think this is also true for the Maya and, to a certain extent, for the decendants of the Cliffdweller. I hope that this book delivers this message: That the old ways are returning and must be recognized as an important part of our collective culture in the Americas.

INVOCATION

8

TO THE WINDS OF THE EAST

where the Sun rises

is the beginning of a new day

Let this light from within and without

illuminate our inner vision

and guide us through darkness in time

of chaos

Come Great Eagle

come and teach us how to spread our

own wings

bring us renewed vision

take us

take us with you in this spirit flight

HO

GREAT EAGLE

TO THE WINDS OF THE SOUTH

is the place of Fire where the Great

Serpent dwells

Let us summon this fire from within

to burn away our sorrows

our disappointments

our disease and illnesses

our hidden emotions and attachments

and replace it with joy and happiness

Come Great Serpent

come and teach us how to shed our

old skin

and bring us back to the place of

innocence and purity

HO

GREAT SERPENT

TO THE WINDS OF THE WEST

is the place of deep waters to look within

To the Winds of the West

is the Empress of the Pacific Waters

Home of the beautiful Shell Woman

To Yemaya

Come Mother Jaguar

Come Sister Jaguar

Come the Rainbow Jaguar

Come and bring us power and strength

so that we may endure through the

trials of life

Come the Medicine Cat

Come and bring us courage

so that we may meet the challenges

of today

HO

GREAT JAGUAR

TO THE WINDS OF THE NORTH

is the Path of the Old Ones

and the Ones gone by

all our relations

To the Winds of the North

are our Ancient Masters

Teachers

and Spirit Guides

Come Dragon of the North

the White Horse

the Snow Leopard

the White Buffalo

Come and assist us to open the Gateways

from this world to the other worlds

from the Tonal to the Nagual

HO

GREAT DRAGON

To the Two Legged

and the Four Legged

the Stone People

the Plant People

To all living creatures

and the Guardian Spirits of this land

To the Mother Earth

HO

PACHAMAMA

To our Star Brothers and Sisters

The Sun the Moon

and the greater Planets of the Universe

To the Winged People that Fly

Our Great Spirit

Father Sky

HO

FATHER SKY

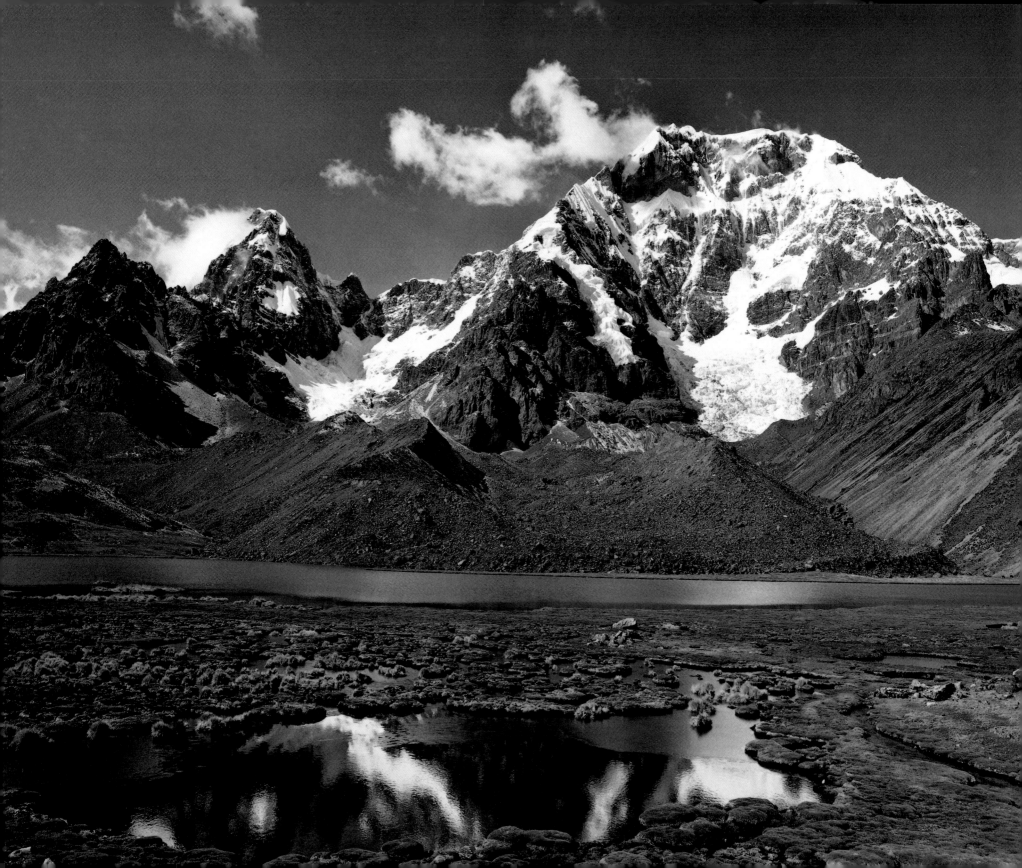

INKA

APU AUSANGATI

ausangati, great mountain

SUYU MALLKU

sacred being

KAYLLANKASKAITA HAYWARISKAIKI

i offer this work to you

HATUN APU CHASKIWAY

mountain spirit accept this

ÑANTA KICHAMUAI

open the way

INKA

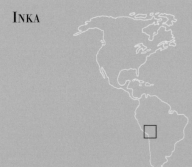

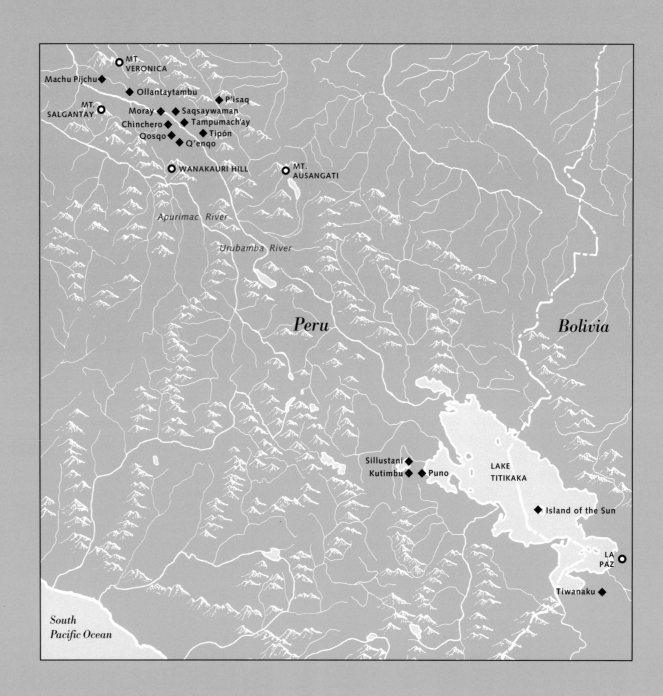

MT. VERONICA

Machu Pijchu

Ollantaytambu

P'isaq

MT. SALGANTAY

Moray Saqsaywaman

Chinchero Tampumach'ay

Qosqo Tipón

Q'enqo

WANAKAURI HILL

MT. AUSANGATI

Apurimac River

Urubamba River

Peru

Bolivia

Sillustani

Kutimbu Puno

LAKE TITIKAKA

Island of the Sun

LA PAZ

Tiwanaku

South Pacific Ocean

Dicen que — "they say that" the ancient stories began as they were told around the fire. Having no formal system of writing, the Inka relied on the oral tradition to preserve their history, and contemporary investigators have had no alternative but to consult the Spanish chronicles to reconstruct the past of this formidable state.

Even more revealing than the chronicles of the conquistadors is a story that is written with a lexicon of images, a vocabulary of stones that tells of an extraordinary social, military, and religious organization that formed the backbone of an empire stretching from modern-day Columbia to central Chile. When Pachakùteq Inka, "the one who made time stand still," faced the advancing Ch'anka warriors with a ragtag army of children and old men, it is said that the stones became braves and threw themselves against the Ch'anka. Later, when Pachakùteq's armies set out to expand the border of the empire, they carried the stone Waka (shrine) of Wanakauri, the rainbow prince. With this stone in their midst, Pachakùteq's army was victorious.

This vocabulary of stones—the words and the sentences they spell—remains an enigma. Why did Inka masons carve stones with up to 32 angles and fit them into walls that stand robust and splendid even today? Why did they cut stones for the ramparts at Saqsaywaman, some weighing up to 120 tons, from quarries 45 miles away, when there was no shortage of quality granite nearby?

To decipher the stories sung by these ancient stones we must understand the mythological origin of the Inka, for they were born inside the earth, in the rich damp darkness where stones are born. The first Inka emerged from the caves at Tambut'oku as splendid luminous beings: part men, part gods. The legends say that one of the first brothers, Wanakauri, returned to the place of emergence to retrieve a golden cup, and the cave collapsed, sealing him inside the earth forever. Wanakauri reappeared as a stone Waca that stands undisturbed even today in a corner of the cathedral in Qosqo. The task of founding the empire was left to his

brother, Manko Qhapaq, and his sister-wife, Mama Oqllo, who arrived in Qosqo in the year 1250.

The oral tradition does not separate legend from history. Indeed, before the Spanish chronicles, conjecture and fact blend together to weave a rich, if inaccurate fabric of the past. For the first 150 years of their history, the Inka were merely another village in the valley of Qosqo, tilling the soil and raising herds of llamas and alpacas. Not till the Ch'anka War in 1438 and Pachakùteq's rise to fame as a ruler and military commander did the Inka begin to forge their empire. Between 1440 and 1473, the year of his death, Pachakùteq began the construction of cities in the clouds — of an architectural scale previously unknown in the Americas. Among Pachakùteq's achievements are the citadel of Machu Pijchu, the fortress temple of Saqsaywaman and Ollantaytambu, the temple of Qorikancha in Qosqo, and over 10,000 miles of granite roads and highways connecting the kingdom.

To achieve these architectural feats Pachakùteq needed a highly disciplined army and a sophisticated and well-organized work force. Contrary to conventional military wisdom, Pachakùteq's armies swelled in size the farther they traveled from Qosqo. Conquered peoples were obliged to join with the Inka warriors; thus integration and assimilation of the peoples were immediate. Strict rules prohibited looting and pillaging along the army's path, and farmers' fields and villages were left undisturbed. It was to a weaker adversary's advantage to join the Inka army before a bloody clash rather than after. But the Inka used military force only as a last resort; they conquered with their knowledge of agriculture, of irrigation, and with corn, a plant their ancestors had taught them to domesticate and that produced bountiful crops.

For the Inka, territorial expansion was intrinsically tied to their conception of the divine. They permitted conquered peoples to keep their local Wakas and even invited them to place their own deities at the temple of Qorikancha in Qosqo. In return, those conquered had to accept the supremacy of the Inka creator Wiraqocha

and his children, Inti the Sun, and Pachamama, Mother Earth.

The Inka conception of the divine revolved, and revolves today, around the concept of Ayni—loosely translated as reciprocity. Andean peoples make Ayni to Pachamama, and the Earth returns great ears of corn and fertile flocks. They make Ayni to others, and others return honor and respect. They make Ayni to the Apu, the great mountain peaks, and the Apu return the strength to endure one's work, thus the heavens return order and meaning to their lives.

At the time of the conquest, Inka storehouses held a twenty-year supply of food. Today the grandchildren of the Inka do not have grain for even twenty days, or the wherewithal to acquire such food. A handful of gold crazed conquistadors, in the name of God and the King, broke the backbone of the Inka empire in 1538. Still, the spirit of the Inka remains intact. The Descendants of the Children of the Sun are eating the same corn, quinoa, and potato that their ancestors ate.

They raise the same llamas, play the same Andean flutes, and make Ayni to the same Apu.

In the early 1500s, the church decreed that the Inka no longer could parade the mummies of their kings around the plaza on the day of the solstice. Instead they were given the Christian saints to parade. The tradition has continued for 500 years. A few years ago, when the effigies of the saints were being restored, workmen discovered Inka robes underneath the Christain ones, and that the hair and nails of the saints were human—Inka.

The Children of the Sun have returned—long may they live.

Alberto Villoldo

In the City of Light
The night creeps toward me;
A slow wave of darkness
Pushed by the wind's
Balmy whisper
Breaks in silence.
And in the darkness
My fire echoes
From sepulchral stones;
Flames lick the cold,
And tickle the air
That carries a voice.
Listen. It is there...

In the beginning we traveled far, through time, in no space. We are the ancestors, the ancient ones, awakened from a dream of our birthplace in the stars. Our first home was dark. There was only the breath of the Creator.

Illa Teqse Wiraqocha
Pachayachachiq
Resplendent One,
The Lord,
Foundation,
Instructor of the World
Kontiki
Who sits in the North, the South,
The East, and the West,
Who sits above us

And below,
Who is known by one thousand names and
Who is Nameless.

A long time passed in which we did not see. And a great wind began to blow; if we had faces, we would have felt its caress; we would have heard its whispers if we had ears.

Then from the center of the great sea on top of the world, the first light shone on the island where the Sun was born. All that was unseen was visible in its glory and we opened our eyes, for we were the Children of the Sun. The first words we heard were:

"Such beauty needs eyes to be seen,
Ears to be heard,
Hands to be touched,
Love to be loved."

We are the Children of the Sun, and our first act was to make an altar of stone to the Creator of All. We will return to the First Altar before our final breath, taking leave of life at the place where life was born.

At the end of the first day, when everything stood still, the breath of the Creator called upon the Moon to send her silver rays into the waters of the sea at the top of the world — the sea called Titikaka — so the first day was gold and the first night was silver.

Then there came among us one who was neither woman nor man, one whose wisdom and

··· page twenty-four

SPIRAL CARVINGS ON
STONE BLOCK

Puma Punku, Tiwanaku

These spiral carvings could have been a reminder of the Inka ancestors' first journey to the earth from the stars, from which the ancient people of Tiwanaku came. The spiral appears often in the art of many ancient civilizations throughout the world, as a symbol of migration.

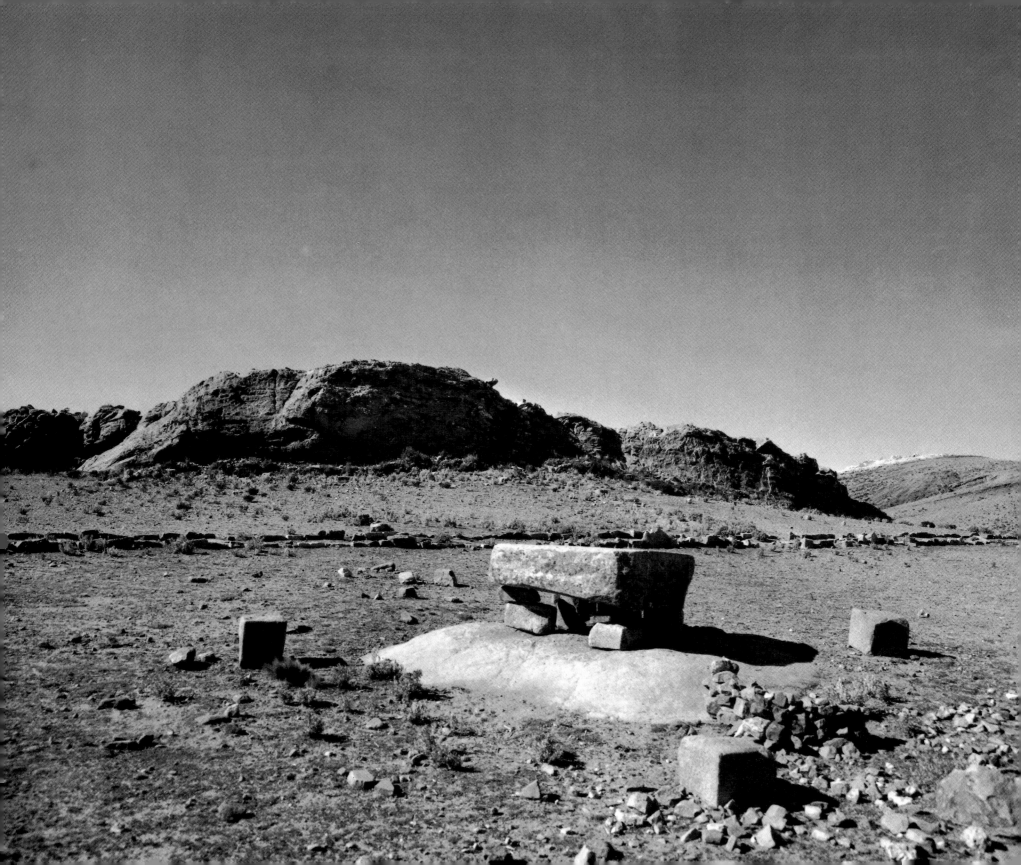

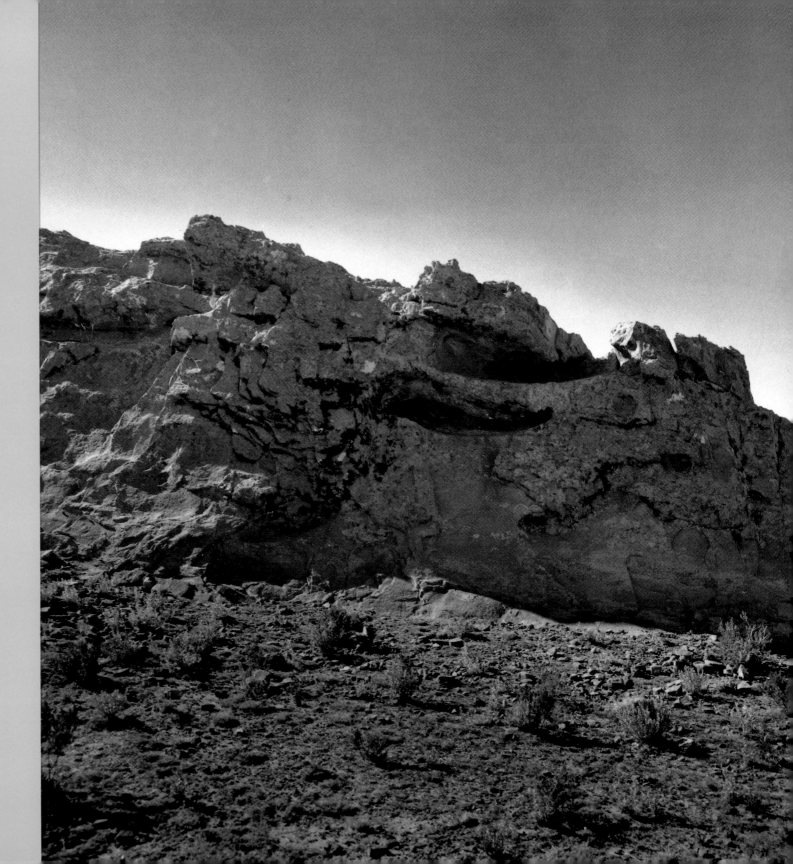

BIRTHPLACE OF THE SUN
AND THE MOON

Island of the Sun, Lake
Titikaka

A stone altar raised on a polished circular stone base appears to emerge from the earth. This suggests a miniaturized representation of the Island of the Sun itself.

DETAIL

The curved rock face in the background once was covered with gold panels and believed to have been the First Altar. According to legend, the Sun emerged from the upper slot and the Moon from the lower, and the first four Inka couples were sent to this island by the Creator, Teqse Wiraqocha.

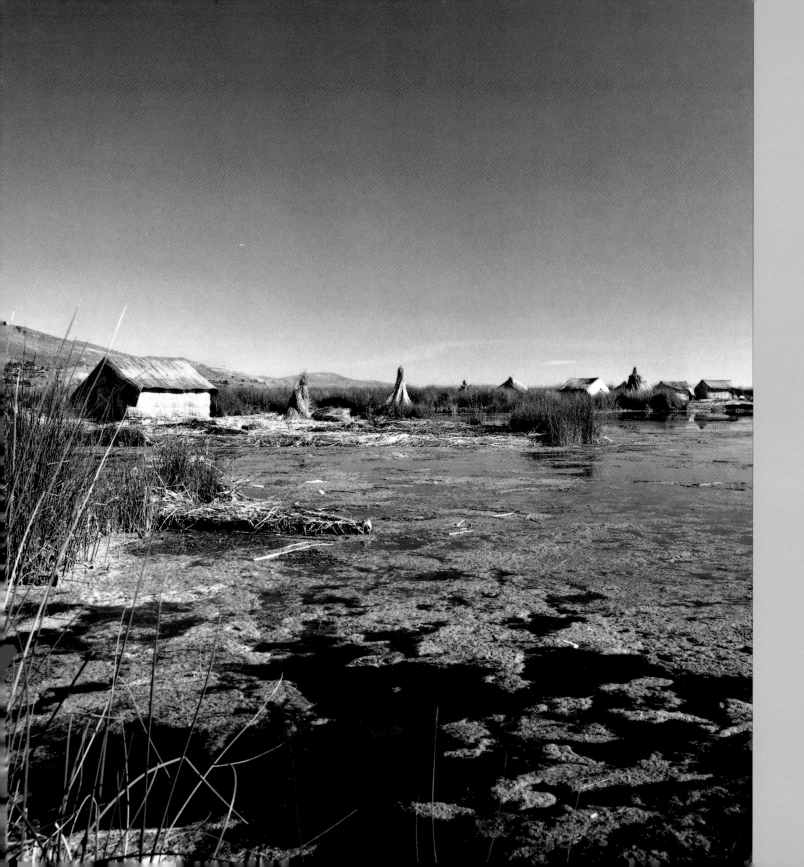

FLOATING ISLANDS OF THE UROS

Puno, Lake Titikaka

The Uros people lived in these waters before the arrival of the Aymara and the Inka. They believed that their ancestors came from the constellation of Orion. Later, the Inka came into the area and adopted the ancestral history of the Uros for their own, before departing for Qosqo to build their empire.

DETAIL

Thatched huts made of dry reeds sit on the floating island, also made of layers of centuries-old reeds. The reeds grow abundantly in the shallow area of the lake. When dried, they are used as building material for houses and boats, and for animal feed.

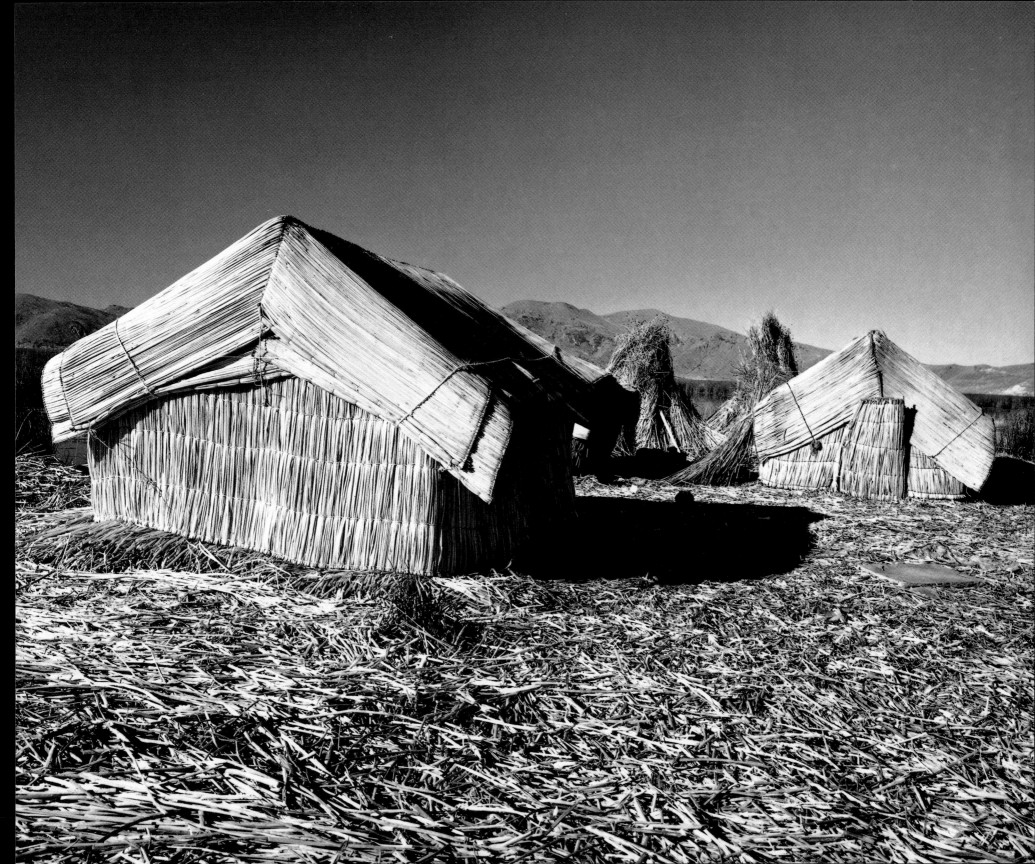

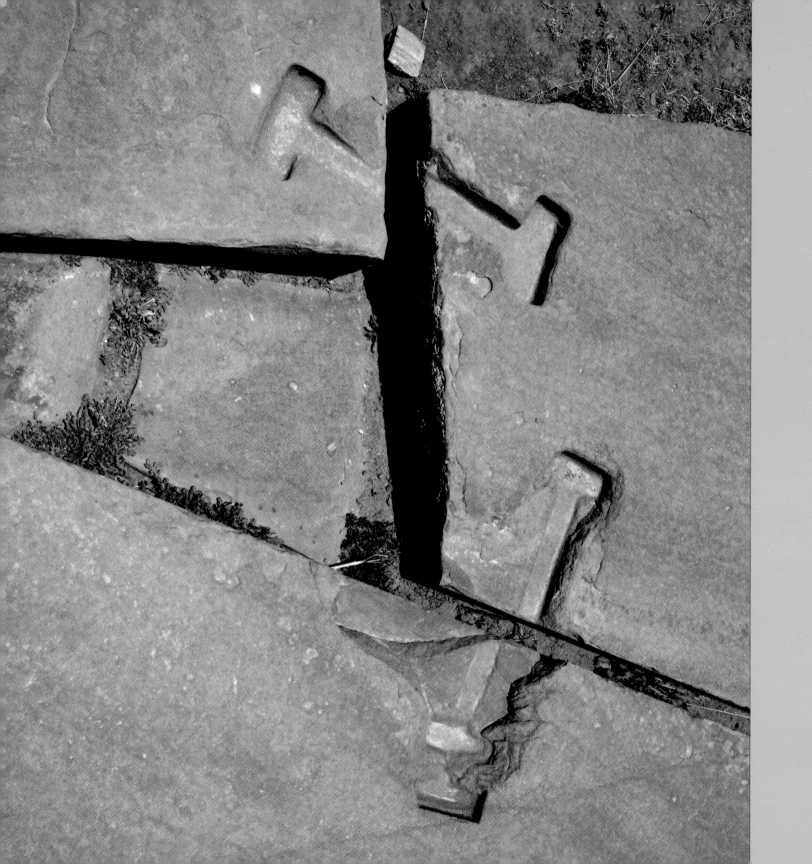

RECESSES IN STONE BLOCK

Puma Punku, Tiwanaku

The recesses formed in the stone blocks at the Gate of the Jaguar suggest that metal masonry ties were used in construction by the Tiwanaku people.

WEST WALL OF SEMI-SUBTERRANEAN TEMPLE

Tiwanaku

This intricate Tiwanaku wall is one of four forming the temple courtyard. The combination of monoliths with smaller stones used for this wall later became a prototype for the most sacred Inka wall construction.

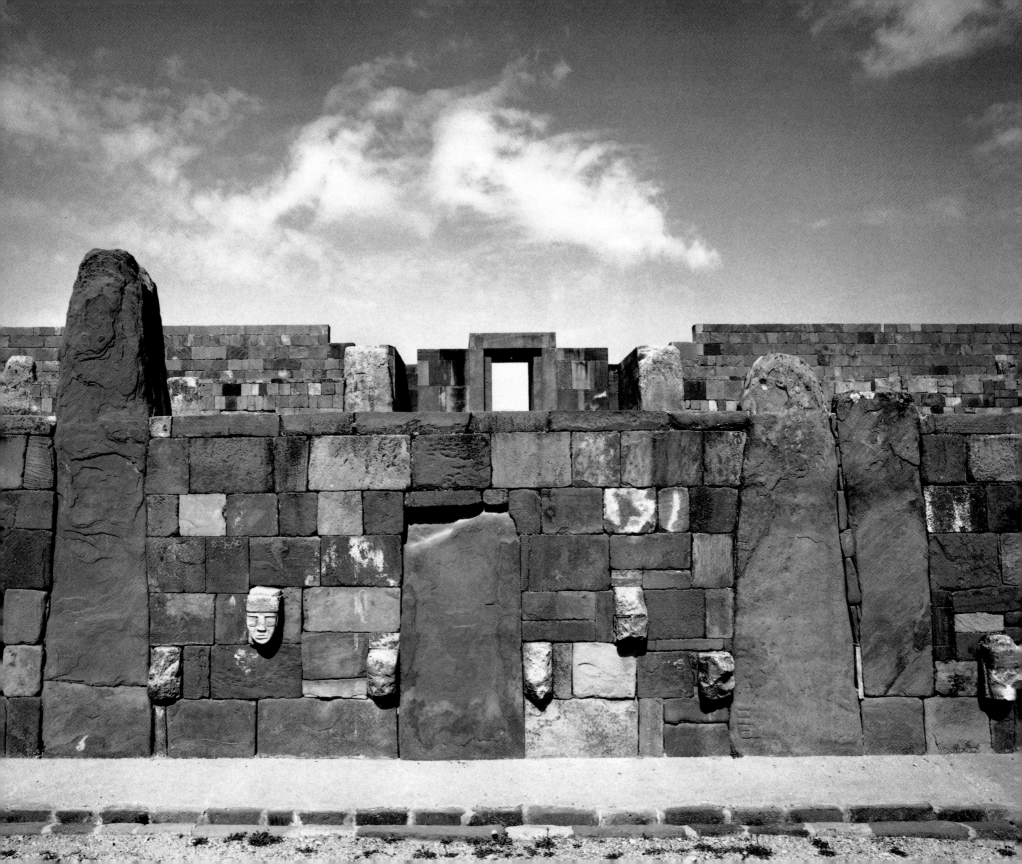

power was so great that we knew this one was the Maker of Things, our Beginning. We called this one P'unchaw.

It was P'unchaw who made the mountains and the plains, the hills and the valleys, the deserts and the jungles. P'unchaw made the reeds grow in the waters of Titikaka. The reeds gave us shelter, made our floating islands and our boats, and with time we became like the reed; we learned to bend with the wind and to reach through the waters of the lake to the Pachamama — the Mother Earth.

P'unchaw brought us corn, a gift of the Sun. P'unchaw called us Children of the Sun, Inka. He told us that at the end of our lives our bodies will return to the great mountains, the Apu; and our spirits will return to the Sun, our Father.

Then P'unchaw went to the edge of the sea, spread his great cloak of feathers yellow, orange, and green, and sailed over the waters of Titikaka up into the Sun.

And the world stood still while the Sun above held gloriously at midday. Father Sun's own eight children were sent from the stars and brought into being on the earth. Father Sun shed a tear of liquid gold, fire, at their birth. And the Four Brother-Husbands: Wanakauri, Ayar Ucho, Ayar Awaqa, and Manko Qhapaq; and the Four Sister-Wives: Mama Q'ora, Mama Rauwra, Mama Wuako, and Mama Oqllo sat in council around the tear of fire. The Sun

said, "The time has come for you to leave your home on the water. Take your gifts of corn and your wisdom to a sacred valley." And Father Sun gave them a golden staff that would sink into the Earth when they had found the place to make their home.

The waters of Titikaka rose until the place of their beginning was under an enormous sea; all that remained was the First Altar. One by one, they went there to lie upon the altar. They offered themselves to Father Sun. One by one, they returned to the Pachamama, the belly of the Earth.

Then a great bolt of lightning struck the First Altar, and the waters receded, and the Four Brother-Husbands and Four Sister-Wives emerged from the Earth at Paqariqtampu. They wore robes of feathers, yellow, orange, and green. And they wore chest-plates of gold, like the sun.

Wanakauri carried a sling of gold; he could flatten the highest peaks with a single blow and change the course of a river's flow. And when he returned to Paqariqtampu to retrieve a golden cup with which to drink from the foaming waters of the Urubamba, the Earth trembled and the mountain fell around him, sealing him in the Earth forever. Three days later, his spirit appeared to the other Brother-Husbands and Sister-Wives; it hovered on wings of light above a mountain peak and showed them where to descend to the sacred valley. His spirit turned to stone on the hill called Wanakauri.

··· page twenty-eight

These complex architectural foundations once supported a large tower containing a reservoir at its base and a fortified residence for the Inka ruler Pachakùteq and his family at its upper two levels. From the top of the tower, the ruler must have had a commanding view of the city of Qosqo.

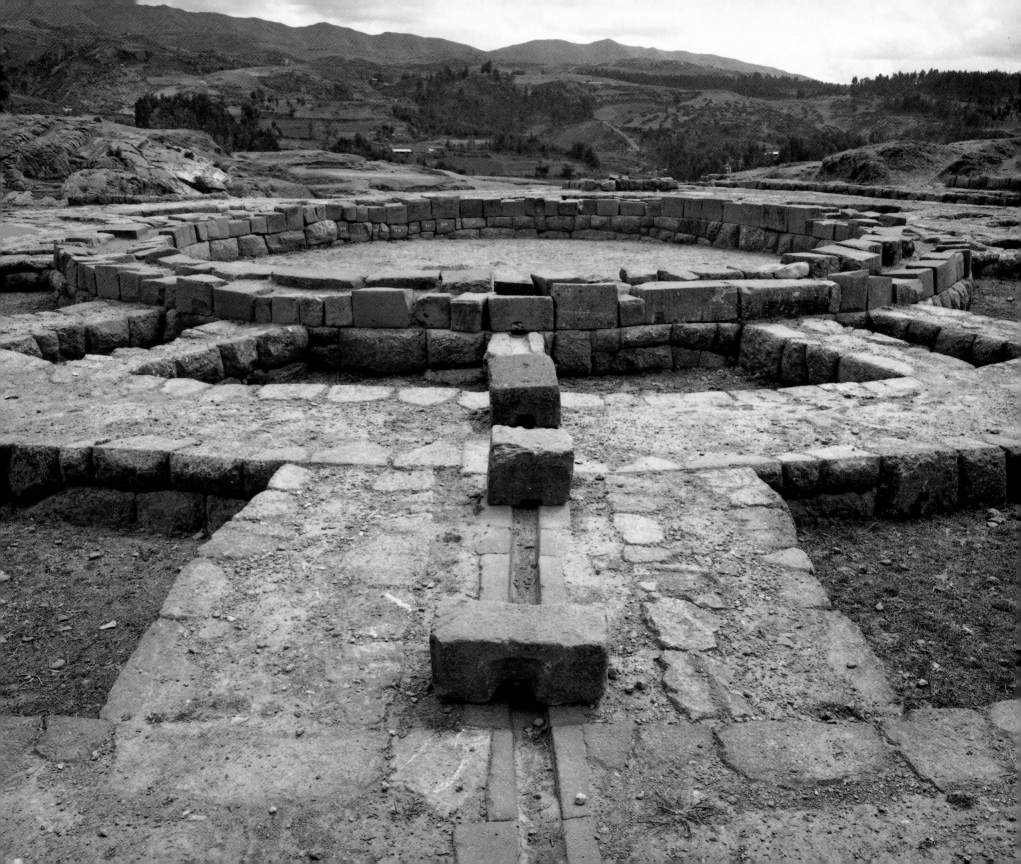

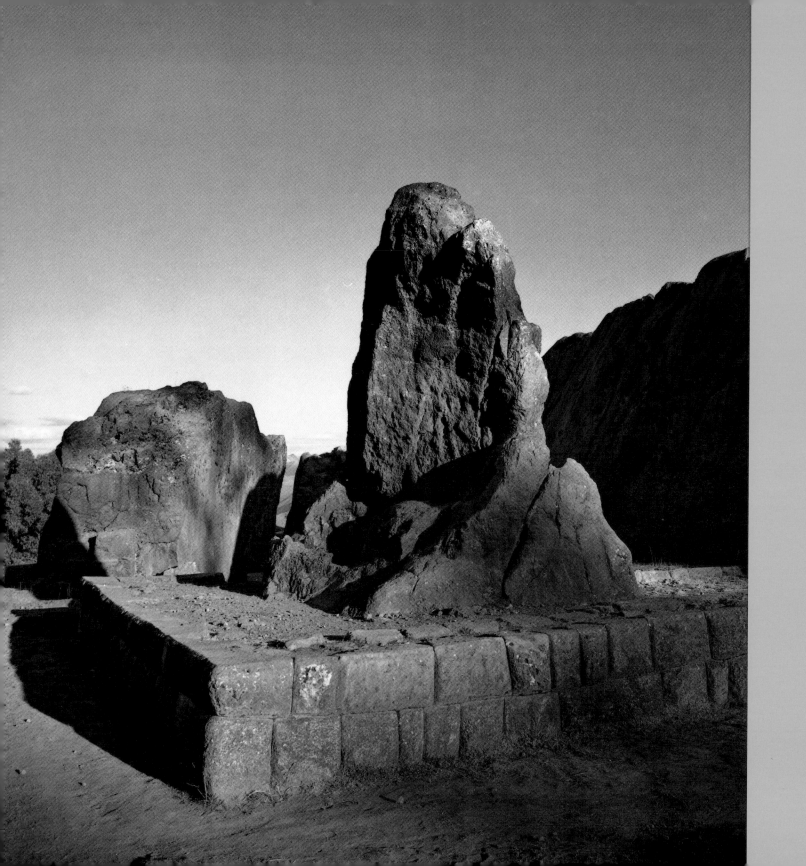

THE SEATED PUMA

Q'enqo, Qosqo

In the legends of the Inka, many of these sacred rocks are transformations of mythic heroes. A labyrinth of tunnels and caves extends within the massive outcrop behind this stone.

SAQSAYWAMAN, QOSQO

This view of Saqsaywaman, the so-called Full Head of the Falcon, shows the garrison and its sawtooth-shaped walls guarding Qosqo. There are many shrines in this area, one of which was the first and foremost Temple of the Sun. In times of danger the Saqsaywaman was accessed by an underground tunnel that led from the Qorikancha at the city's center.

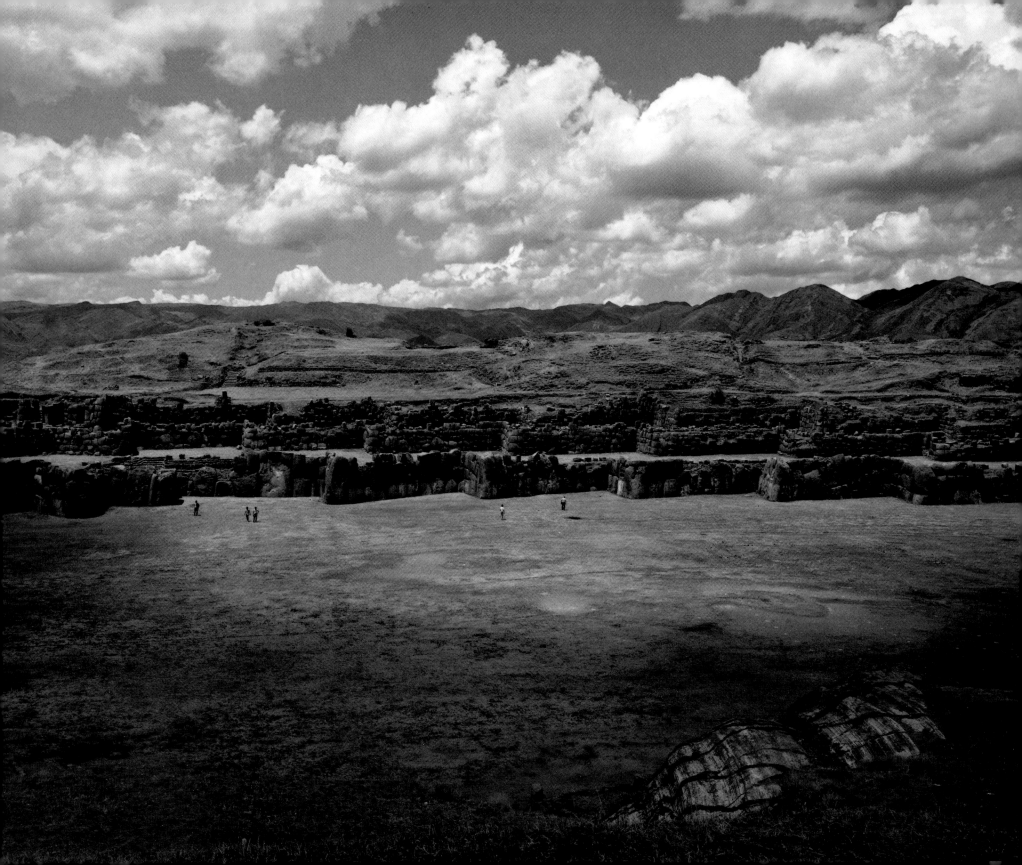

The remaining Brother-Husbands and Sister-Wives went down into the valley where the rivers Saphi and Tullumayo met. When the golden staff touched the Earth at this junction, it sank, and they called the place Qosqo. Manko Qhapaq, the Splendid One, sowed corn there. They built their homes in this place and called it Qorikancha, the Golden Lodge; it became the center of the empire of the Inka.

The three Brother-Husbands and the four Sister-Wives built the city of Qosqo in the shape of a jaguar, with the great fortress of Saqsaywaman at its head. At the place called the Full Head of the Falcon they made a tower of stone called Muyuq Marqa; this they covered in gold like the walls of Qorikancha, because gold is the memory of the Sun's first tear.

The people of the land were simple; they were nomads who worshipped many gods and ate roots and wild plants. And Mama Oqllo showed them the corn, saying, "Father Sun created us like the corn to sprout as young shoots from the belly of Pachamama, our Mother Earth, to bathe in the rains of the sacred mountain — the Apu.

"The touch of the Divine is everywhere. Do not think of the lightning and thunder as gods—they are like us, like the plants and the animals, designs woven into the sacred fabric of time. See the face of Father Sun everywhere. The presence is great, the song is so grand that no temple can contain it.

Celebrate in nature the Great Spirit, the Maker of All Things, and there will be great peace. Make Ayni to Mother Earth and she will reward your lives with great harvests of corn and make the animals fertile. Make Ayni to each other and all will honor all. Make Ayni to the Heavens, and the Heavens will return abundance, harmony, communion, and the song of Creation. Make Ayni out of Love."

So the three Brother-Husbands and the four Sister-Wives made the deserts green and the mountains fertile. They fed their empire with food for the bellies and love for the hearts of their people.

And Manko Qhapaq and Mama Oqllo gave birth to Sinchi Roka who ruled for many years. And Sinchi Roka was succeeded by:

Lloque Yupankí

Mayta Qhapaq

Qhapaq Yupankí

Inka Roka

Yawar Waqaq

Wiraqocha Inka

And the one whom the Apu themselves named Pachakùteq, Renewer of the World, He Who Made Time Stand Still.

During Pachakùteq's father's reign, the city of Qosqo lived under constant attack by the fierce Ch'anka from beyond the Apurimaq river. Finally, the Ch'anka captured the heights above the city. The old king, Wiraqocha Inka, realizing that Qosqo

Known as the Temple of the Sun, Intiwatana is significant for its unique design. In the center there is a natural stone with a hitching-post on top. Surrounding it is a finely crafted D-shaped stone wall and a trapezoidal gateway. The extensive agricultural terraces in the valley below, the lack of grain-storage houses, and the defensible nature of the architecture of P'isaq suggest that its primary role was to protect the rich farmland that supplied Qosqo seventeen kilometers away.

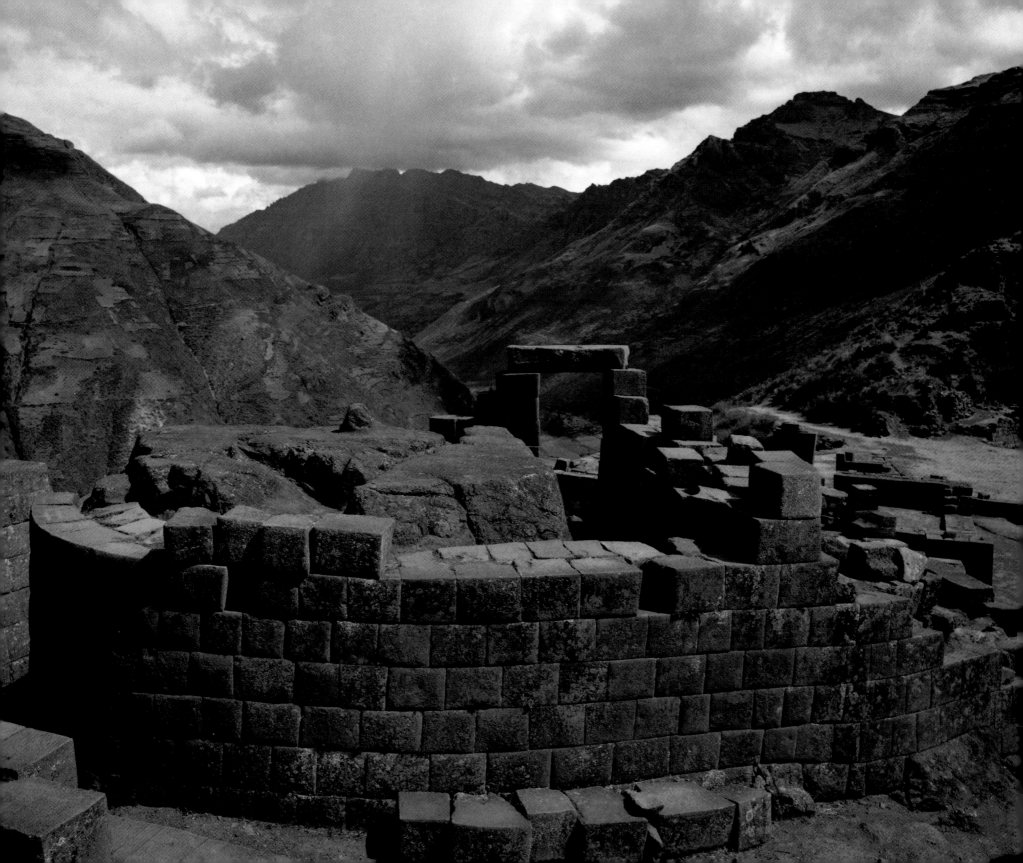

was indefensible, abandoned the city of mud and thatch to plan a counterattack.

While the Ch'anka were invading Qosqo, the young prince, Pachakùteq, was returning to the capital from the provinces. He stopped to rest at a spring called Su'qsuypujiu. As he gazed at his reflection on the still waters, a crystal, black and polished like a mirror, fell from the sky, and in it was the face of a being with a head which shone in three colors. He wore earplugs and his forehead bore the royal fringe. Writhing serpents coiled at his shoulders and his cape was the pelt of a jaguar. The luminous one spoke: "I am the Sun, your Father. I have come to show you the expanse of your empire."

As Pachakùteq looked into the mirror, he saw distant lands—the snow capped peaks of the Andes, the Amazon jungle, the desert coast, and even the great ocean.

Pachakùteq arrived in Qosqo to find it all but deserted by his father's warriors. He watched as the outer edge of the city was overrun by the Ch'anka. But Pachakùteq had received a vision and his heart was full of purpose, so he rallied the warriors who remained to defend the inner city. Under the cover of a morning mist, the prince, wearing the pelt of a jaguar, crept with his men to the Ch'anka camp. As the mist cleared Pachakùteq led a desperate attack. He was overwhelmed by the number of Ch'anka warriors. As his warriors fell around him, the Apu

took pity on his brave heart and noble purpose; the Apu transformed the stones of the battlefields into warriors—the very stones that Pachakùteq later would use to rebuild the city. The warriors of stone sprang to life for as long as the battle lasted, until the Ch'anka returned to their place where the Apurimaq river flows white with rage.

It was the Apu who taught the young prince how to shape the living rock into great cities and fortresses. And after Pachakùteq became king, he rebuilt the city of Qosqo as no city had been built before. And there he laid the ramparts of Saqsaywaman.

Pachakùteq set out from Qosqo toward the Antisuyu, where the Sun burns through the mountains. He took with him one thousand warriors to protect a legion of architects, farmers, shapers of stone, and old ones who knew how to move water. They built a great road and dammed the lagoons and fashioned aqueducts to bring water to the fields and gardens of the empire.

He traveled east, toward the dawn, and when his passage was blocked by another enemy tribe, the Tampus, Pachakùteq sent gifts of corn, fruits and llama to trade for peace. He waited for a response from the Tampus for three moons to no avail. During the winter of that year Pachakùteq decided it was time for action. He and his warriors forded the river Urubamba and encircled the camp of the Tampus.

The Temple of the Waters stands alone in the hills around Qosqo. Its three water spouts are fed from an underground sacred spring. The empty niches above the terraces were used to house idols of the Inka gods and the mummies of significant priests and royal family members.

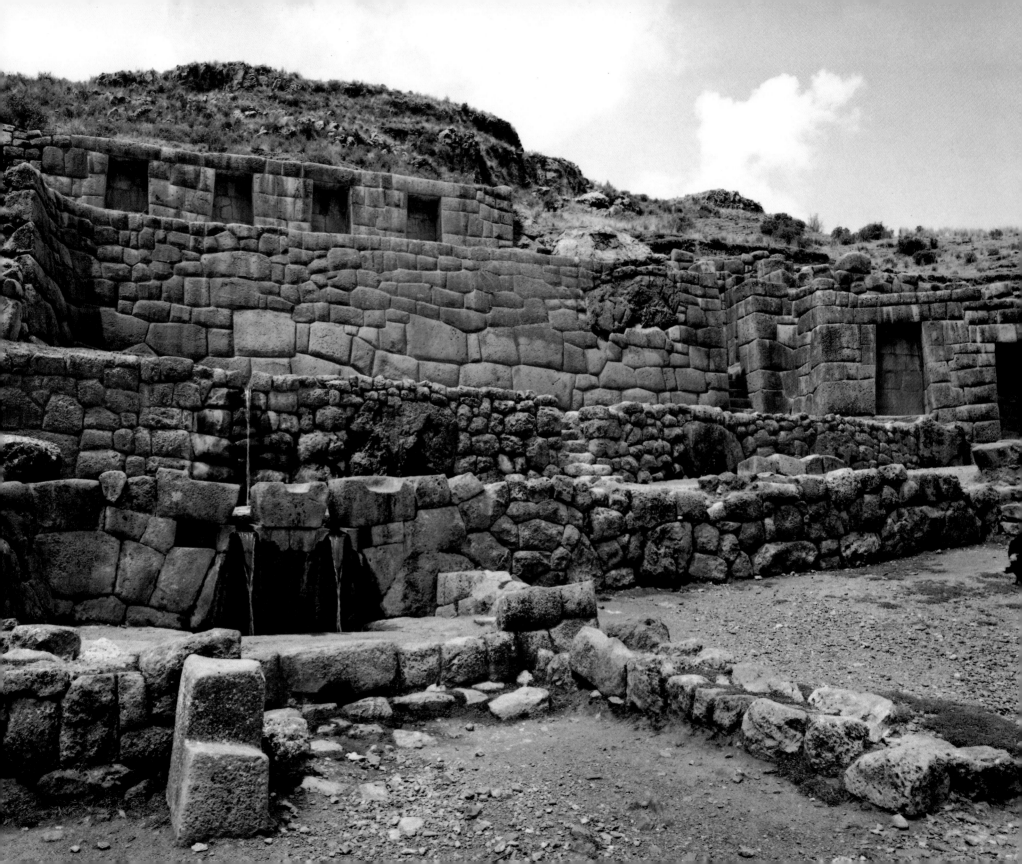

Pachakùteq and his men charged, and by sunset the Urubamba ran red with the blood of the Tampus.

Overlooking this newly won rich and fertile valley, Pachakùteq asked Ollantay, his most fearless general, to build him a summer palace at the headwaters of the Urubamba.

Ollantay was a handsome warrior. He loved Pachakùteq's daughter, Smiling Star, and the princess loved him. But he was not of royal blood, and King Pachakùteq had the princess imprisioned in a far off palace. Ollantay shut himself in the fortress he had built, and waited for the king, his friend, to die so that he might consummate his never-ending love for the princess Smiling Star.

Pachakùteq continued on his way towards the dawn to build a city worthy of the Creator. It would be a City of Light, and it would take all of his life to build.

He said to his people, his architects, his shapers of stone, "Build this city as a city for the gods. Make every room a house for the Creator. Let every wall stand until the end of time."

And on the peak called Machu Pijchu, they began to build the Holy City. Noble men and women from the four corners of the empire worked beside the humblest of laborers, for all were equal in the City of Light. Great rites were held and Ayni was offered before the working of a single rock.

Twenty times the Mother Earth danced around the Father Sun. As the city grew from the top of Machu Pijchu, women brought corn and water from the Urubamba below and men cut and carried the stones that would make the walls.

Pachakùteq was an old man when he set out to walk the Royal Road from Qosqo to Machu Pijchu. And when he stood at the Intipunku, the Gateway of the Sun, overlooking Machu Pijchu, he was filled with joy.

He left his attendants standing at the Gateway and descended to the Spirit Canoe of granite outside the walls of the city. Like his ancestors, the Brother-Husbands and Sister-Wives in Lake Titikaka, he lay down upon the Spirit Canoe and called the Spirit Jaguar to come from the west to take his spirit to the place of silence and darkness. Next, Pachakùteq called upon the Spirit Eagle to return his soul to the east, the place of new light, new life. When Pachakùteq stood up again, death could not claim him, for he had been claimed by life.

He descended the stone steps and entered Machu Pijchu through a small gate as others gathered by the stone canoe to watch.

He went to the Temple of Stars to pray in front of the two circular altars of water. Gazing into the mirrored pools of evening sky, Pachakùteq remembered the origin of his ancestors from the stars.

The faithful people, the warriors, the architects, the farmers, shapers of stone, and the old ones who knew how to move water, watched as the Sun rose

··· page thirty-seven

Seeds from all different parts of the Inka empire were found in the terraces; thus, it is believed that this site was an experimental farm. At different times of the day the three low hills, surrounding the terraces, cast shadows on the site which combined with the different elevations of the terraces to create varying climatic conditions. This allowed them to reproduce a vast variety of crops that were grown throughout the empire.

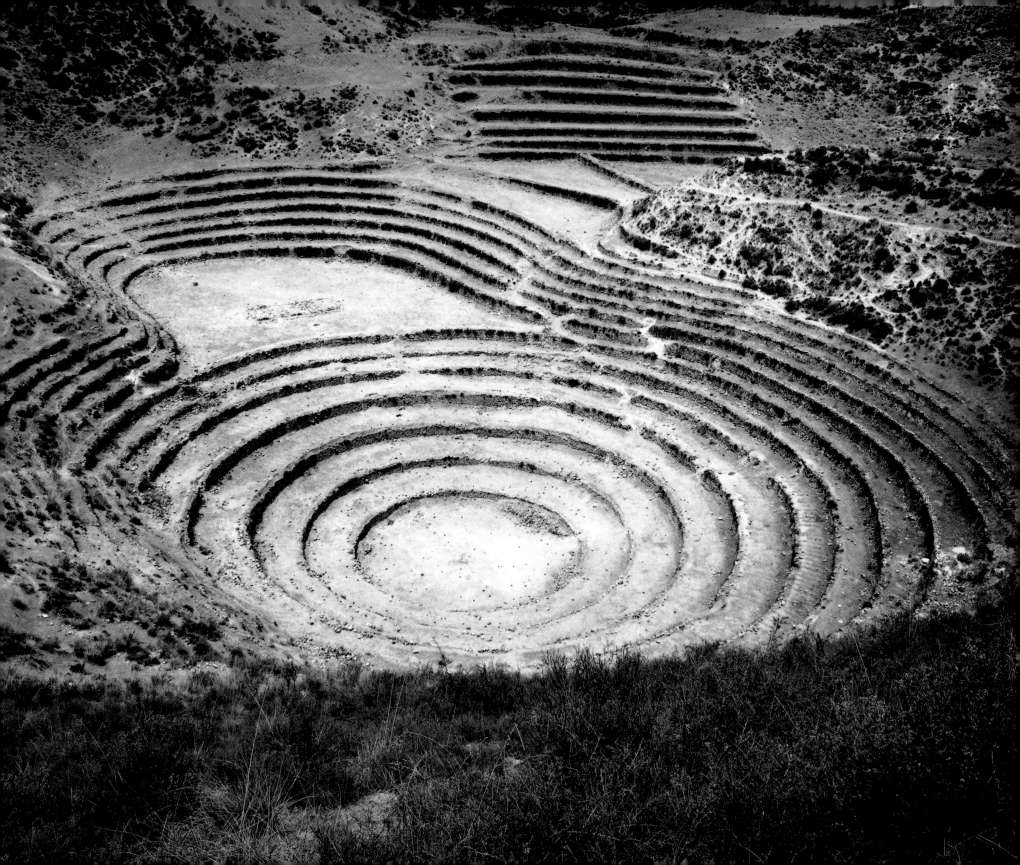

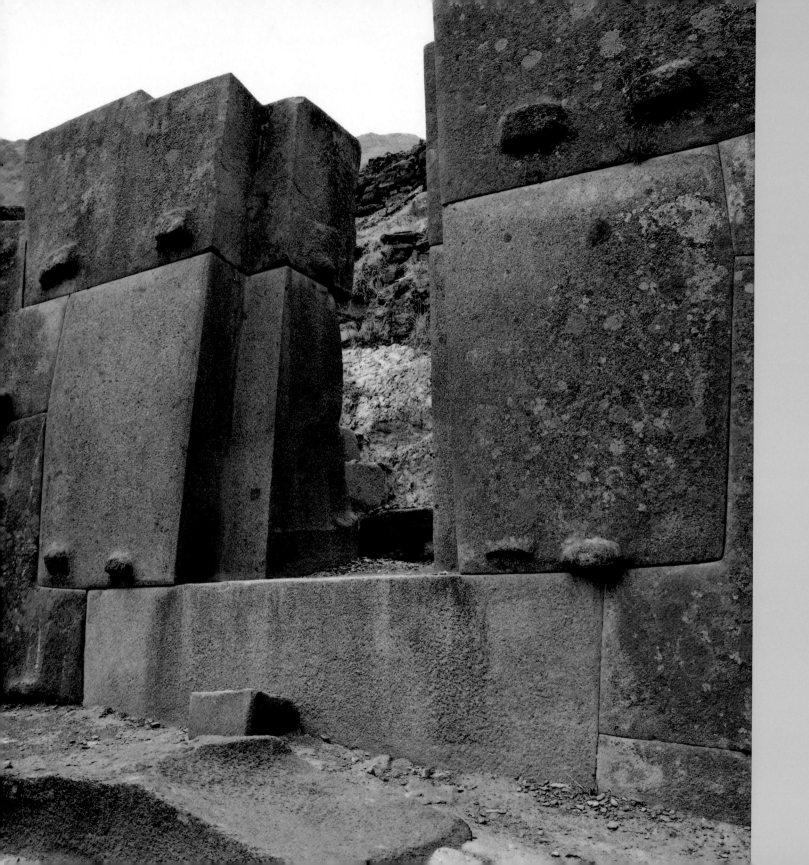

THE GATEWAY TO INTIWATANA

Ollantaytambu

The beauty of this wall lies in the fact that each stone is uniquely shaped and cut. These stones interlock like a jigsaw puzzle to prevent earthquakes from destroying the wall.

EAST-FACING ELEVATION OF INTIWATANA

Ollantaytambu

Six monoliths separated by five narrow vertical stone wedges make up the east-facing interior wall of the Sun Temple. The central monolith bears three symbols of the northern star, in low relief, which are barely visible today due to erosion.

It is believed that these cross-shape designs have their origins in Tiwanaku.

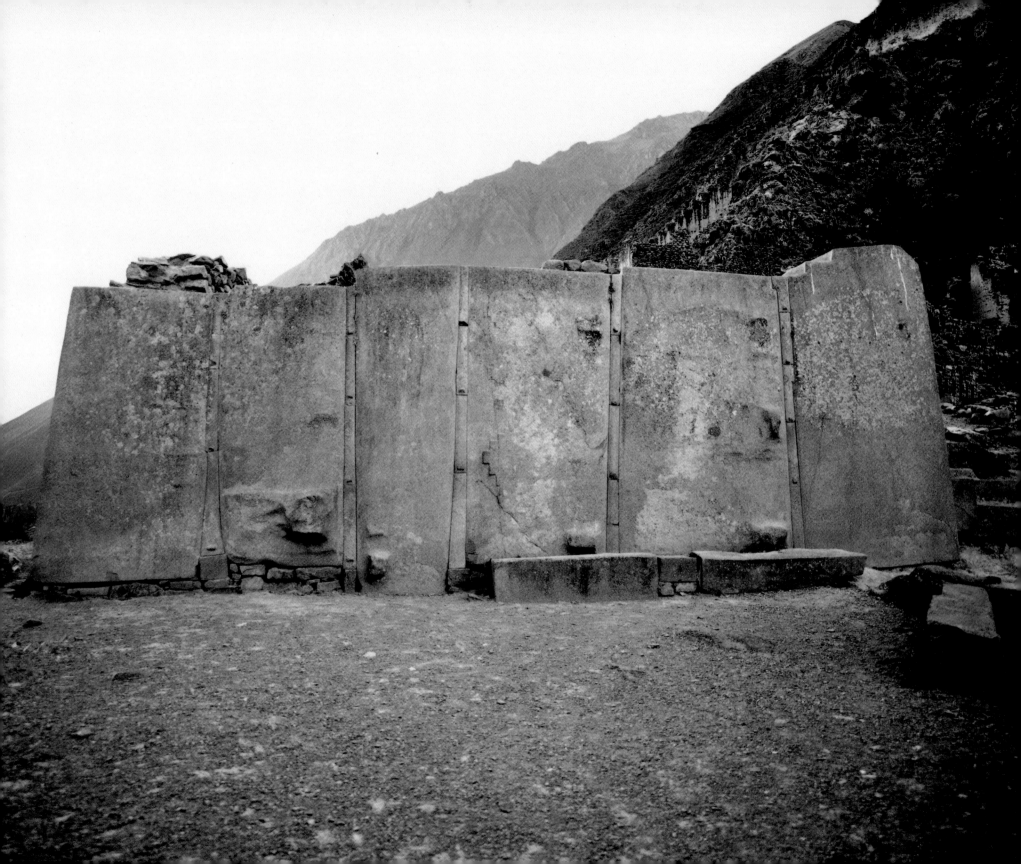

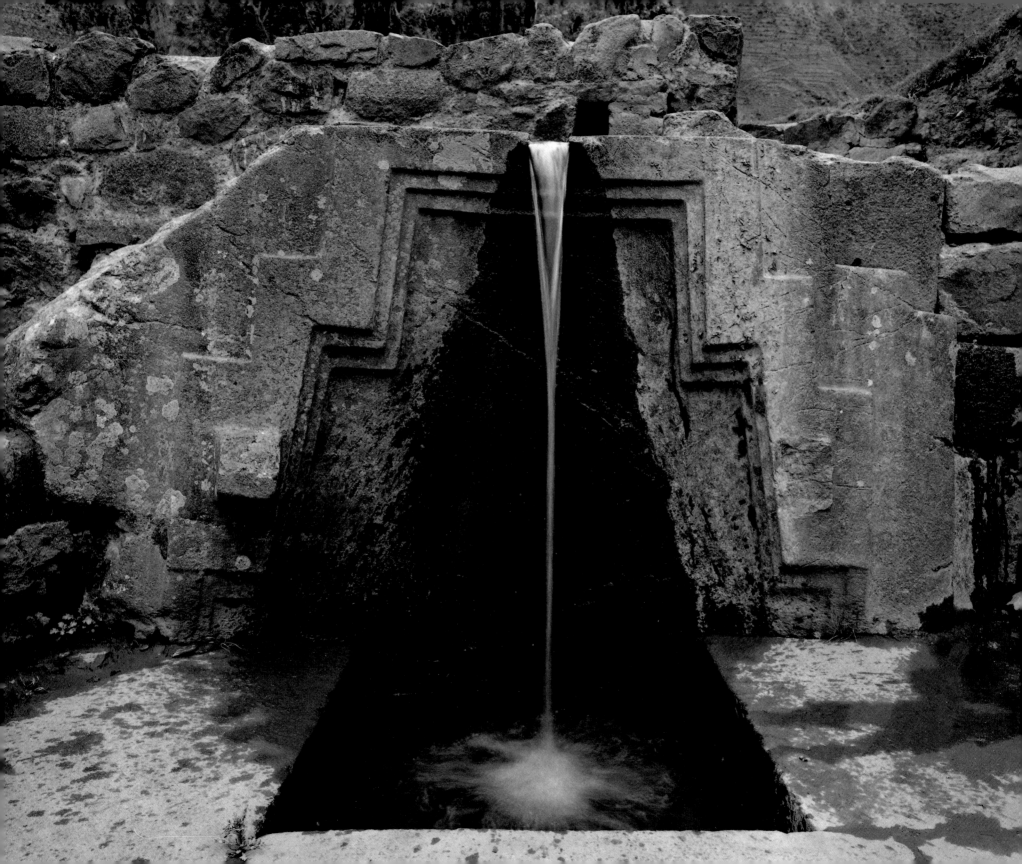

FOUNTAIN OF THE PRINCESS

Ollantaytambu

*Legend tells that this
fountain was created by
General Ollantay to honor
the princess Smiling Star,
who was the daughter of
King Pachakùteq. The
general, who was not of
royal blood, was in love with
the princess but was not
allowed to marry her because
she had been banished by
her father to the House of
the Chosen Women.*

on the new day and Pachakùteq climbed the steps to the Intiwatana, the Hitching Post of the Sun. As the first light touched the place where the Sun is tied, the old king touched his forehead to the stone canoe and remembered the first story ever told—the one about the day that the Sun shed a tear of joy that landed on the Earth, how it washed through the rivers and crevasses of the Mother to find a home in her belly.

And when Pachakùteq had remembered, he went to the stone of the Pachamama, Mother Earth. He spread his arms and She stepped from the stone and embraced him. And the wind whispered to him his final words.

He turned to face each of the four directions, he touched the Earth and raised his face to the Sun, and he spoke these words:

"Wayra,
 Winds of the East
 Place of the Rising Sun, My Father.
 I give back to you my breath.
 Great Condor,
 Guide me through the night;
 Teach me how to fly wing to wing
 With the Great Spirit.

"Mach'qway
 Winds of the South
 Great serpent,
 Teach me how to shed my skin,
 My pain, my sorrow, my years,
 To touch my belly one last time
 To the belly of the Mother
 With innocence and purity.

"Uturunku,
 Winds of the West
 Mother Jaguar, Sister Jaguar,
 I return to what is yours,
 What death will never claim.
 Take it back to the sacred mountains
 Apu Salgantay, Apu Ausangati.

"Amaru,
 Winds of the North
 Great Dragon,
 Grandmothers, Grandfathers,
 Ancient Ones,
 I have seen too many golden sunsets,
 Too many fields of new corn;
 Long have your songs
 Sung within me.
 I come Home."

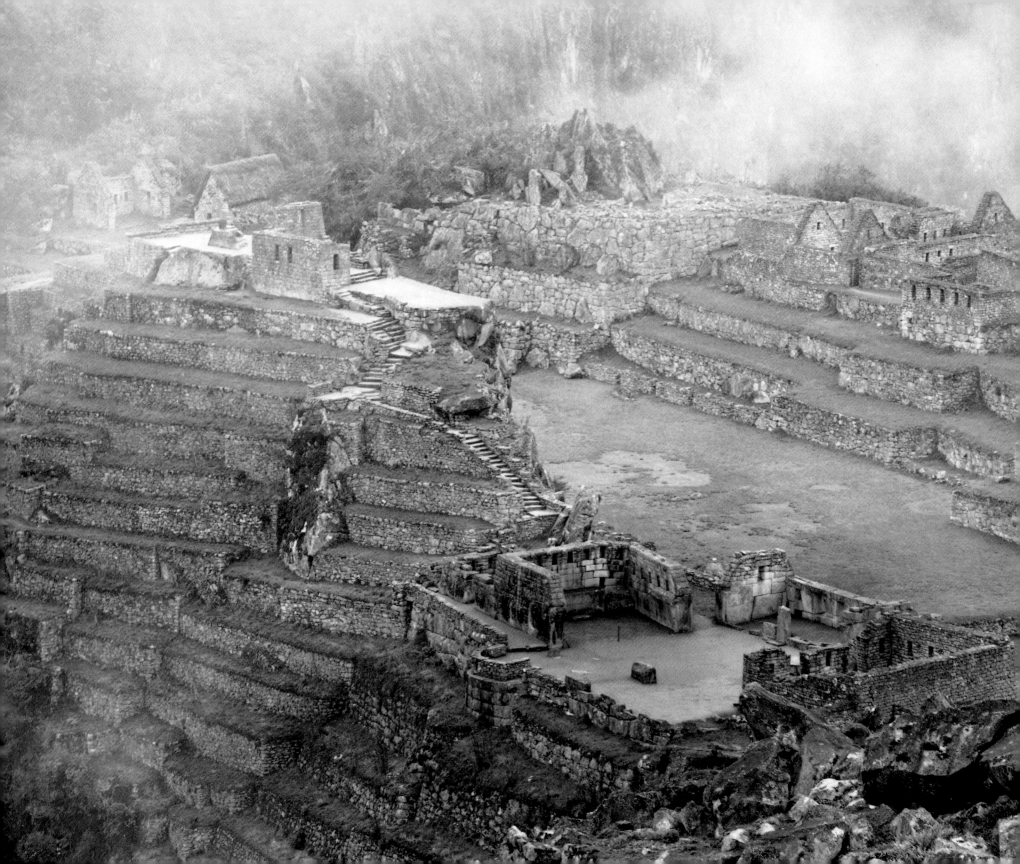

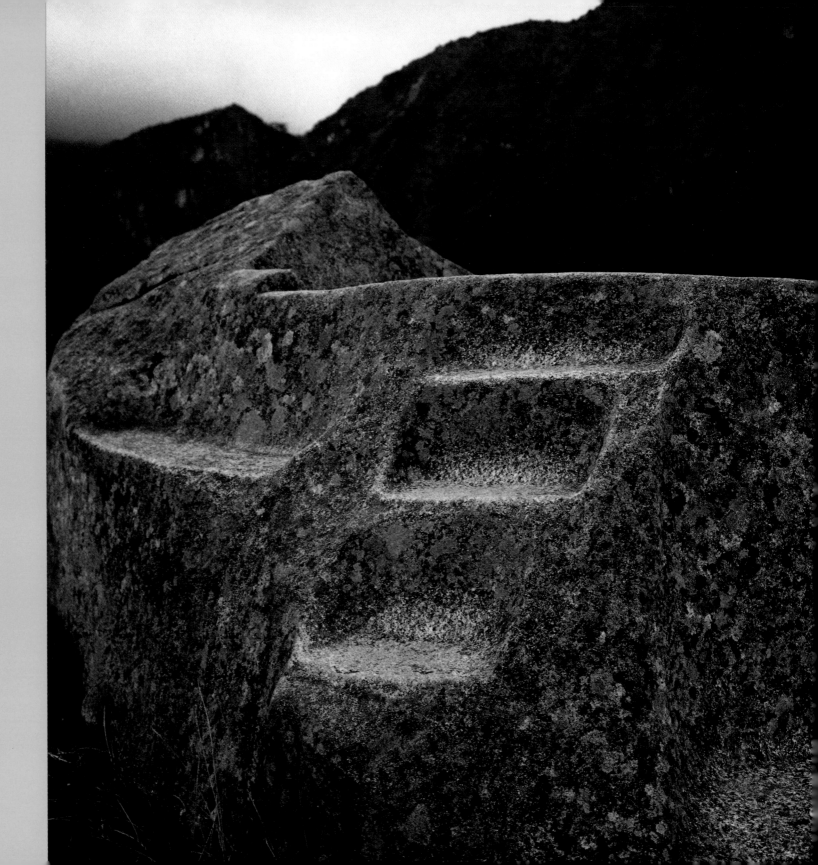

WESTERN BUILDING GROUP AND THE GREAT PLAZA

Machu Pijchu

In the foreground a small plaza is bordered by three buildings: the Principal Temple, the Temple of Three Windows, and the Residence for the High Priest. Preparation for the Sun Ritual probably took place here, before the priests ascended the steps behind the plaza to the Sun Temple.

SPIRIT CANOE

Machu Pijchu

This side view of the stone canoe shows its ceremonial steps and ledges for offerings. Legend reveals that the Inka, on their pilgrimage route from Qosqo to Machu Pijchu, had to stop at the Spirit Canoe to participate in a death ceremony before entering the city.

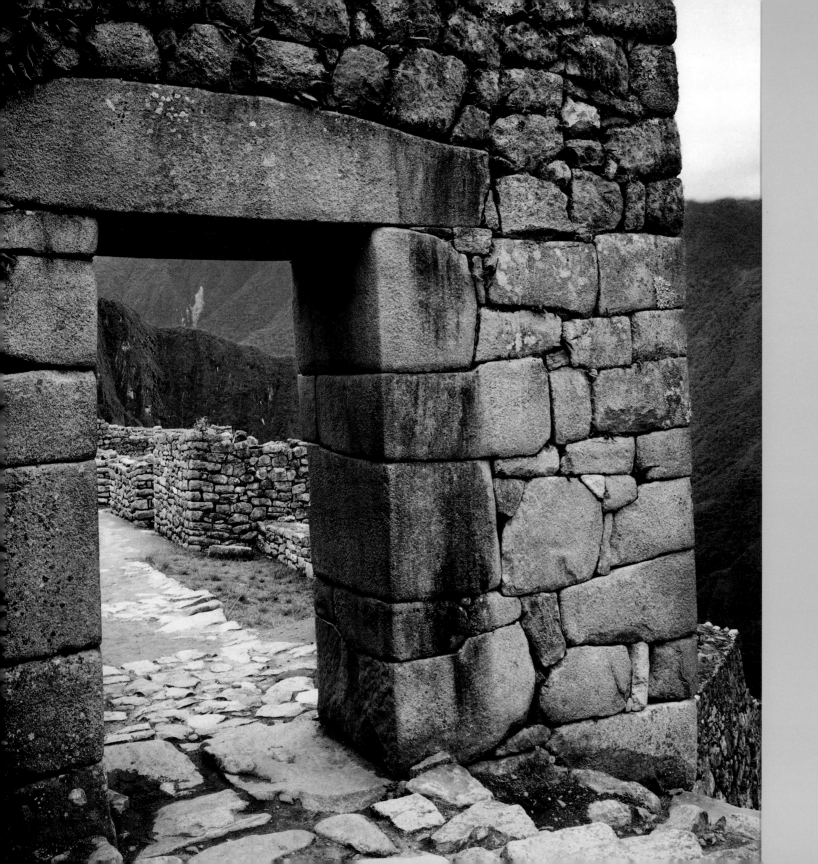

MAIN GATE OF MACHU
PIJCHU

*This relatively small gate
is the only entry to the
Holy City of Machu Pijchu.*

CENTRAL PLAZA AND

EASTERN BUILDING GROUP

Machu Pijchu

*Machu Pijchu consists
of two major building
groups; each group is a
self-contained unit with its
own temple complex. The
eastern group has a
different character from
the western one. This may
suggest that there were
two religious sects.*

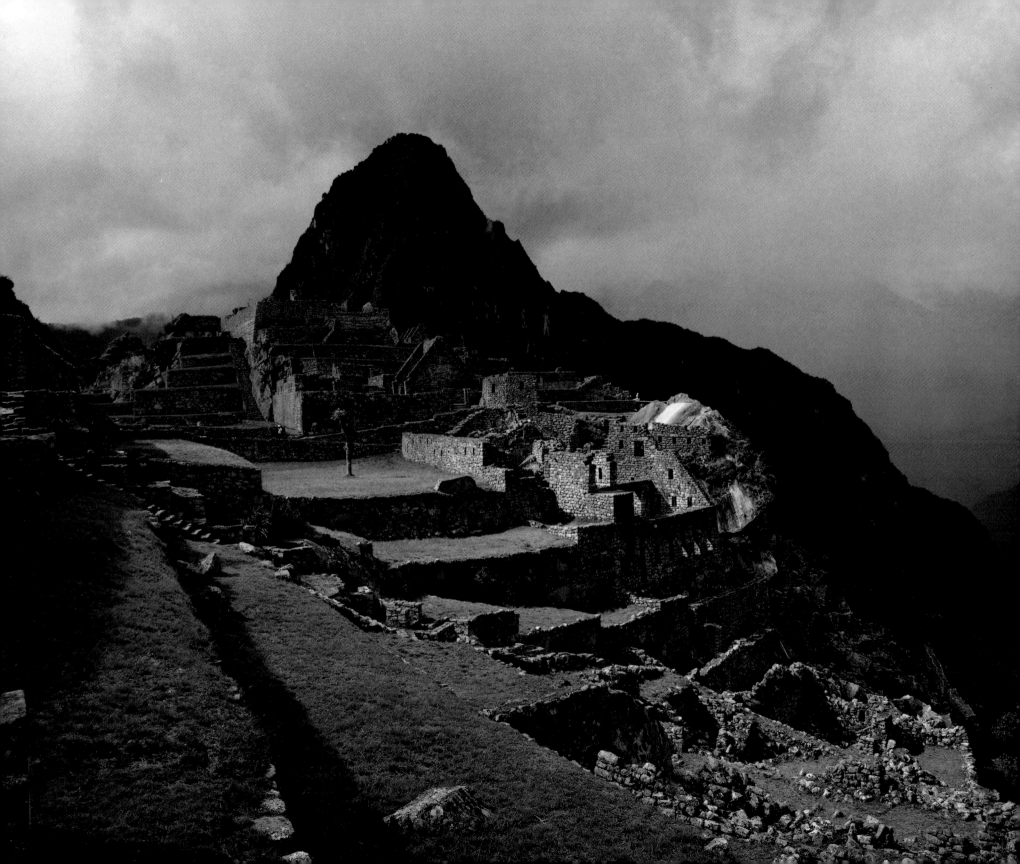

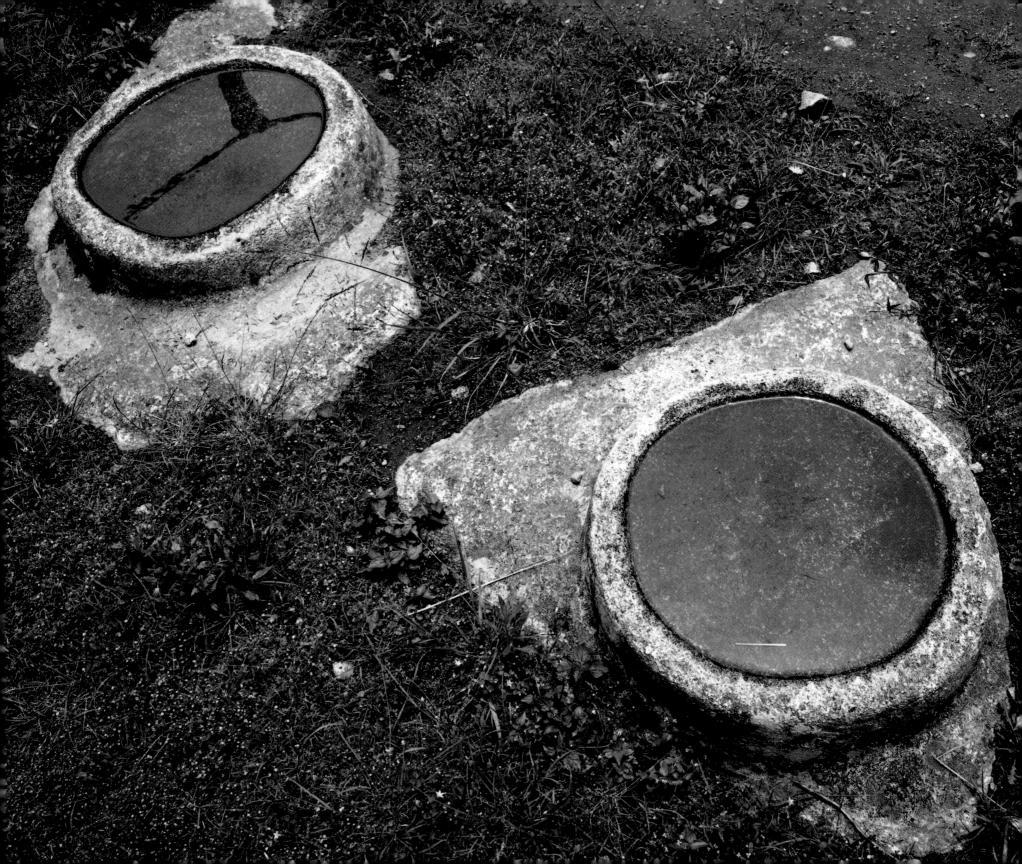

REFLECTING POOLS

Temple of the Stars,
Machu Pijchu

The water in the basin of each
stone captures and mirrors
the movements of the evening
stars above.

SACRED BATH

Machu Pijchu

This ritual bath is the
most articulated, refined,
and elaborate of the sixteen
baths on the site. The baths
were placed on terraces so
that the water could flow
from one to the other.

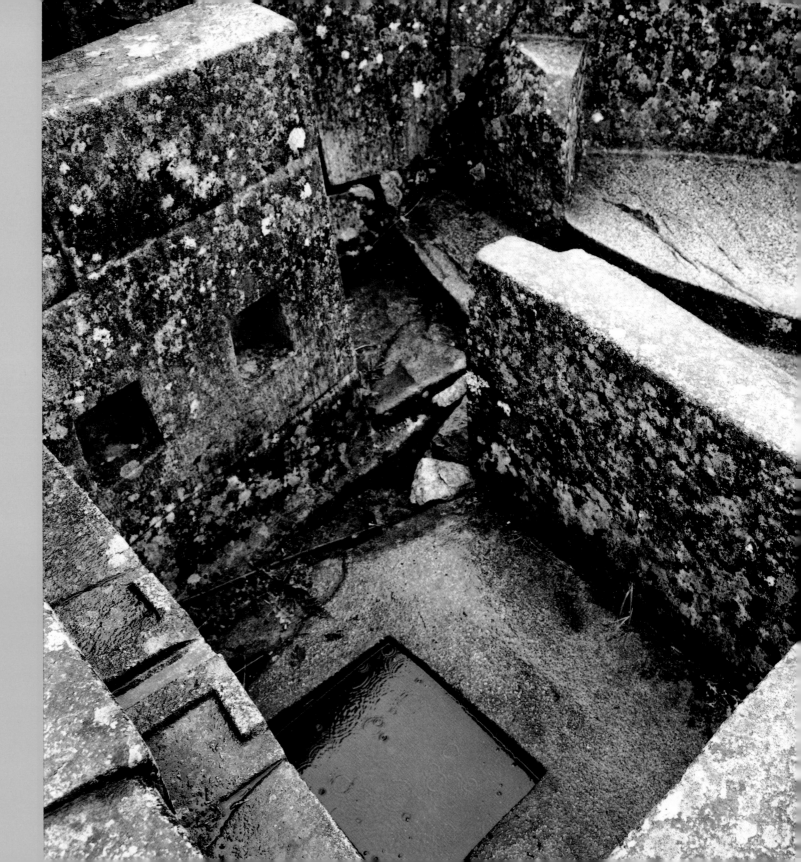

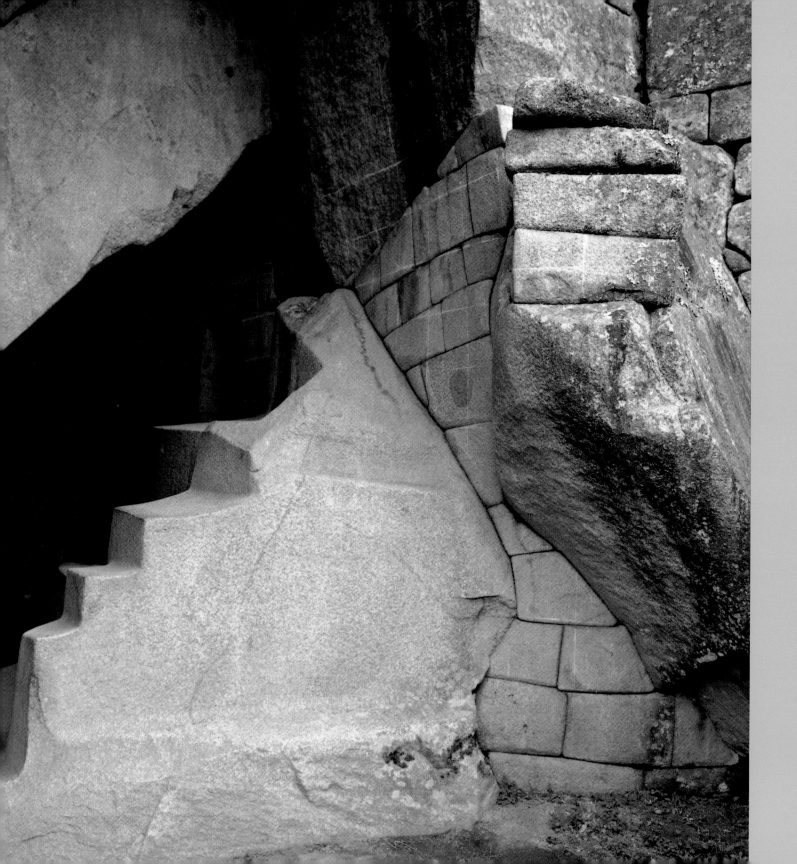

LOWER CHAMBER OF ROCK TEMPLE

Machu Pijchu

Local priests consider this chamber to be the heart of Machu Pijchu. Early discoverers have identified this place as a mausoleum; however, archaeologists have not found anything to justify this claim. This was more likely a place of worship because of the presence of sacred niches and ledges for offerings

INTIWATANA

Machu Pijchu

This altar, located at the highest point of the western building group, is known as The Hitching Post of the Sun. At sunrise this altar is the first place to receive sunlight. The contour of the altar, viewed from this angle, resembles the outline of Wana Pijchu beyond.

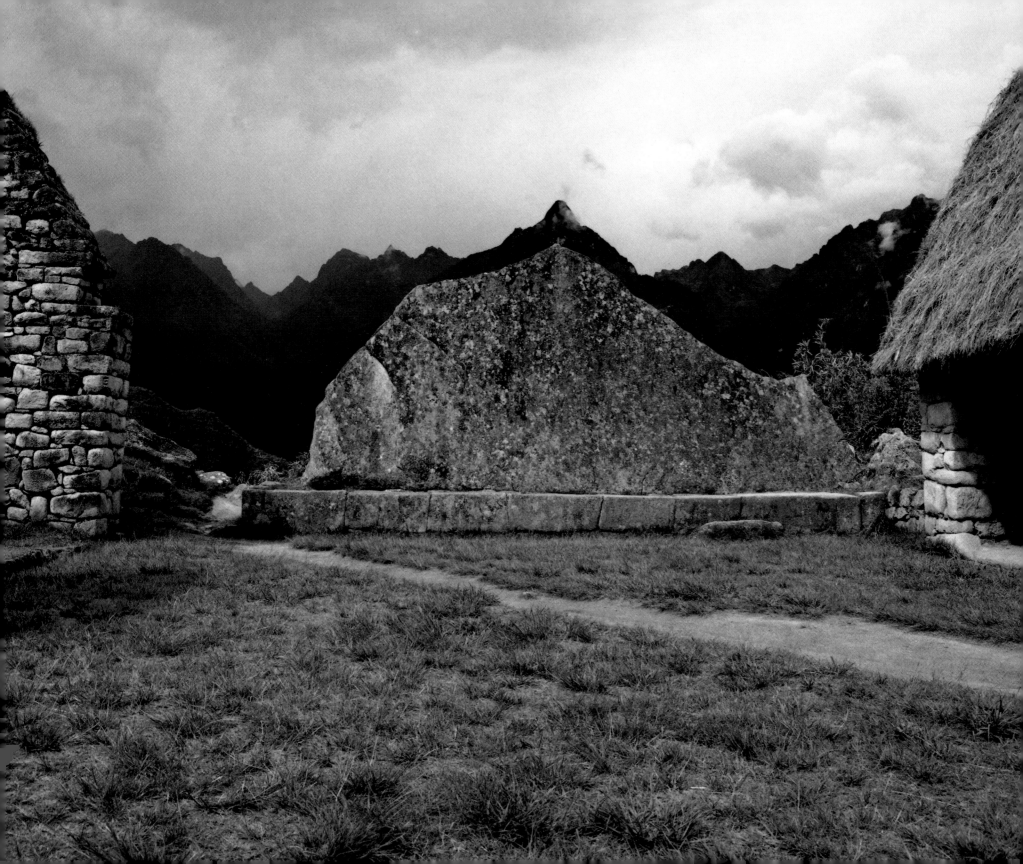

ALTAR STONE

Pachamama Temple,
Machu Pijchu

*The focal point of the court
of Pachamama Temple
(Temple of Mother Earth)
is the altar stone, which
recalls the shape of the
mountain behind.*

HOUSE OF PACHAMAMA

Wana Pijchu

*This temple was built deep
into a large cave with many
tunnels radiating from the
site into the heart of the
earth. The location suggests
that the temple was a place
of worship to Mother Earth.
This is in contrast to the
common belief that it was a
Temple of the Moon. It
would not have made a good
observatory, the view being
obstructed by Wana Pijchu.*

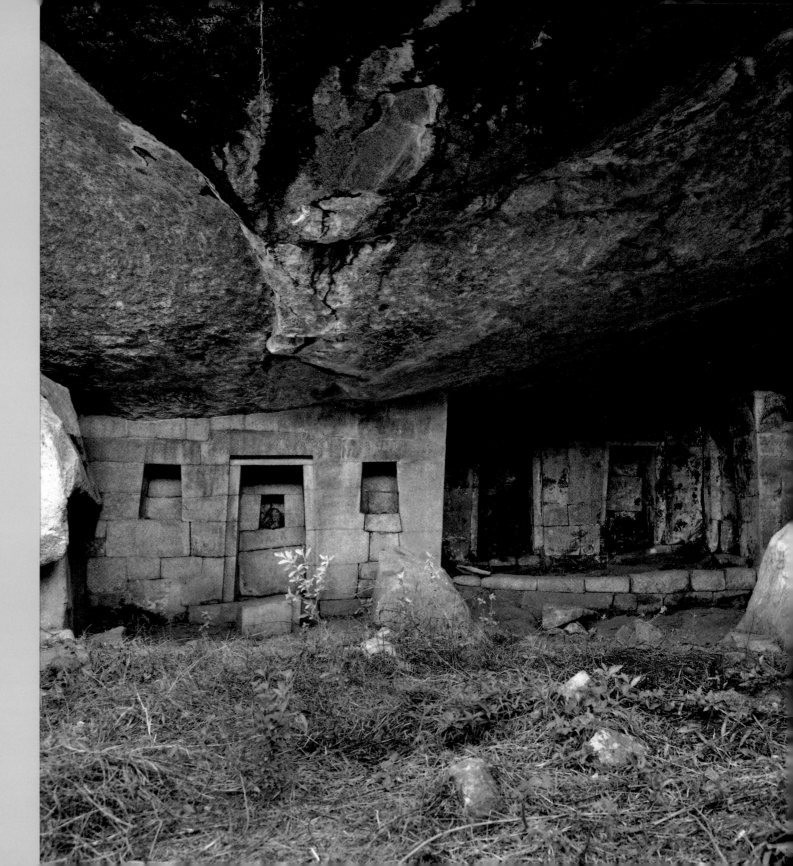

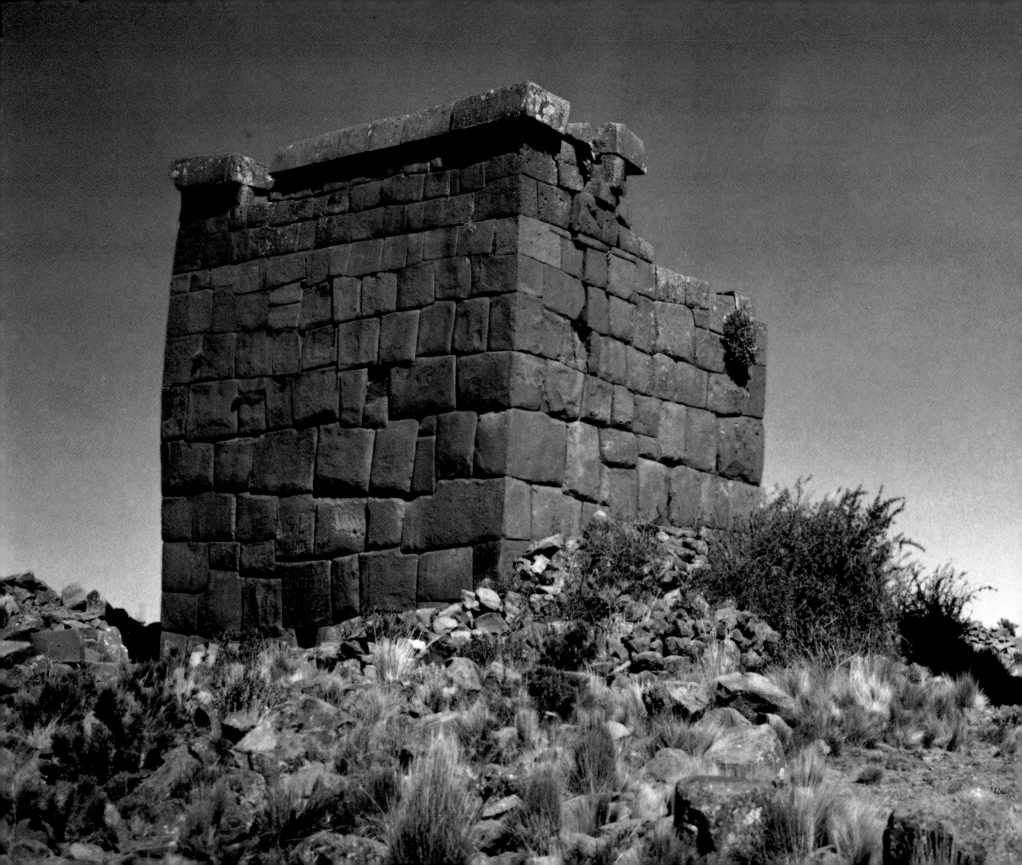

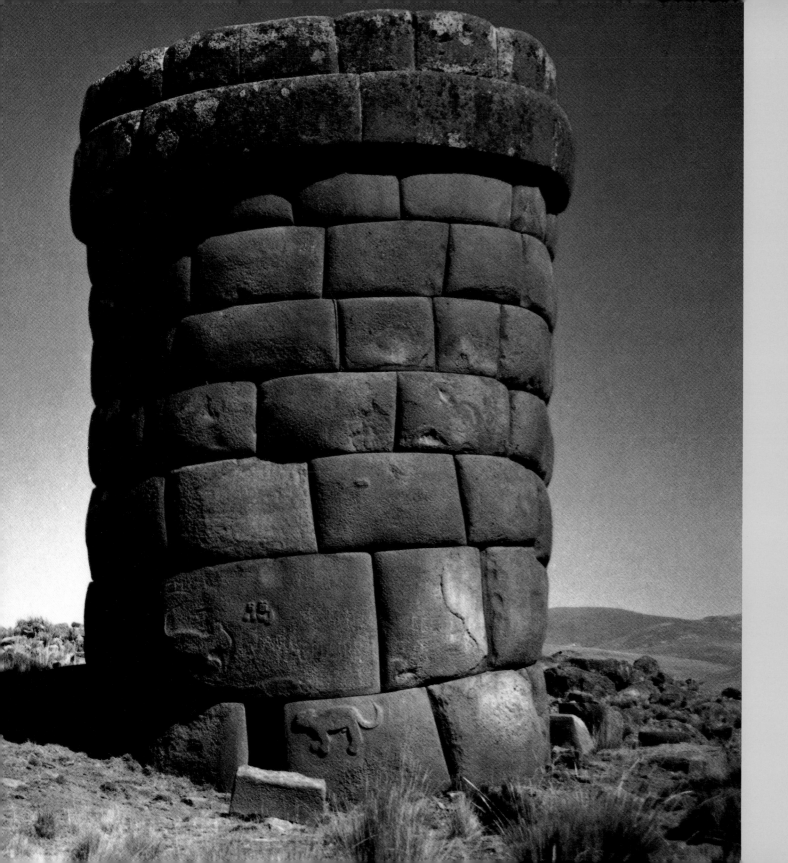

CHULLPAS AT KUTIMBU

Lake Titikaka

*These burial towers on top
of the Mesa of Kutimbu
represent the finest masonry
techniques borrowed from
the Tiwanaku civilization
in the Lake Titikaka
region. Large stone blocks
with hairline joints and
beveled junctions are typi-
cal of Inka architecture.
The feline reliefs on the
circular chullpas guard the
secret entry at the base of
the structure.*

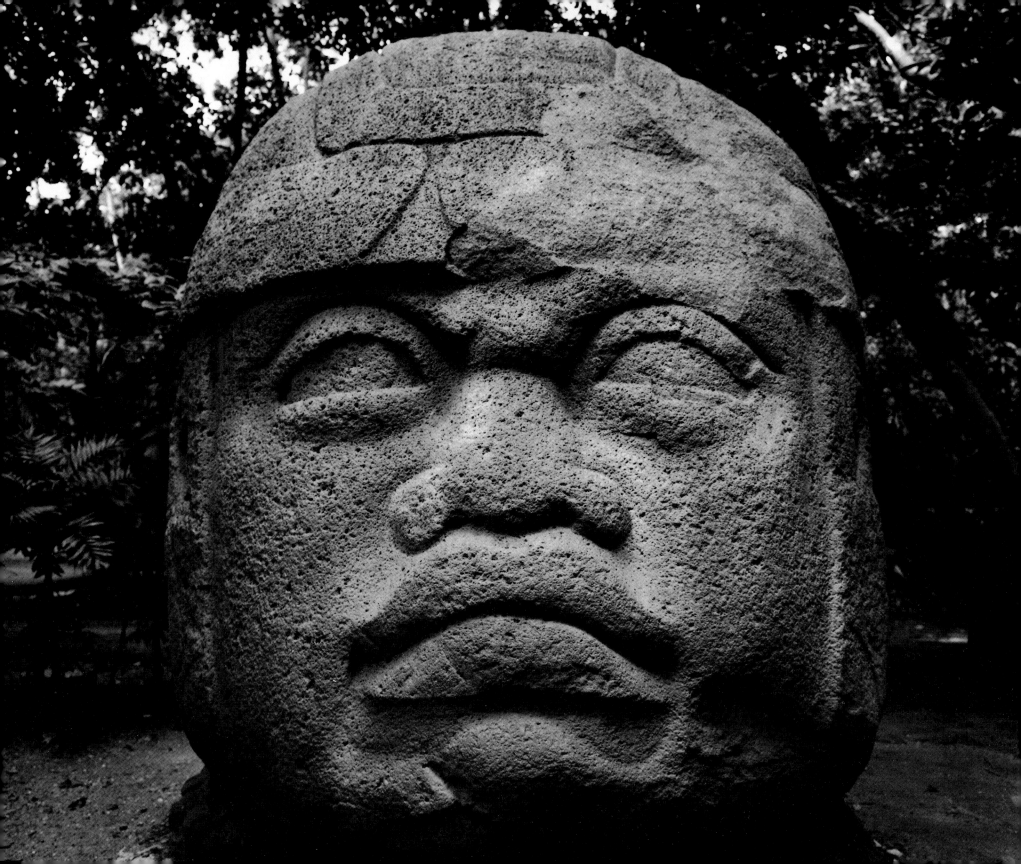

MAYA

AKAROK, AT TZAKOL, AT BITOL
salute! oh maker, oh architect

KOH AV ILA, KOH A TA
look to us, hear us

AT KABAVIL CHI KAH, CHI'ULEV
oh god in the heavens, oh god in the earth

CH A YA TAH QETAL, QA TZIHEL
give us your sign, your word

CHI BE Q'IH, CHI BE ZAQ
that there will be day, that there will be light

MAYA

Gulf of Mexico

◆ Chichén Itzá

CANCUN ◯

Cobá ◆

Uxmal ◆ ◆ Kabah
Sayil ◆ ◆ Labná

◯ COZUMEL

Tulum ◆

Yucatán Peninsula

Mexico

Caribbean Sea

Villahermosa ◆

TABASCO

Guatemala

Belize

◆ Palenque

◆ Tikal

◯ SAN CRISTOBAL DE LAS CASAS

◆ Caracol

CHIAPAS

Honduras

Pacific
Ocean

◯ QUICHÉ

CHICHICASTENANGO ◯

◆ Copan

◯ GUATEMALA CITY

El Salvador

It is generally agreed that the area where the Maya lived was populated by small nomadic bands as early as 9000 B.C. By 2000 B.C., a single Maya language, Proto-Maya, had already been in existence in what is now the western Guatemalan highlands, and in Chiapas, Mexico. Between 2000 B.C., and A.D. 150, effective farming and densely inhabited villages were found throughout the Maya area. This is known as the Preclassic Maya.

The Olmec were the first civilized people to appear in Central America. They settled in the coastal region of the Yucatán, around 1200 B.C., in the modern-day Mexican states of Tabasco and Veracruz, and began carving colossal heads in stone. They developed a system of numbers, as well as lunar and solar calendars. They were the first domesticators of maize and were masters of city planning. The Olmec civilization vanished about 400 B.C., but it is believed that they were the ancestors of all the peoples of Mesoamerica.

From A.D. 250 to A.D. 900, the Maya, being the descendants of the Olmec, inherited the craft of stone. They evolved the technology to build the monumental pyramids that rise above the jungle of the Yucatán. The culture blossomed into a great artistic and intellectual power with an extensive trade and a flourishing economy that supported a large population. This is known as Classic Maya.

Maya was not a unified empire but rather a series of city-states ruled by semi-divine kings and bound by a common language and religion. They developed an accurate astrological calendar along with a complex system of writing. Only recently have epigraphers been able to decipher the glyphs carved into stelae. These great stone tablets were erected in front of pyramids and other monuments to commemorate the great leaders and their extraordinary achievements.

From these written records, experts learned that the Maya flourished about A.D. 250, and that they had settled in what is modern-day Mexico, Belize, Guatemala,

Honduras, and El Salvador. However, A.D. 900 marked the end of the great city-states. Many stelae were either unfinished or left uncarved in Tikal, Palanque was abandoned, and Chichén Itzá fell into disuse.

For many years, the fall of the Maya has puzzled experts. Currently, they have been able to decipher the Maya glyphs and, through careful analysis of underground debris and skeletons, have gained insight into the causes behind the decline of this great culture. The progressive increase in the numbers of the ruling class resulted in intense rivalries, thereby expanding the magnitude of warfare. The escalation of conflicts between neighboring states caused large-scale destruction. Furthermore, overpopulation lead to the exploitation of the rain-forest ecosystem and the disintegration of the agricultural system developed by the Maya.

Considering the vulnerable nature of the water supply in the Yucatán and the many stresses placed on an over-populated society, it is quite possible that the end of the Maya civilization came in

A.D. 900, as the result of a single natural disaster such as drought, flood, or an epidemic.

When the Toltec of Tula descended from the north about A.D. 950, the major Maya cities had already been abandoned. For the next three hundred years, until A.D. 1224, the Toltec dominated the area and ruled the Yucatán from Chichén Itzá.

During their reign in the Yucatán, the Toltec brought with them the deity Quetzalcoatl, the Feathered Serpent; bringer of medicine, irrigation, astronomy, mathematics, architecture, as well as the ways of the ascending god and the inner teachings. Thus, the Feathered Serpent motif surfaced on the Maya buildings during the Toltec reconstruction of Chichén Itzá, Labná, and Uxmal. Although the Maya have an equivalent serpent deity, K'uK'ulKan, which is associated closely with the rattlesnake, it has neither the plumed body motif nor the highly elaborate legend of Quetzalcoatl.

When the Toltec lost control of the Yucatán, the Maya began to return, about A.D. 1250, and feebly

ruled the remnants of their great civilization. They slowly degraded into village life and loosely affiliated city-states until around A.D. 1290, when they regained prominence as an economic power through sea trade. Maya thrived until the Spanish drove them into the jungle and hills in the 1500s.

The architectural monuments of an ancient civilization, like its myths and legends, are subject to foreign influence, either through cultural exchanges by way of economic trade or through political dominance. The ancient Maya civilization received far more cultural influence from its non-Maya neighbours than it was able to give. Neither the photographs nor the myths in this book attempt to present images that are purely Maya, for like a living language, the culture and its buildings have a life of their own. It would be unfair to claim that these images represent pure Maya architecture, as if they were objects frozen in time, untouched and untainted by outside influence. We as observers today may never reach that pure Maya time, no matter how much archeological evidence we are able to obtain, for the magic and the majesty of this culture can be understood only through the emotions evoked in its poetics.

This is the beginning of the ancient word, the source of everything that has been. This is the account how things were placed in shadow and brought into light by

The Maker, Architect,

The Mother and Father who is known as

Hunter Possum, Hunter Coyote,

The Great Plumed Serpent,

Heart of the Lake, Heart of the Sea.

This is the Council Book, a place to see the Dawn of Light.

And great is the moment and the wisdom of those who understand the beginning of Heaven and Earth. And great is the moment when it was made into the Four Directions, when all four parts were given names, and its form separated from the other. And great is the moment when the length was measured between Heaven and Earth, and to the Four Corners by

The Maker, Architect,
Mother and Father of all Life and of Creation,
Giver of Breath,
Keeper of Peace and of the Eternity of your
Children,

Bearer of the Lasting Light,
of those born in the light and conceived in
the light.
All is empty under the sky,
and there is yet no person, no fish, no bird,
no tree, no canyon, no hollow, no forest.
Only the sea stands alone, like a pool, under
the sky.
Nothing stirs. All is at rest.

Only the calm sea, only the great water, murmurs and ripples in the darkness of night. Only the Maker, Architect, Great Plumed Serpent, Mother-Father, Wise Ones, are glittering in the water like lighting inside the sea, all decked in brilliant quetzal feathers of gold and green.

THEN CAME HIS WORD.

Before there was Dawn, Heart of Sky spoke with the Great Plumed Serpent, and their words and their thoughts joined and became one; and then humanity and the trees, the bushes and all of life became a thought, a seed. The three of them were born that day at the Dawn of Life: the first was Thunderbolt Hurricane, then Newborn Thunderbolt, and then Raw Thunderbolt.

And they decided that the Earth should be drained of all the water so that the tips of mountains and the

Tall, freestanding carved stones, such as Stele Number 2, were used by the Olmec as commemorative plaques in front of their monuments, a type of sculptural decoration later adopted by the Maya to embellish their pyramids. The figural motifs surrounding the central figure seem to be strongly related to some characters used in the ancient Olmec writing system, called Epi-Olmec, which appears to have been the basis for the Maya writing system as well.

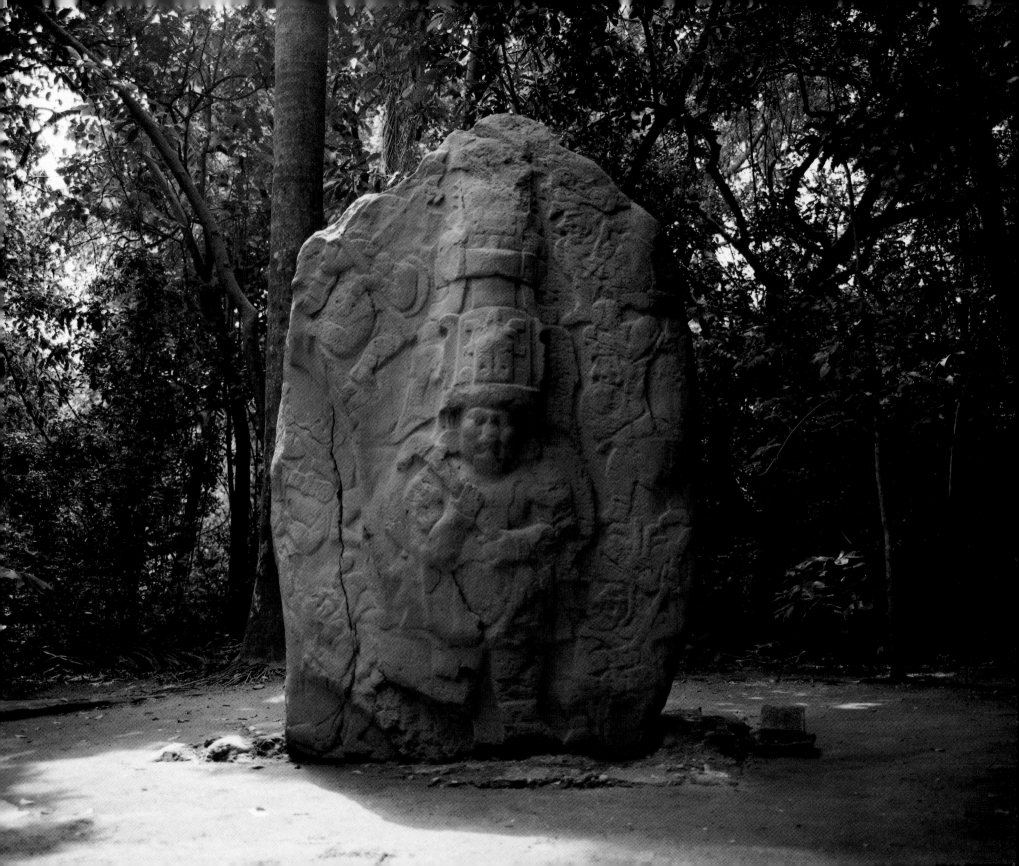

valleys could appear. Then the Earth arose from the water, and it was simply their word that made it so. In the beginning they simply called the word EARTH. And before its echo died the mountains were separated from the waters and rose all at once, filled with cypress and pine.

And the Great Plumed Serpent was pleased.

And so the earth was formed by Heart of Sky, Heart of Earth, the waters were separated, winding their way through the mountains and valleys.

Next they thought of the guardians of the forests, the birds, the deer, the jaguars, the serpents, the rattlesnakes, and they fixed the nests of birds both great and small. And then the Maker, Architect, said to them, "Speak to us, know our names, for we are your Mother and your Father:

Hurricane

Newborn Thunderbolt, Raw Thunderbolt,

Heart of Sky, Heart of Earth,

Maker, Architect,

Mother-Father,

Speak to us, call our names, keep our days."

But they all howled and chirped and chattered in confusion, each giving a different cry and a different song.

"It hasn't turned out the way we hoped," they spoke among themselves. "Our names have not been named and our days have not been kept."

And the animals were allowed to keep all that was theirs, the canyons and the valleys and the forests.

And they tried again, knowing that the time of the Dawn was near, thinking, "How else can we be remembered in the face of the Earth?"

This time they made a body of earth and mud, but the body was soft and crumbling, and its head wouldn't turn, so it couldn't look around. And although it talked at first, it made no sense. Being made of mud, it was quickly dissolving in the water.

"It can't walk," they said among themselves. "And it seems to be melting away, so just let it dissolve, let it be only a thought."

And then they asked themselves, "What can we create that will turn out right, that will keep our days and call our names in prayer?"

And they called on Xpiacoc and Xmucane, Grandmother of Light, Grandfather of Day, the most ancient daykeepers, and said, "Pass your hands over the corn-kernels, over the seeds of the coral tree, and see in your days whether we should carve its face and its body from the wood of the coral tree."

A natural opening brings light into the cavern. Beyond are petroglyphs and remains of wild horses from the Early Hunters Period (9000 B.C.) and sculptures and places of worship from the Maya period, as well as many natural pools of water. The trees emerging from the darkness to the light could be interpreted as symbols of the Tree of Life as described in the Quiché Maya Popol Vuh.

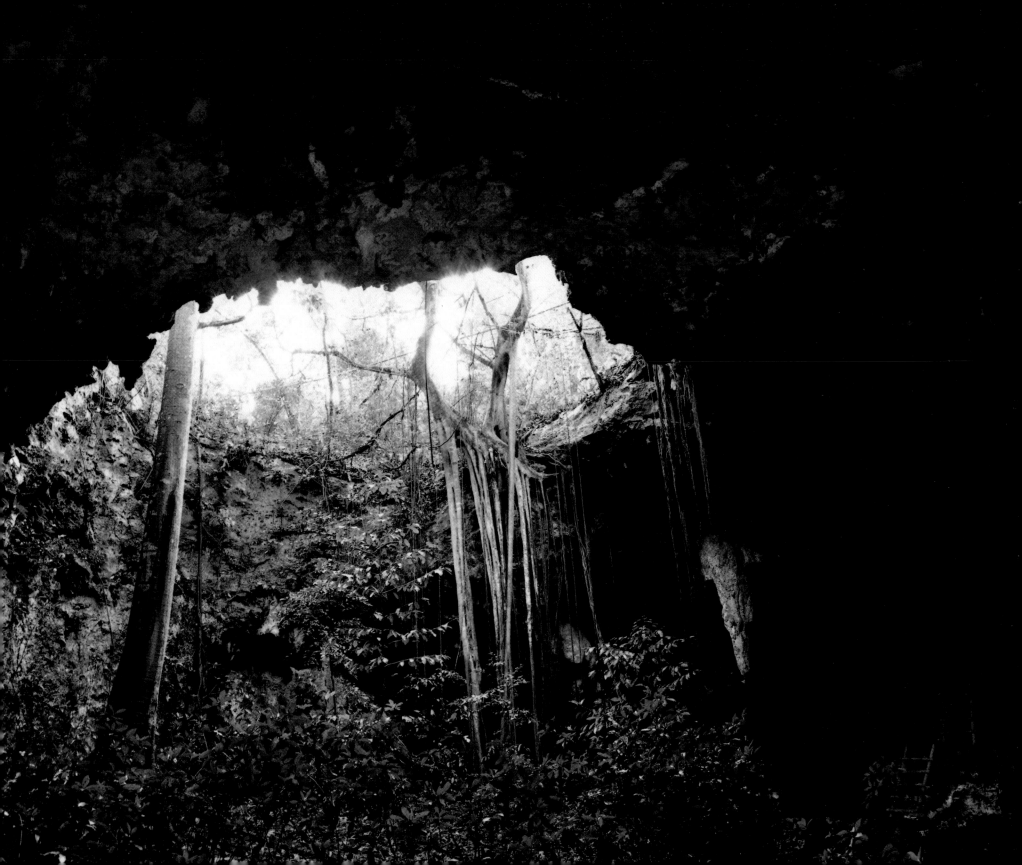

The Daykeepers, Diviners said, "You shall make the wood-carvings so that they speak and walk on the face of the Earth. So be it."

And saying this, the humans-made-of-wood appeared, and they spoke, and they had sons and daughters, but their hearts were barren and their minds empty, and they had no memories of their Maker. They did not even remember the Heart of Sky.

And even though they talked, their faces were dry, and they had no blood, no sweat, no fat, and they accomplished nothing to make their Maker proud.

Then a great flood came down upon their heads; and the one called the Gouger of Faces came and gouged out their eyeballs; even their kitchen utensils, the tortilla griddles, the water jars, the cooking pots all turned against them; and even the stones from their hearths came shooting out at them, aiming for their heads, causing them pain.

And the one called Quick Bloodletter came and snapped off their heads, then came Crunching Jaguar who ate their flesh, and Ripping Jaguar who tore their limbs apart. They were smashed and turned to dust, down to the bone, because they did not love their mother and father, the Heart of Sky, the one called Hurricane.

Some of the humans-made-of-wood climbed up trees, trying to escape the mayhem, but the trees threw them off. They wanted to run inside caves, but the caves closed in their faces. And the only ones who managed to escape hid in the forest and became monkeys. This is why monkeys look like people.

As the dawn was approaching and the first rays of the first light began to break over the horizon, the Maker, the Architect, the Mother and Father named Great Plumed Serpent sat in council and decided they must search for other elements to make humans. They went on thinking in the darkness, searching in their minds for what to do, as it was only a short time before the Sun, Moon, and Stars were to bring in the light.

And they realized that it was the food from the Earth that they must use to make the human flesh. It was the fox, the coyote, the parrot, and the crow who took them to the break in the horizon where the light first shines and showed them the yellow corn and the white corn.

Water was used for the blood, to run through their veins as it runs through the rivers and streams. And the yellow corn and the white corn was ground nine times by Xmucane who mixed it with water and raising her hand to the skies turned it into body fat. The white corn and yellow corn were used for the flesh, legs, and arms of the first humans.

ALTAR NUMBER 5, LA VENTA
MUSEUM

Villahermosa, Tabasco

This altar shows an Olmec figure with a jaguar headdress emerging from a cave-like opening holding a child. This motif may symbolize the beginning of Olmec civilization, which divided the universe in two: the earth (world of darkness) and the sky (world of light).

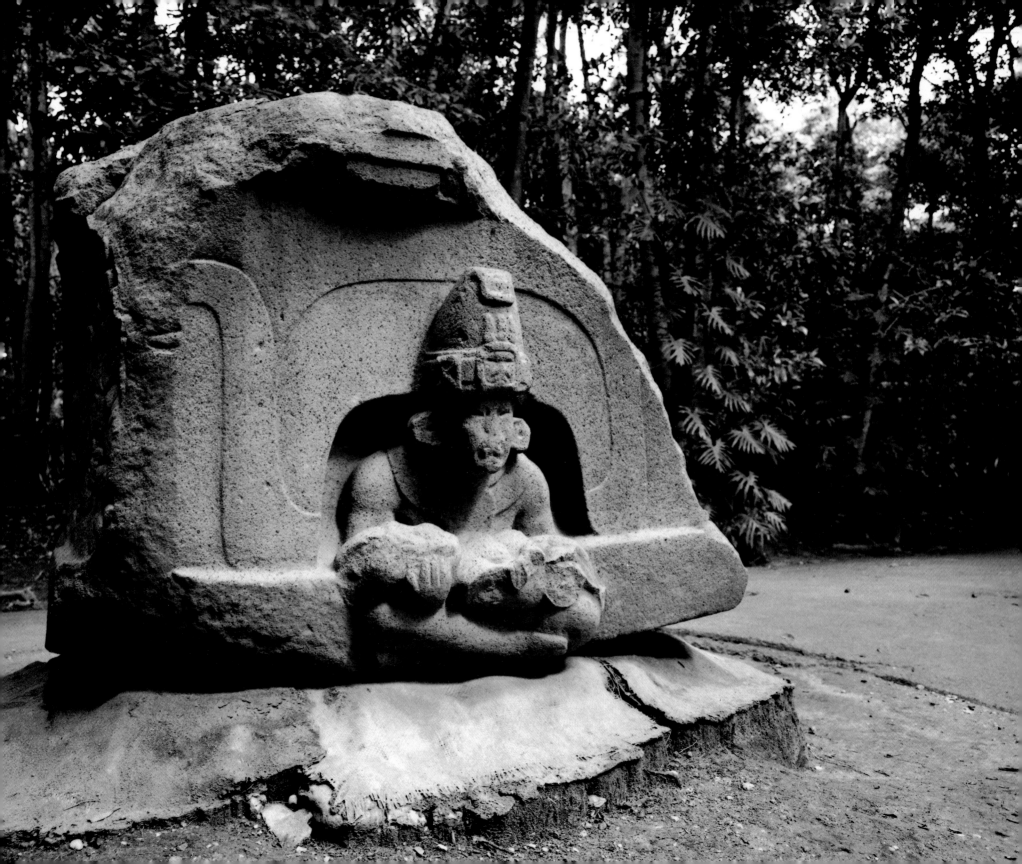

The first four people who were made were:

Quiché Jaguar of Poison Laughter

Black Jaguar of the Night

Deer Jaguar

Chief Jaguar.

These are the names of our first grandfathers.

No woman gave birth to them. By sacrifice and vision alone they were made and they talked and made words, they walked and worked, and their thoughts and visions came all at once. They saw perfectly and they knew everything perfectly wherever they looked under the sky.

And their knowledge was perfect, and they saw through trees and rocks and lakes and mountains. And they saw everything in heaven and earth perfectly, and they thanked the Maker, Architect:

> We are grateful that we have been formed,
> Given our mouths, our faces,
> We speak, we hear,
> In awe and wonder we walk,
> In knowledge, we understand
> Everything that is far and near,
> The great and small
> All that is under the sky,
> Thanks to you,
> Grandmother, Grandfather!

And their wisdom was perfect. They knew the Four Corners of the world, and the Maker and Architect found this a little bit disturbing.

"They understand everything that is far and near, all that is under the sky," they said. "This is not good. What should we do?" they asked. "They will become as great as us at the dawn of the light, their deeds and knowledge will equal ours. They see all. We must take them apart just a little bit."

And then Heart of Sky breathed upon them and they were blinded, like a mirror when it is fogged. Only when they looked nearby were things clear.

And this was how our first grandfathers lost the way of knowing everything.

And then their wives came into being, created by the Maker, Architect. They were beautiful women.

> Morning Seahouse was the wife of Quiché Jaguar
> Beautiful House was the wife of Black Jaguar
> Hummingbird House was the name of the wife
> of Deer Jaguar
> Parrot House was the wife of Chief Jaguar.

With their wives, their knowledge and understanding grew. They all were happy at heart and gave birth to all the people of all the tribes, great and small.

These wives were the four mothers of our people.

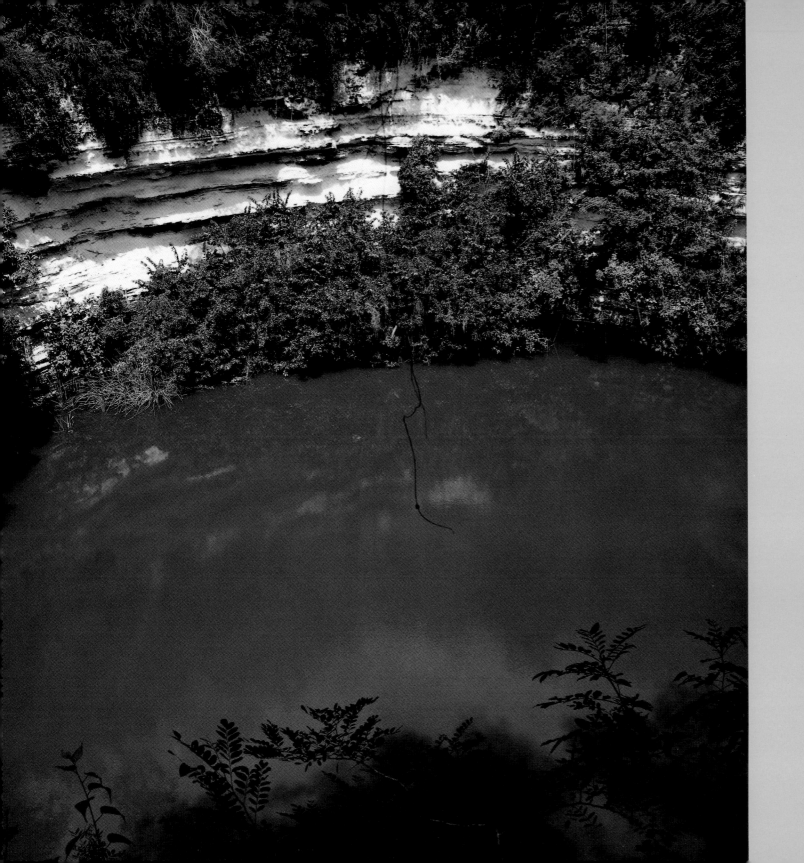

Xtoloc Cenote

Chichén Itzá, Yucatán

Chichén Itzá (the mouth of the well at Itzá) derives its name from this cenote, which was the most sacred place in the Yucatán. Numerous treasures and human remains have been found at the bottom; thus, it is believed that the Maya made many offeings and sacrifices here.

MAYA

Many peoples came into being in the darkness, even before the birth of the Sun and the Light, and they did not know where they were going. They were all huddled in the grassy plain, people of many languages, of many faces — black people, white people — all standing or walking in crowds, waiting at the edge of the sky.

These were the words with which they called to the Maker, Architect, Heart of Sky, Heart of Earth. These words were enough to keep them mindful of what was in shadow and what was still dawning. They brought their faces to the sky with reverence, making prayers not for themselves, but for their daughters and sons:

Hear!
Oh Maker, Oh Architect,
Look to us, hear us,
Don't allow us to fall, don't leave us to the wayside
Oh god in the Sky, Oh god in the Earth,
Heart of Sky, Heart of Earth,
Give us your sign, your word
That there will be day, that there will be light.
Give us a steady light, a good light, a level ground,
A good life and a good beginning.

Give us all this, Oh Hurricane,
Newborn Thunderbolt, Raw Thunderbolt,
Great Plumed Serpent,

Bearer, Begetter,
Xpiacoc, Xmucane,
Grandmother of Day, Grandmother of Light,
When it comes to the dawning,
To the sowing of the light.

They all gazed toward the East, looking for the Daybringer, the Morningstar, and they were all weary at heart, all the tribes gathered at the grassy plain.

And the elders, as they sat in council, got word of a great city called Tulán, Seven Caves, Seven Canyons, where they should go to receive a sign, a symbol from the gods—where they were to receive the gods themselves.

And they walked for many leagues: the elders, their wives, and all their children. And at the great city their gods were given out to Quiché Jaguar, Black Jaguar, Deer Jaguar, Chief Jaguar; and they were happy.

"We have found what we were looking for," they said, and Quetzalcoatl was the name of the god carried on the back of Quiché Jaguar.

All of the tribes came: the Rabinal, the Cakchiquel, those of the Bird House, and the Yaqui people, and the language of the tribes changed there. Before we spoke the same tongue; now we could no longer understand one another as we came away from Tulán. And then we broke apart, some going east,

DETAIL OF STELE NUMBER 11

North Acropolis, Tikal

Glyphs and figural designs were carved into the front surfaces of stelae. These markers were memorial plaques built to commemorate the rulers who created new monuments for the city. Usually, a carved circular altar was placed in front of each stele. These two items were sometimes deliberately broken and defaced when the temple behind was ritually desecrated for the building of a new temple.

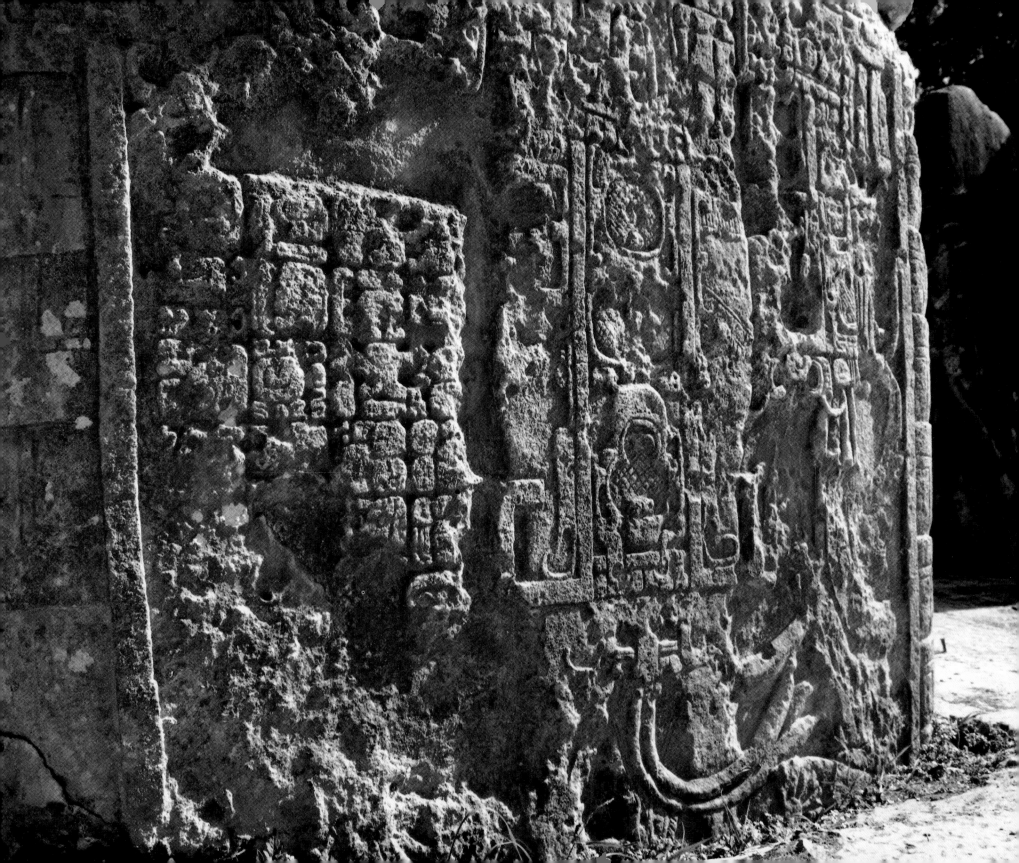

all of us dressed in animal hides, when we came away from Tulán, Seven Caves, Seven Canyons. So says the Ancient Word.

Before we arrived at Tulán there was no fire. How it came about no one knows, as the fire was already burning when Quiché Jaguar and Black Jaguar first saw it. And this was the warming of the tribes, and all the peoples were pleased with the fire.

After that a great rain began, and hail began to shoot down from the sky and the fires of all the tribes were extinguished by the hail. No matter how they blew upon the dying embers, their fire would not start again.

Quiché Jaguar and Black Jaguar spoke to Tohil, the fire maker, and said, "We will be finished by the cold if we do not have fire." So Tohil whirled his foot inside his sandal and started a fire.

And yet, the fires of the other tribes were out; they were trembling, so they all gathered to ask for fire from Quiché Jaguar, Black Jaguar, Deer Jaguar, and Chief Jaguar. They could no longer tolerate the cold and the hail — their teeth were chattering and their arms and legs kept shaking. Their hands were stiff by the time they arrived.

"Won't you take pity on us and allow us to remove a little something from your fire?" they asked.

"Wasn't it so that we were from one home and one mountain when we were made and shaped? So please take pity on us."

But already their language had become different from that of Quiché Jaguar, Black Jaguar, Deer Jaguar, and Chief Jaguar.

"Oh! We have left our language behind. How did we do it? We are lost," they thought. "We had only one language when we came to Tulán, and we had only one place of emergence and one place of origin. What has happened to us?"

Again the tribes came, in the hail of the darkening storm, amid the white crystals of cold, groping along, doubled over in the darkness for there was still no dawn, grieving that they had nothing of value to trade for the fire and warmth, for they were poor.

"And what will you give us for taking pity on you?" Quiché Jaguar asked.

"Whatever you might want," they responded.

They asked Tohil, the fire maker, who said, "Isn't it their heart's desire to receive me, to embrace me?"

"Very well," said the tribes, "We will receive him, we will embrace him." They made no delay but said, "Very well, right away," and then received their fire, and they warmed themselves around it.

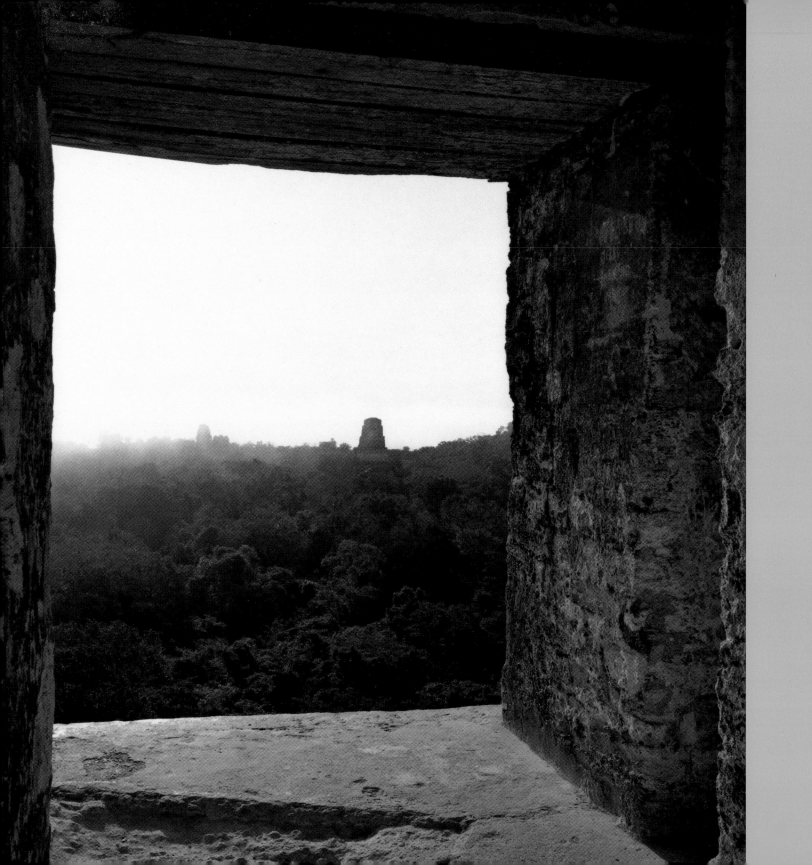

VIEW OF TEMPLE III FROM TEMPLE IV

Tikal

Photographed against the rising sun and through the dense fog, the morning sunlight at the spring equinox penetrates deep into the back wall of the chamber of Temple IV. This reveals that the Maya coordinated their calendar and the ritual of the return of the sun with the orientation of their buildings.

But there was one tribe that simply stole the fire, the Bat House of the Cakchiquel. The Cakchiquel didn't ask for their fire, nor did they receive the fiery splendor and majesty like Quiché Jaguar, Black Jaguar, Deer Jaguar, and Chief Jaguar. They sneaked right past in the midst of the smoke and stole the fire.

Tohil told them that they must leave Tulán for it was not their home, only the place the where gods came from.

When they left Tulán they fasted and waited intently for the coming of the dawn and the Daybringer Star. They did not need to eat, for all of them, all the tribes, received fiery splendor in Tulán, together with great knowledge and dominion. All this they received in the darkness, in the night, when they received the fire from Tohil.

And then came the breaking of the light and the dawning of the Sun, Moon and Stars. And Quiché Jaguar, Black Jaguar, Deer Jaguar, and Chief Jaguar were filled with joy when they saw the Daybringer Star which looked dazzling as it came up ahead of the Sun. Then they unwrapped their copal incense, placing it on the fire, crying sweetly as they raised and shook their burning offering, the precious copal.

And when the Sun came up, the animals, large and small, were overjoyed. They ran up from the rivers and canyons, and danced on the mountain peaks.

Together they looked towards the edge of the world where the Sun emerged.

And the parrot called out first from up high, then the puma and the jaguar cried, and the animals were truly happy. And the birds spread out their wings and danced, together with the Cakchiquel, the Rabinal, the Bird House People, and the Yaqui People—all of the peoples.

There was one Dawn for all tribes.

At the very instant when the Sun, the Moon, and the Stars were born, Tohil and all the other gods were turned into stone, along with the idols of the puma, the jaguar and the rattlesnake. Everyone of them became stone for they were no longer needed after the work of creation.

The face of the earth, which was wet and muddy before the sun came up, was dried out. And Quiché Jaguar and Black Jaguar and Deer Jaguar and Chief Jaguar were glad and their hearts were filled with joy.

The sun was a being when he showed himself on the first day, and he revealed himself only the day he was born. It is only his reflection that they now see, and so the ancient words: "The sun that shows itself is not the real sun."

After the sun had crested its zenith, the people gathered again and began to sing a song of lament:

··· page seventy-two

The House of the Sun, Uxmal

The buildings of Uxmal often were decorated with serpent motifs. This structure has an arrow-shaped opening that represents the head of an upturned rattlesnake, flanking S-shaped decorations which symbolize a coiled snake, and a frieze with an undulating motif which illustrates a serpent mimicking the perpetual path of the sun.

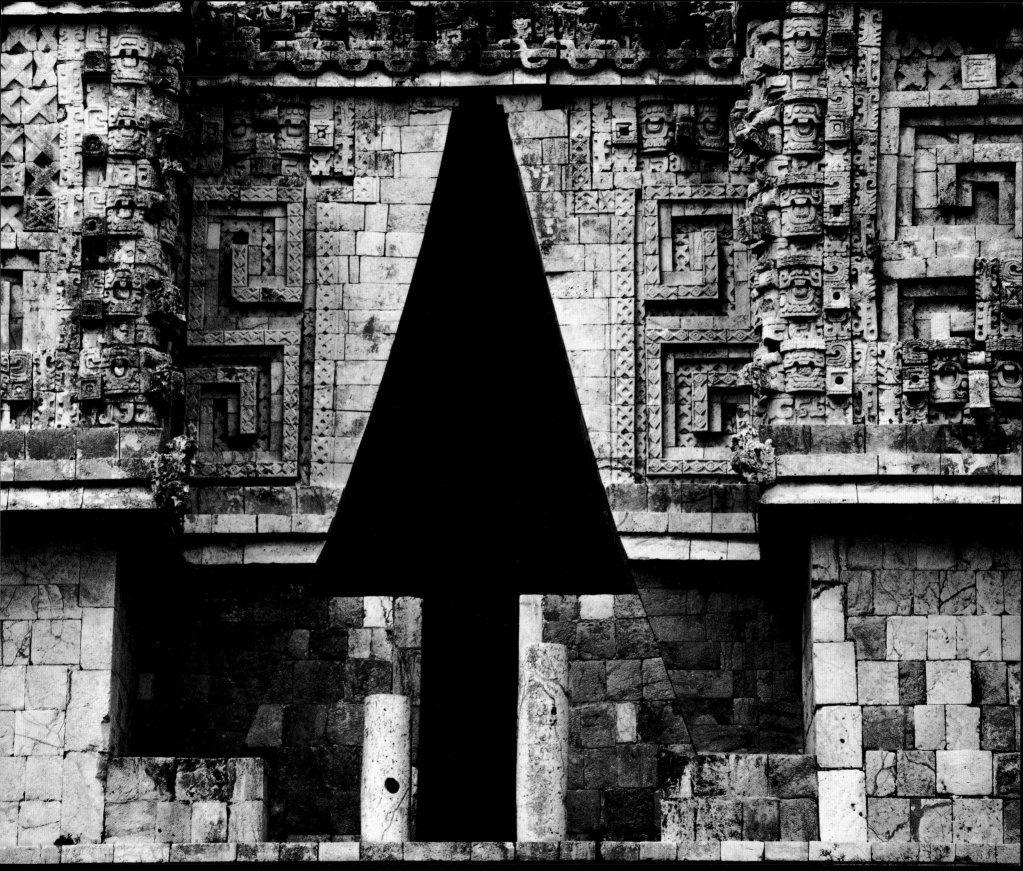

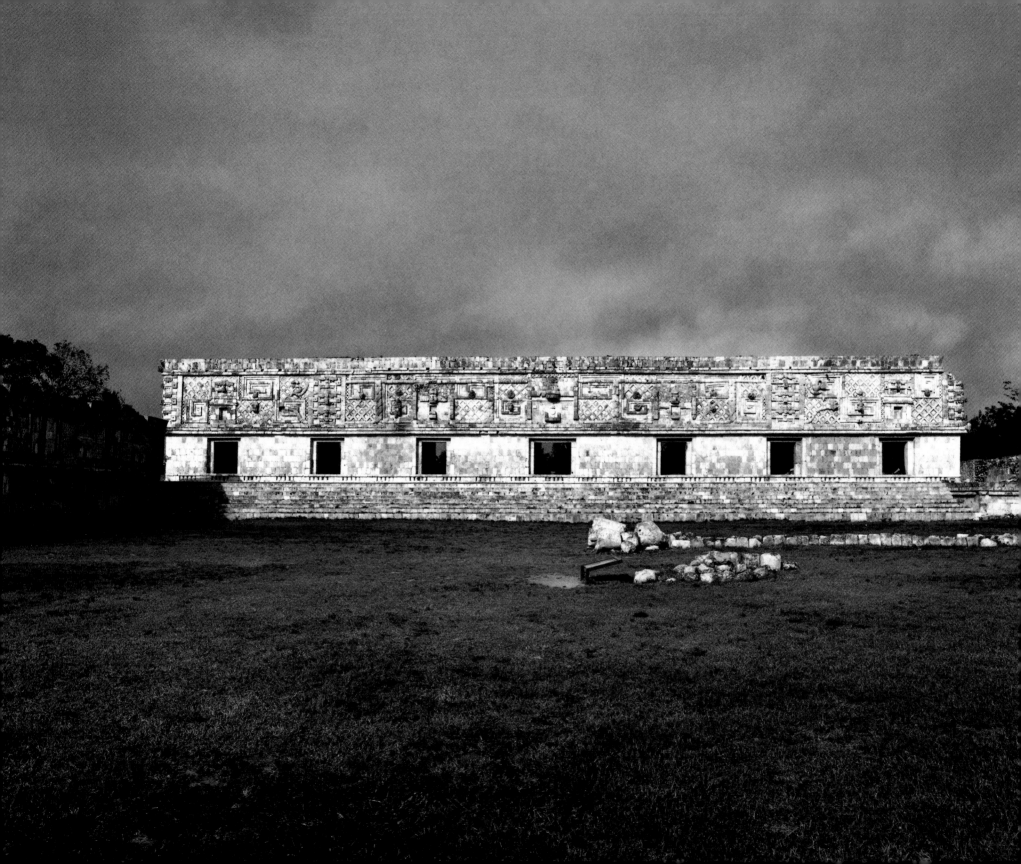

CHIKIN WEST BUILDING

Uxmal

The animated, sculptured frieze depicts a serpent weaving in and out of different panels. It illustrates Quetzalcoatl's journey through life.

DETAIL

Two different attributes of the Feathered Serpent can be seen in this detail. The rattlesnake tail supports a bowl from which springs the water of life. The open mouth exposes a human head, whose mustache and beard are typical features of the Toltec of Tula, from whom some Maya people claim their ancestry.

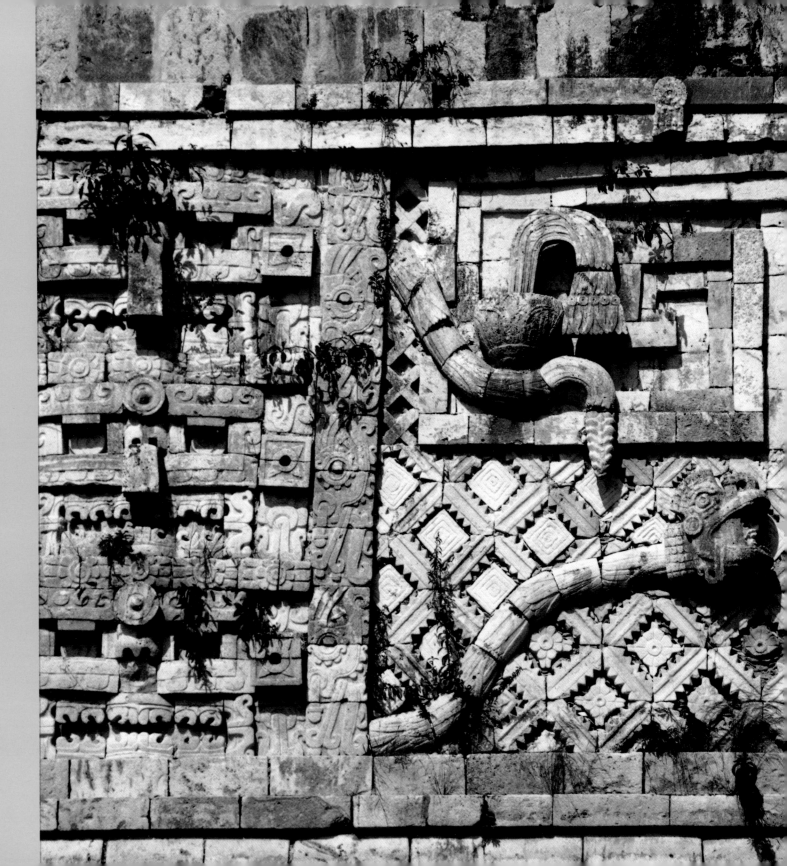

MAYA

"So it is,

We were lost at Tulán!

We scattered to the winds!

We left our older brothers behind

We left our younger sisters behind!

Where were they when the sun was born?

Where have they gone now that the Dawn

has come?"

They were speaking of their brothers and sisters, the people of Tula. They were speaking of Tohil, now turned to stone, who later returned as Quetzalcoatl, the Great Plumed Serpent, who gave them his own flesh, his own blood, on the year One Reed, many cycles after the Sun was born.

...POPOL VUH

He never knew where he came from, whether from the land or the sea, the wind or the sky. All he knew was that one night the wind and the sea carried him to the sandy shore, naked, covered in sea foam, lashed to an uprooted almond tree.

Naked and with no memories of his birth, dawn found him outstretched on the beach, remembering nothing but that he came from the place of the rising sun, and the tree which carried him through the howling wind and boiling seas safely to this shore.

He asked himself, "Am I still me?" and he tasted the blood and salt on his lips, and his eyes closed, and his mind was filled with a darkness almost like death.

The new Sun awoke the birds who, with a rustle of blue, yellow, and orange plumage, came and perched on his bare back, on his arms, and on the tree trunk that was still secured to his back. They came silently so as not to wake him.

Only the children had seen the blazing Feathered Serpent that morning, blinding in the light, gliding over the waters from where the sun had risen. Only the children had the time and curiosity to draw near. The bravest one stepped close and tripped on the sand, frightening the rainbow-colored birds, which took flight in a blanket of fiery light.

FEATHERED SERPENT COLUMNS

Temple of the Warriors,
Chichén Itzá

Columns in the shape of Feathered Serpents seem to descend from the heavens. Their surfaces are covered with stylized feather decorations. The absence of glyphs here may reflect a change in government from individual rulers in earlier Maya states to an administrative council.

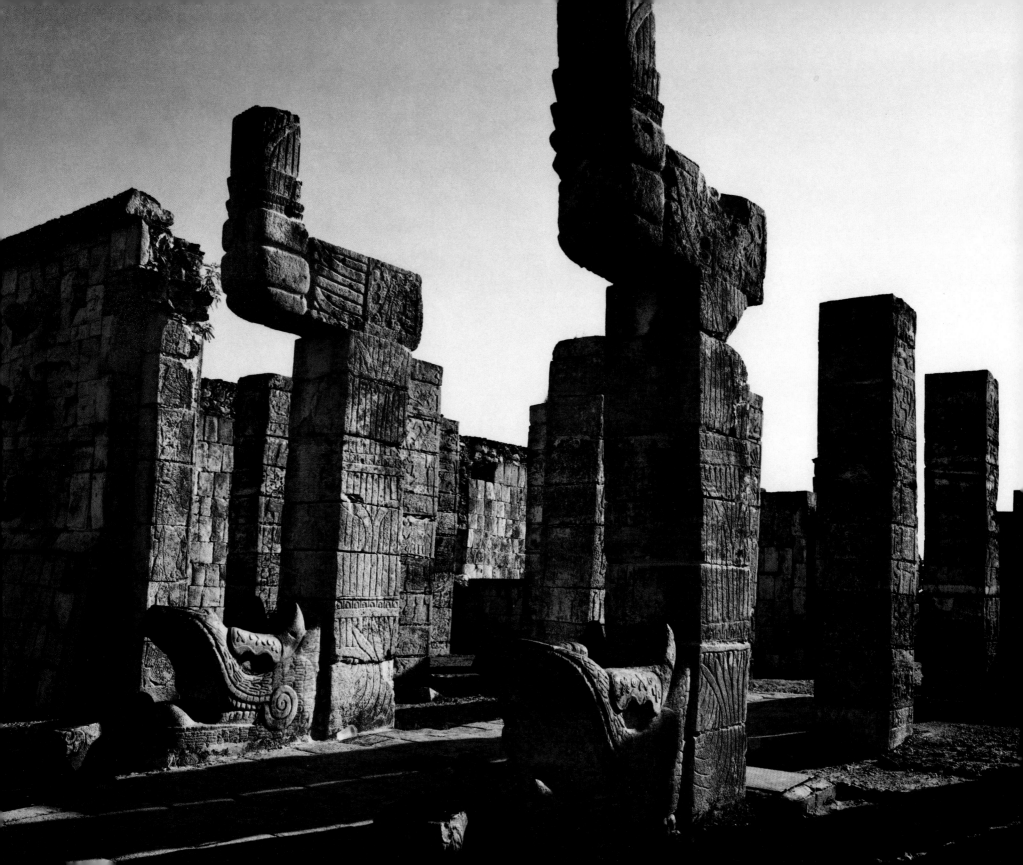

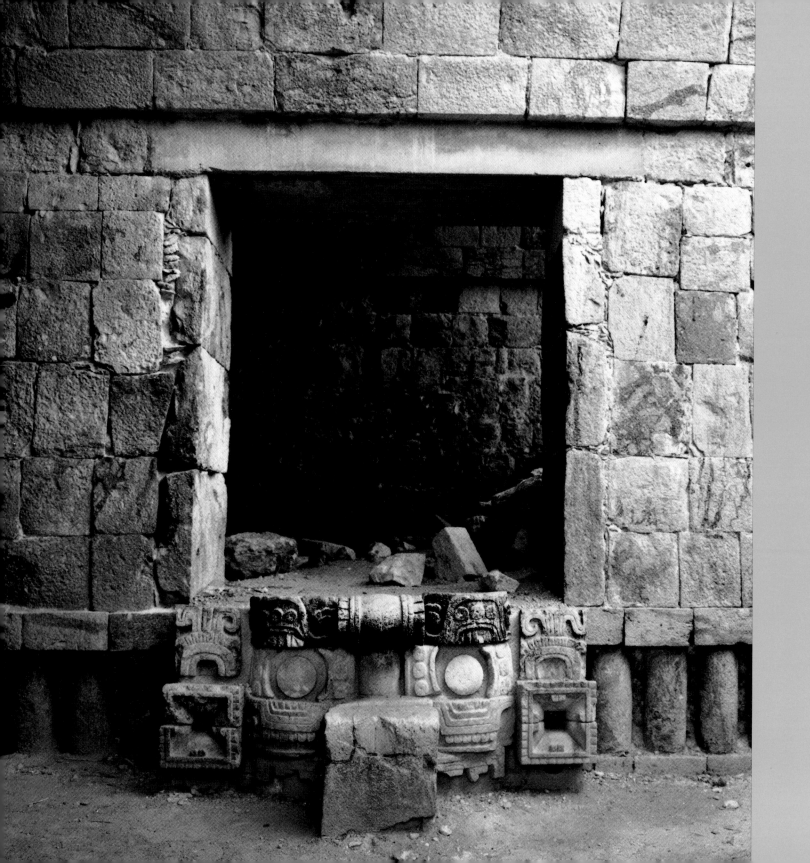

DOORWAY BETWEEN INNER
CHAMBERS

Codz Poop (Palace of the
Masks), Kabah

*An oversized mask of Chac,
the Rain God, provides the
step to the inner chamber.*

DETAIL OF EXTERIOR WALL

*Approximately 250 stone
masks of Chac embellish the
facade of this building. Their
long noses project from the
surface and curl up resem-
bling elephant trunks.*

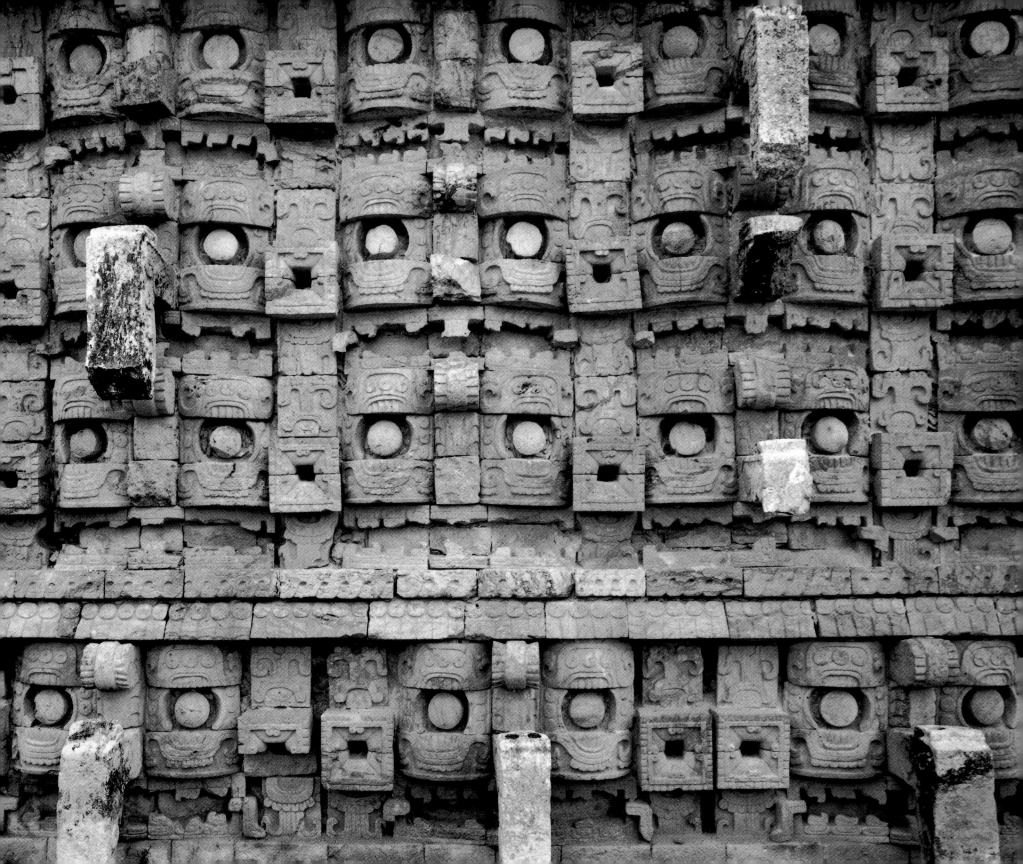

"He has become human!" they said excitedly among themselves. "The Plumed Serpent has become a man!" and they cut the ropes that bound him to his tree. The oldest boy, Tonatiuh, took him by his long beard and dragged the limp form to a small pond at the edge of the forest and splashed cool water on his face. The man stirred, and Tonatiuh thought to himself, "He must be a god, he is so big. Or perhaps he is only a man, suffering."

For twenty days Tonatiuh brought him honey, corn meal, yucca and fresh tortillas, and kept him hidden in a cave. When Tonatiuh returned on the twenty-first day, the Feathered Serpent was no longer there.

The villagers asked Tonatiuh if he had eaten the serpent all by himself, and why he had not shared it with them, for they had all heard of the Feathered Serpent.

And every day of that month they saw a serpent of light in the evening sky. "It's his mother," they said among themselves "She who has come back to look for her child."

And Tonatiuh was brokenhearted and returned to the beach and for two days he did not eat or drink; and then on the dawn of the third day, he saw the Feathered Serpent, his plumed cape gliding over the waters, his figure cresting the highest waves. As he drew close he cast his cape like a net and captured Tonatiuh, and with a deep, sonorous

laugh, took him to a clearing deep in the forest, where he built a fire and they shared fish.

They were together from the day One Reed, when he was first washed onto the shore. Tonatiuh learned of things and places he had never dreamt before; the other learned to speak, and Tonatiuh taught him of the things of the earth.

One day he turned to Tonatiuh and said, "We must go. There is a lord somewhere who has sent me to guide and to teach. I know, yet I do not remember how I know." Then Quetzalcoatl planted on the Earth the tree that had been his life raft, and sent Tonatiuh ahead to announce his coming.

Tonatiuh returned to his village to herald the Plumed Serpent, yet no one believed him. They accused him of stealing the snake all for himself, and the priests sentenced him to death. "When you die, your blood will feed the sun and the stars, and keep them rising and setting in the heavens," they said to him.

But Tezcatlipoca, the Smoky Mirror god, never got to taste Tonatiuh's blood. It happened like this:

Quetzalcoatl arrived with his arms outstretched, while a great wind rustled his cape of brilliant orange and yellow feathers as if they were living fire. He bolted up the hilltop where Tonatiuh lay stretched on the temalacatl stone, where the priests

Considered to be the most beautiful gateway in the entire Yucatán, this decorative portal is a place of transition between two ceremonial courtyards. Flanking the entrance are two openings. The upper one is a unique design: a small niche carved into a stone thatched hut. It once housed a statue of a seated ruler similar in design to the low relief carving of a ruler on the Piedras Negras Stele Number 25.

prepared to wrench his heart out from his chest. The Plumed Serpent cast his cape over the stone effigy of the god Tezcatlipoca and brought it down upon the priests, crashing down the side of the hill into one hundred pieces.

And then he cried, "The sun will continue to rise, and Tonatiuh shall live!" And a great thunderstorm blew in from the sea. Lighting and hail struck terror in the hearts of the villagers.

Then everything was still, and the old people in the village cried out:

"You have slain our idols.
You have sealed the blood-thirsty mouth
of Tezcatlipoca.
You shall now be our god,
Quetzalcoatl!"

But the Plumed Serpent said, "I cannot be your god, for I am barely a man. I have killed ten priests to save one man, and killing is against all the laws of Omeyocan, the place of all creation. I will go to the mountains and make peace." And he cut open his arms as he descended, shedding his blood for the blood that he had shed.

Before departing, Quetzalcoatl agreed to leave a sign of his power and love, and planted the first Tule tree in the earth, saying, "This is the Tree of Life. Water it,

tend it well. Eat of its fruit, grow with it and cherish it. Its roots reach deep into the place of your origin. Its branches stretch to the four corners of the Universe."

And then, without saying another word, he set off accompanied by Tonatiuh, and a young boy named Chipetotec, the first boy who had seen him when he washed onto the beach.

For two days Quetzalcoatl walked without eating or speaking a single word; he stopped only to carry Chipetotec on his shoulders, when the boy became tired. When they reached the mountains, the Plumed Serpent said to them, "Go ahead of me, tell people what you have seen. Tell them of my coming. Return for me in one moon."

And for the next month Quetzalcoatl fasted and prayed and made amends for the pain and death that he had caused.

Tonatiuh and Chipetotec returned along with many people from different tribes, and they said to Quetzalcoatl, "We have spoken to the people of your great knowledge and power, and have shown them your sign—the Tree of Life. And word has reached them of your glory, that you destroy idols and even kill so that there may be no more killing."

He stood up slowly, weak from not eating, and looked upon the multitudes and said:

THE GREAT PALACE

Sayil

Stepped, horizontal buildings were rarely designed with highly decorated second stories. The use of long, continuous portico, surmounted by a frieze with panels of the Rain God Chac, and the Diving God, and surrounded by a wide terrace, is unique.

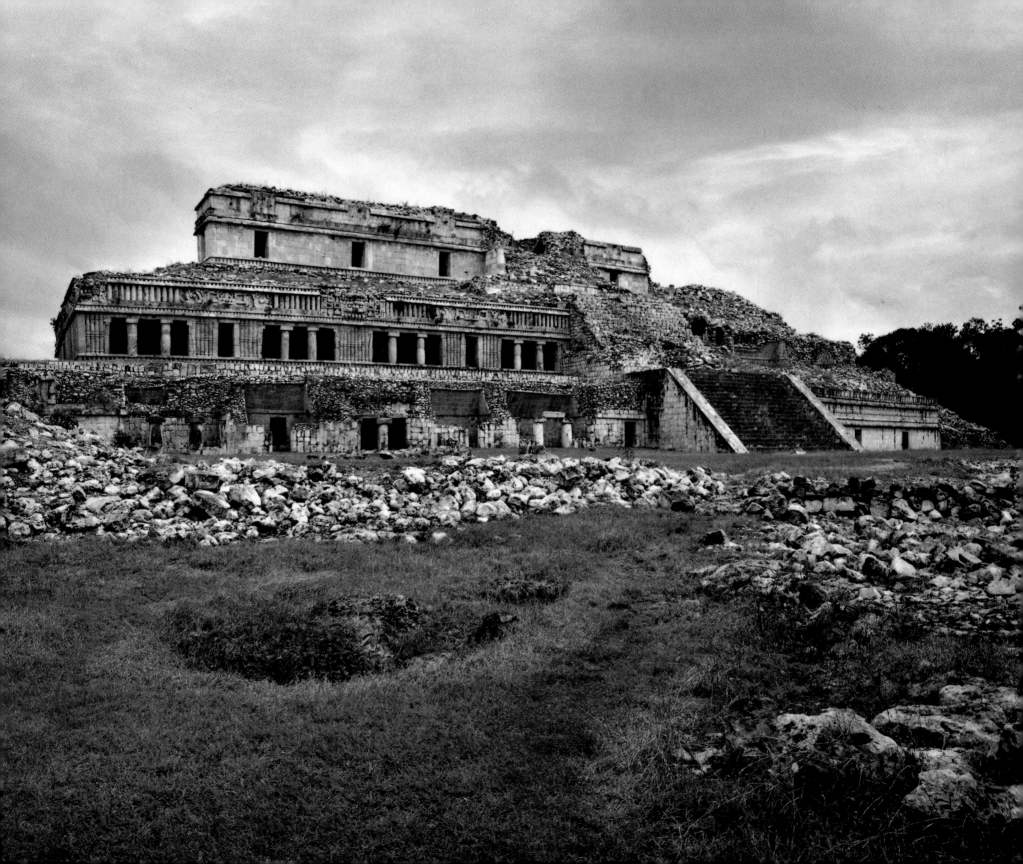

"I am Quetzalcoatl.
I do not know where I come from.
I know only that I come from the place of
the rising sun.
I love heaven and earth equally, and I come
to plant the four branches of the Tree of Life."

And then Tonatiuh spoke, "We know how you are called, but not who you are. We do not care so much where you come from, but where you are heading. They say you came like a thunderbolt in the night. We understand little of what you speak. We wish to know you and your works. Make your house among us. We will give you servants, we will give you women, and you will give us children."

"I will make my house among you," Quetzalcoatl said. "But I will take no woman. You all will be my children."

And they carried him on their shoulders to the great city called Tulán, and all the people they passed brought flowers and feathers for him, for they thought he was a god.

The third day after his arrival in Tulán there was to be a great sacrifice: two handsome young men would be sent to their deaths at the hands of the dragon priests from a fierce Chichimec tribe that lived south of the citadel. Ever since their defeat by the Chichimec, the Tulán were forced to a pay trib-

ute of two young princes every spring. At daybreak, sombre drums resounded through the city, calling all to mourn the loss of two of their young.

Unbeknownst to anyone, Quetzalcoatl had changed places with one of the young princes. He allowed himself to be taken by four priests of Tezcatlipoca, who intended to crack his back on the rounded temalacatl stone and cut open his chest with obsidian knives to rip out his beating heart and to offer this most precious of foods to Tezcatlipoca, the Smoky Mirror god.

The other victim was crying and screaming, and had to be beaten and dragged by the priests. Then a deadly hush fell over the people of Tulán.

Quetzalcoatl allowed himself to be taken in silence to the hilltop where the blood sacrifice was to be made. His captors were frightened, for they had never seen a glow like the one they saw in his eyes. Before the altar, the head dragon priest unsheathed the obsidian knife, at which point Plumed Serpent broke free of the lianas binding his hands and legs and said, "I am Quetzalcoatl. Let it be known that no one has the right to shed blood other than his own."

He stepped forth and threw his cape of quetzal feathers over the head priest, and then withdrew it to reveal the man, with his tunic torn, a gash across his chest, holding his own still-beating heart in his hands.

··· page eighty-six

Four-story towers were uncommon in the architecture of the Maya. Inside the tower is a glyph representing Xibalba, God of War, also known to the Maya as the Eveningstar and Morningstar, and by contemporary astronomers as Venus. The Maya timed their battles according to the first appearance of Xibalba in their astronomical cycle.

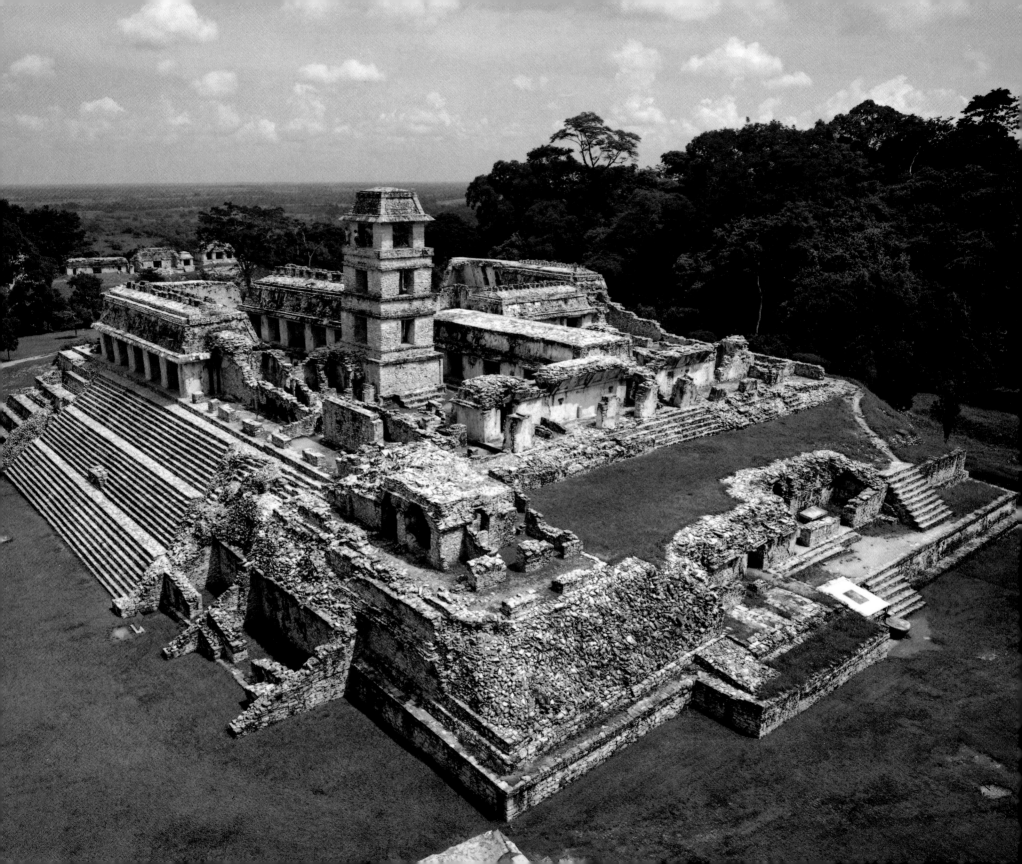

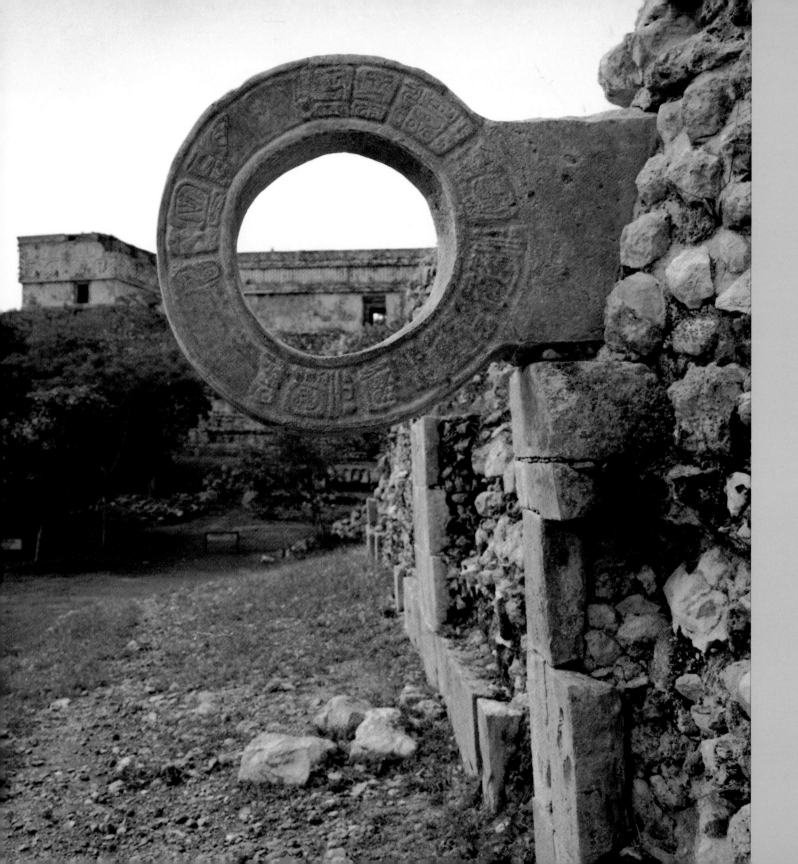

BALL COURT

Uxmal

The stone ring set on the side wall characterizes the Maya Ball Court. The ball was associated with the movement of the sun and the moon. The ritual game ended with the sacrifice of a player, and symbolized the death of the sun or moon, depending on which was necessary for the stars to proceed in their normal cycle.

TEMPLE OF THE MAGICIAN

Uxmal

Legend tells that this temple-pyramid was built by a powerful dwarf magician, who was hatched from an egg by his sorceress mother. Under a threat by an Uxmal king he was ordered to build this temple within a fortnight, or else lose his life.

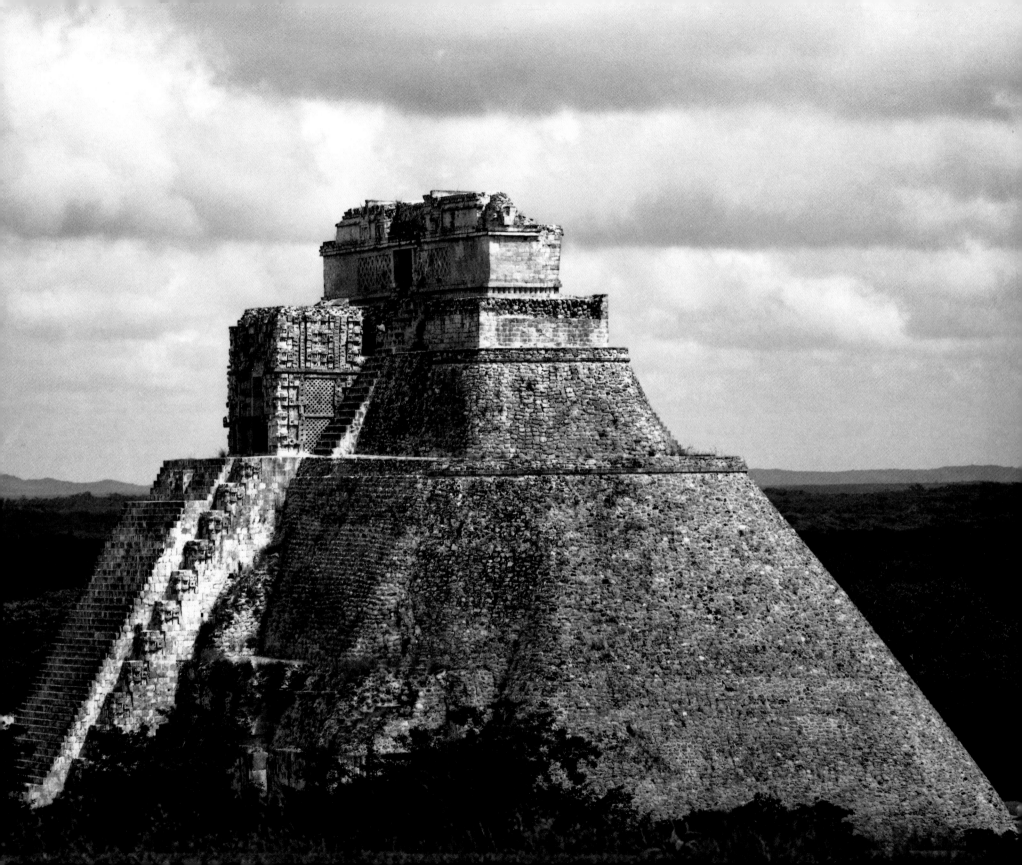

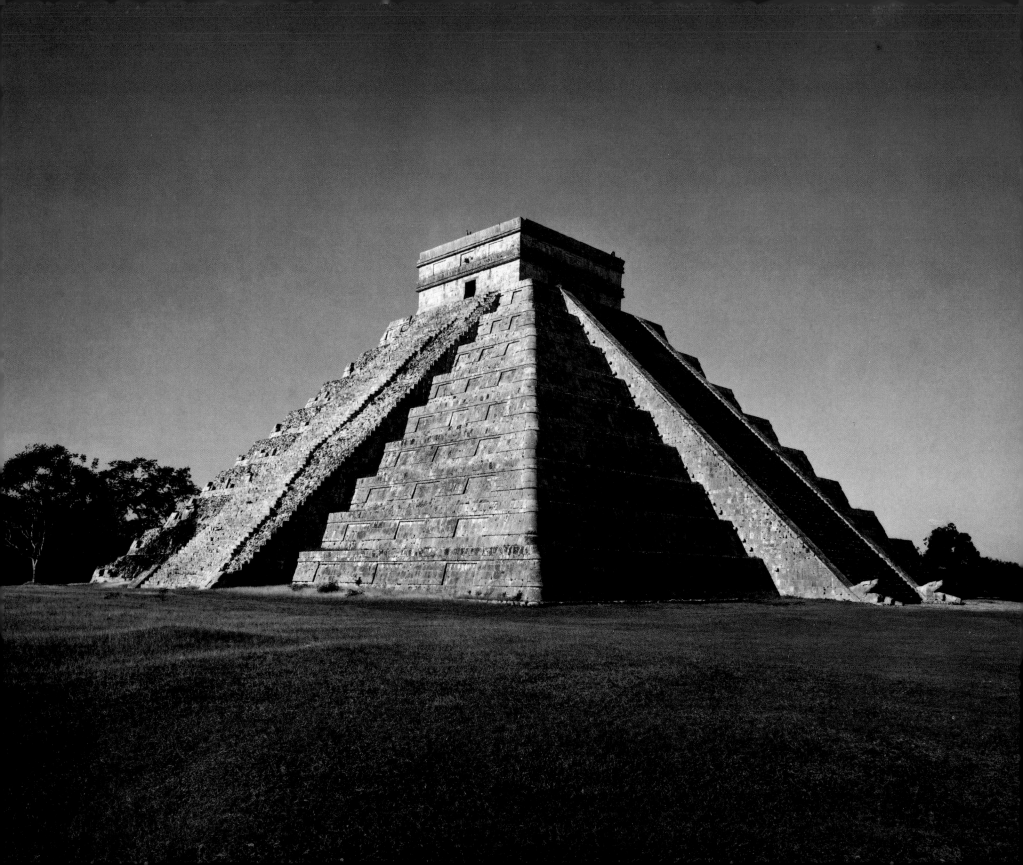

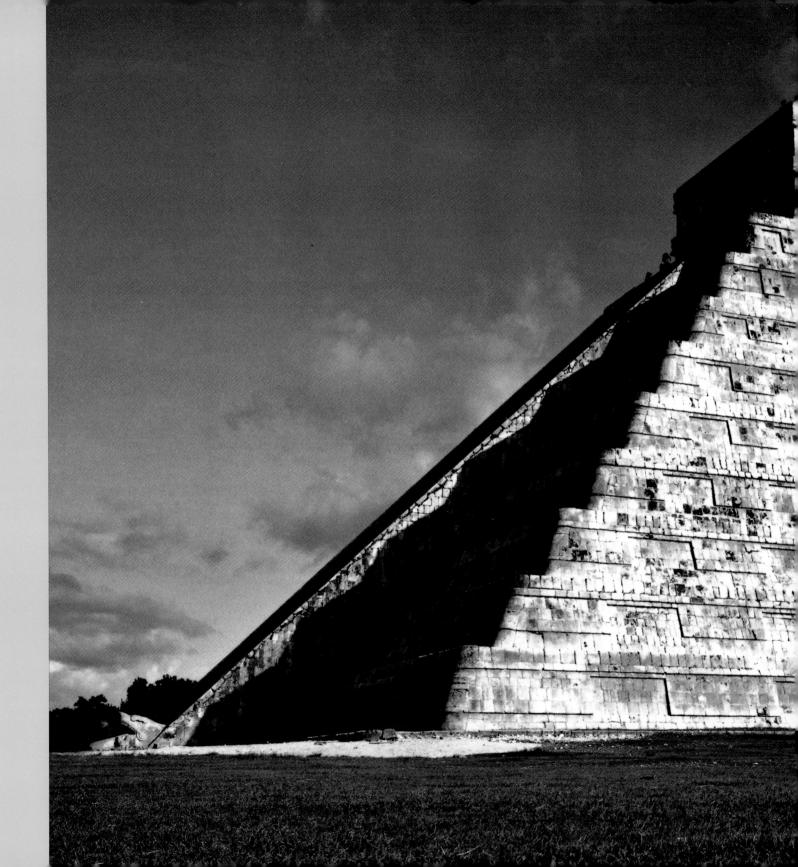

TEMPLE OF XTOLOC
(EL CASTILLO)

Chichén Itzá

Maya architecture is often ritual-specific. They performed a ceremony involving human sacrifices to recall the time of the year when the sun (and the serpent) returned during the equinox.

SHADOW SERPENT AT
TEMPLE OF XTOLOC,

Chichén Itzá

At the vernal and autumnal equinoxes the monument steps are shadowed, the sun casting into brilliant relief the image of a serpent descending the pyramid's face — his tail at the top of the pyramid, his head at the base.

And there was a great commotion and the priests became terrified, fearful now for their own lives.

"I am the beginning of a new order," Quetzalcoatl said. "And the blood of your enemies is no longer pleasing to your god, the Mother-Father. It is the love and the song in your heart that your god desires." And before everyone the Plumed Serpent removed his feather mantle and built a fire. With his own hands, he selected a beautiful tree, carving with the obsidian knives here, burning there, until the tree was hollowed save for two tongues of wood at either end, which he began to tap rhythmically.

"In truth he has made the trees sing," the people of Tulán said among themselves. And Quetzalcoatl continued playing the teponaxtle, as it came to be known. The rhythm soon became a dance, and the people forgot the heat of the day or the burdens of their lives, and they began to dance ecstatically.

At nightfall, Quetzalcoatl spoke again. "My brothers and sisters," he said, "Our god, the Mother-Father, loves the rhythm of your feet more than the blood from your hearts. All the universe moves to a single rhythm: the stars, the moon, even the sun itself. Allow your dance to be your sacrifice of praise and glory."

And upon hearing this the priests were furious, and exclaimed, "We have wasted enough time already.

The sun is in the region of the dead and needs human blood to shine again tomorrow!"

The people hesitated; they were unsure how to react. Then Quetzalcoatl spoke and said, "Here is my blood, take it, I give it to you. I shed my blood not to sustain the universe, which does not float in it, but so that the blood of innocents will be spared."

And he ripped open the wound which had yet to heal and cried softly, explaining to the people that there are only two things they can offer our Mother-Father: their love and their pain. The first is the force that binds the universe together, he explained; the second is the force that separates the universe into its manifold parts. Together, they create the rhythm that brings about change in all creation.

Many days later, Tonatiuh and a group of princes visited Quetzalcoatl, who was teaching his followers how to dye wool and weave it into cloth. They were astonished by this beautiful creation, for before Quetzalcoatl's arrival everyone covered themselves with furs and skins.

"Why are you so surprised?" asked Quetzalcoatl. "You too can weave cloth." And he showed them how to spin the wool, dye it with cochinilla and onion skin, and how to weave it into beautiful capes and blankets of red, black, and orange.

THE MAUSOLEUM OF LORD PACAL (TEMPLE OF INSCRIPTIONS)

Palenque

Since the 1948 discovery of an interior hidden staiway leading to the tomb of Lord Pacal, this building type, traditionally known as a temple, is now also considered to be a funerary monument. In the large vaulted chamber of the temple there are extensive Maya hieroglyphic inscriptions (A.D. 692).

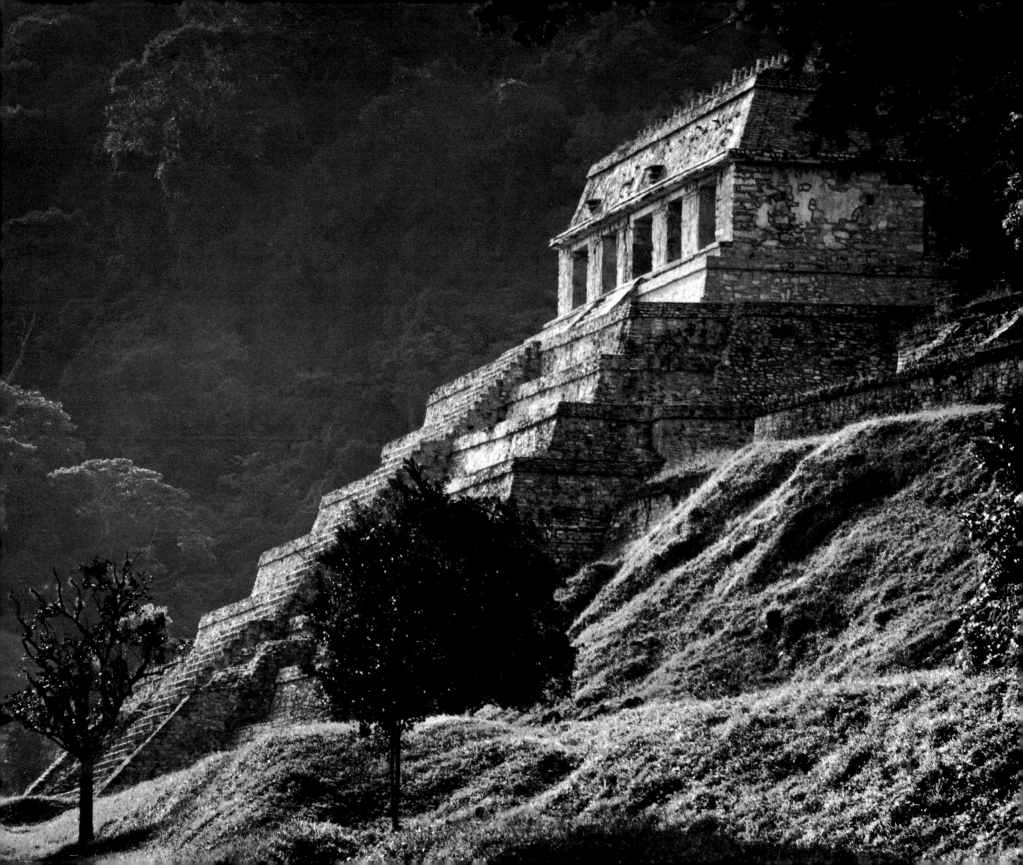

And they said, "The priests have left us, they have returned to their caves, and wrapped our idols in skins and taken them with them. Our gods have left us, and we need you to give us new ones that we can worship."

"There is but one Maker," he said. "And he is our Mother-Father who is everywhere: in the forests, in the trees and the valleys and the rainbow. He is in the butterfly and the nightingale. He is in the thunderbolt and the volcano."

The people were happy, and Quetzalcoatl promised them a Tree of Life that would stand in the place of the old gods, where they could bring their offerings to the Creator, to the Heart of Sky, the Heart of Earth.

And the people asked, "What offerings shall we bring to the Maker, if he is not pleased by blood?"

And Quetzalcoatl promised he would show them how to carve beautiful objects of obsidian and turquoise, to make round, brilliant pottery, to weave clever tapestries from animal and vegetable threads, to till the earth, plant seeds, build aqueducts, and make their fields green.

He taught the people of Tulán, and they learned the arts of medicine and dentistry as well as the domestication of corn, chile, squash, and many other fruits and plants. They learned to build dams, to mine silver and gold, to work the turquoise and coral shell, and to trade their wares and holy copal incense with their neighbors in the north and south.

With time, Tulán became the seat of the Toltec empire, and under Quetzalcoatl's guidance the people learned that the purpose of humanity was not to suffer, or to make blood sacrifice, but to create. They learned that the Mother-Father was the creative force that made man, earth and sky.

"The ultimate good," Quetzalcoatl, now king of the Toltec would say, "is the attainment of wisdom tempered by humility." But even kings can succumb to vanity. This is how it happened:

Quetzalcoatl had begun to adorn himself with stunning jewels and pendants of gold and silver, and the people loved to see him carried on his throne through the streets of Tulán so finely robed. "After all," he said to himself, "this is the product of my teachings, the beauty and the riches that I have brought to the people."

And indeed he had brought great wealth to the Toltec, whose storehouses were filled with grain, and who were the undisputed masters of the land. But Tulán was wounded in the belly. Its wealth was such that it made the neighboring cities covetous. The dog tribe of the Chichimec became aggressive as the people of Tulán became softened by their life of leisure, abundance, and ever more decadent pleasures.

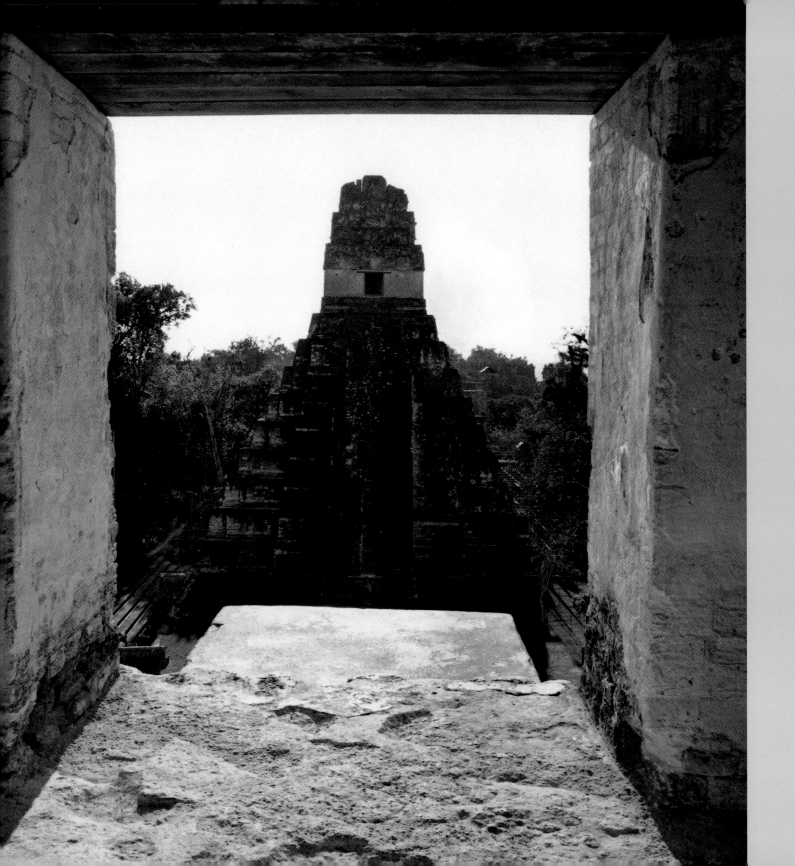

VIEW OF TEMPLE I FROM
TEMPLE II

Tikal

*Particularly in Tikal, the
Maya constructed their
temples to face each other.
Temples I and II take advan-
tage of the sun's rays on an
east-west alignment. This
orientation is heightened
during the vernal Equinox
when the light from the rising
sun penetrates the back wall
of Temple II's chamber.*

With every year that passed, as Tulán's riches grew, so did the ornaments and jewels that Quetzalcoatl wore. But the years took their toll, and his face became full of wrinkles and his long beard and hair turned white.

It was almost fifty-two years since Quetzalcoatl's arrival on these shores, during which time peace, prosperity, and the arts had reigned. Now the King was nearly eighty years of age, when Tonatiuh came to him and announced that the Chichimec had amassed a gigantic army and were advancing toward Tulán. Led by the sorcerer priests of Tezcatlipoca, the Smoky Mirror god, whom Quetzalcoatl had banished so many years before, they arrived at the gates of the city.

The Chichimec had sent one of their sorcerers disguised as a wandering sage to visit the King, and once in his presence, the traitor pulled out a smoky mirror from his cloak and showed Quetzalcoatl his weathered face and wrinkled body, saying, "Look at yourself and know yourself. See what time has done to you!"

The sorcerer then offered Quetzalcoatl a potion that he claimed would return the Plumed Serpent to his youthful vigor. The king replied, "I have seen much, and know there is no such drink. But what does an old man stand to lose?"

By then Quetzalcoatl had removed all the precious stones from his plumed cape, and no longer wore his jewels, having realized how vain they looked on an old man. And then he took the potion made from the maguey cactus, and drank three large portions.

And then the sun and stars burst into dance and fire.

"I am strong," he exclaimed. "Tonatiuh, my son, come announce my coming. Let the Chichimec know they will face the wrath of Quetzalcoatl. Let the people gather under the great pyramid. I will raise their spirits and they will soar with me, they will know the inside of the sun."

All this the Plumed Serpent shouted in his drunkenness, and then he ran through the city, naked except for his jeweled head dress, until he reached the House of the Chosen Women, and there broke the vow of abstinence he had made so many years before.

And when he awoke the following morning, realizing how he had surrendered to lust and passion, he felt ashamed, especially now when his people needed him.

With a great sadness in his heart he turned to his people and said, "My time has come; a great cycle of the heavens has been finished, and another that is not mine is about to start. I have seen the face of Tulán in the smoky mirror."

And he set the great temple on fire, and buried his treasures from the Chichimec, and turned the fertile cacao trees into cacti, and as he was leaving he

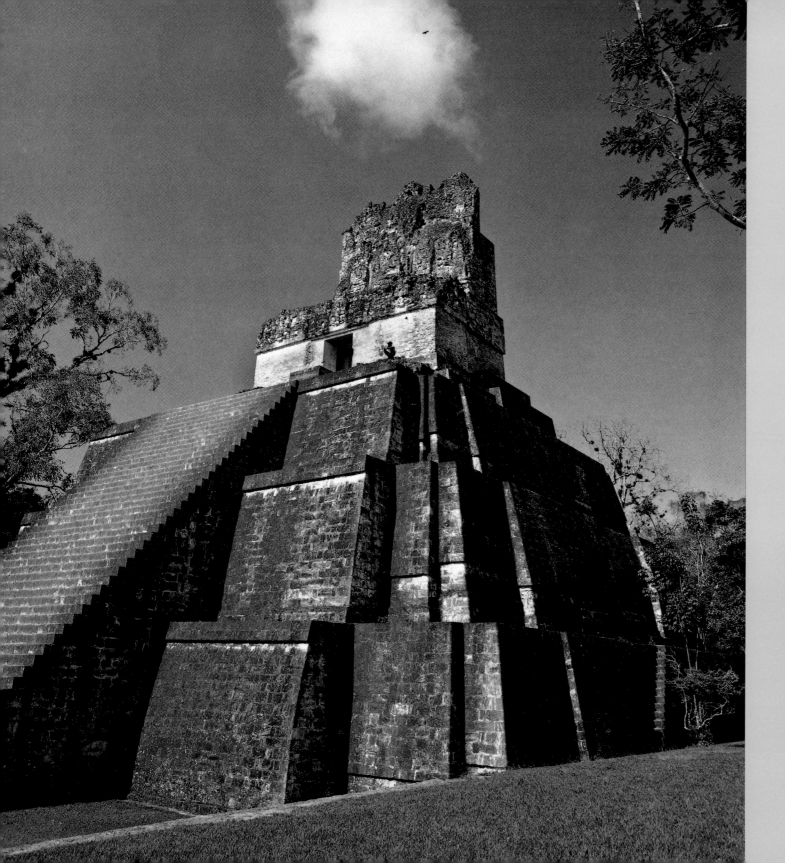

TEMPLE II
(TEMPLE OF THE MASKS)

Tikal

Large grotesque masks that flank the stairway on the front platform give this temple its name. Temples found in the Tikal region have a unique style of bowed terraces with broken corners.

said, "I leave behind me everything that was from the Heart of Earth. I have lost everything, my children, my brothers, my sisters. Now the time has come for me to return to Mother-Father, to the place of my birth. The serpent bites its own tail and the time is now for it to consume itself."

And he touched many people as he made his way back to the place where he had first washed onto the shores. And on his arrival, he cried, and said to the five followers who had remained with him since his departure from Tulán,

"Every moon, every day, every wind,
 storms by and passes as well.
 My blood also has found its place of stillness."

A dark cloud hovered between the beach and the sea, and the white-caps frothed, as if the foam of the sea beckoned him home. His white beard flowed back, tangled with his feather cape. As he raised his hand to his forehead to protect himself from the wind, he looked to the horizon, now red and orange with the setting sun.

During the next three days he built a raft by cutting down great trees, which he then carved into the bodies of serpents. With the last of his energy he felled an almond tree whose powerful branches formed the shape of the Tree of Life which he planted like a mast in the center of his ship.

And Quetzalcoatl said, "Help me, my friends, for I can not leave this earth alone. So his followers tried to push his vessel off three times, and each time the sea returned him. He asked his attendants to lash him to his Tree of Life and he spread his plumed cloak like wings, and the wind and the sea took him back to the house of the dawn.

And he left them a promise:

"Your gods will turn to sand again;
Hopelessly you shall pray to them.
They hide the ropes
with which they will hang your fathers.
There will be a tyranny of words;
the trees will live in slavery,
the stones will be in slavery,
your children will live in slavery.
There will be thunder,
there will be lightning.
The earth will burn.
The smoke steals the heart,
steals the mind.
And then all will be still
the sound of peace shall be heard.
Ten Heavens of decreasing choice
and Nine Hells of increasing doom
and then I shall return to my people."

AND HE WILL.

These three structures were built during the final days of construction of the Maya city-state. It is conceivable that the Feathered Serpent arrived and departed from these shores. The Maya builders of the temple complex probably anticipated the return of Quetzalcoatl.

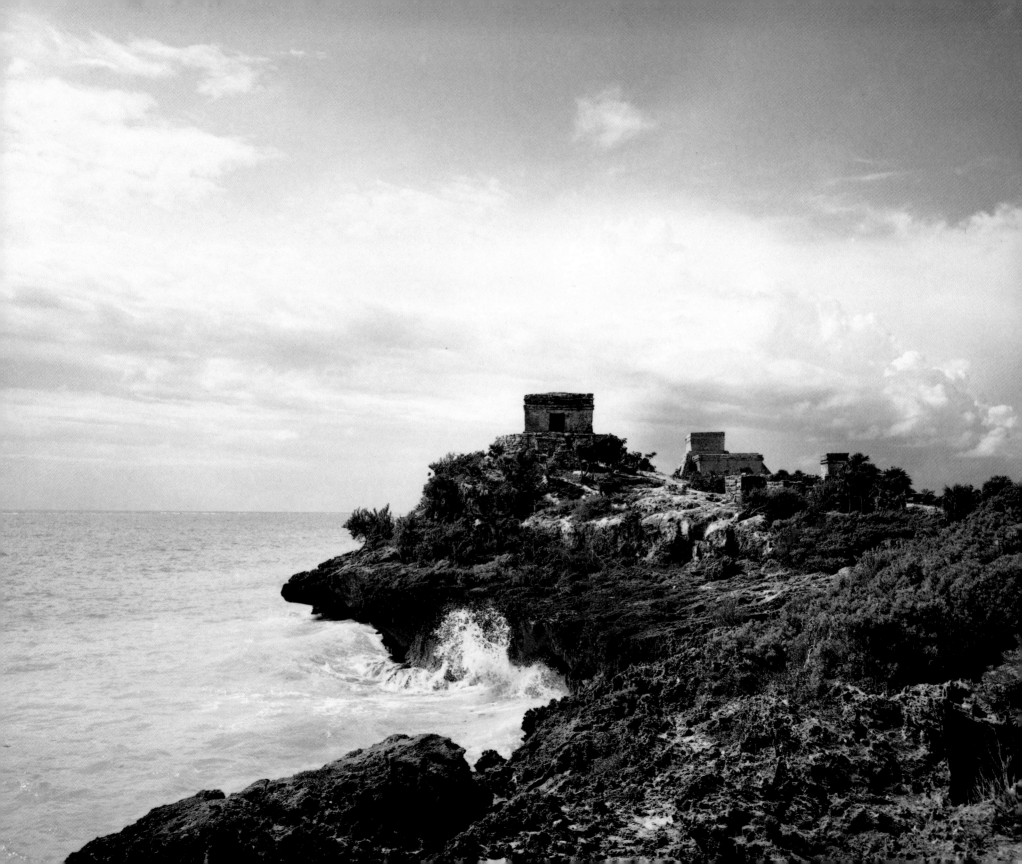

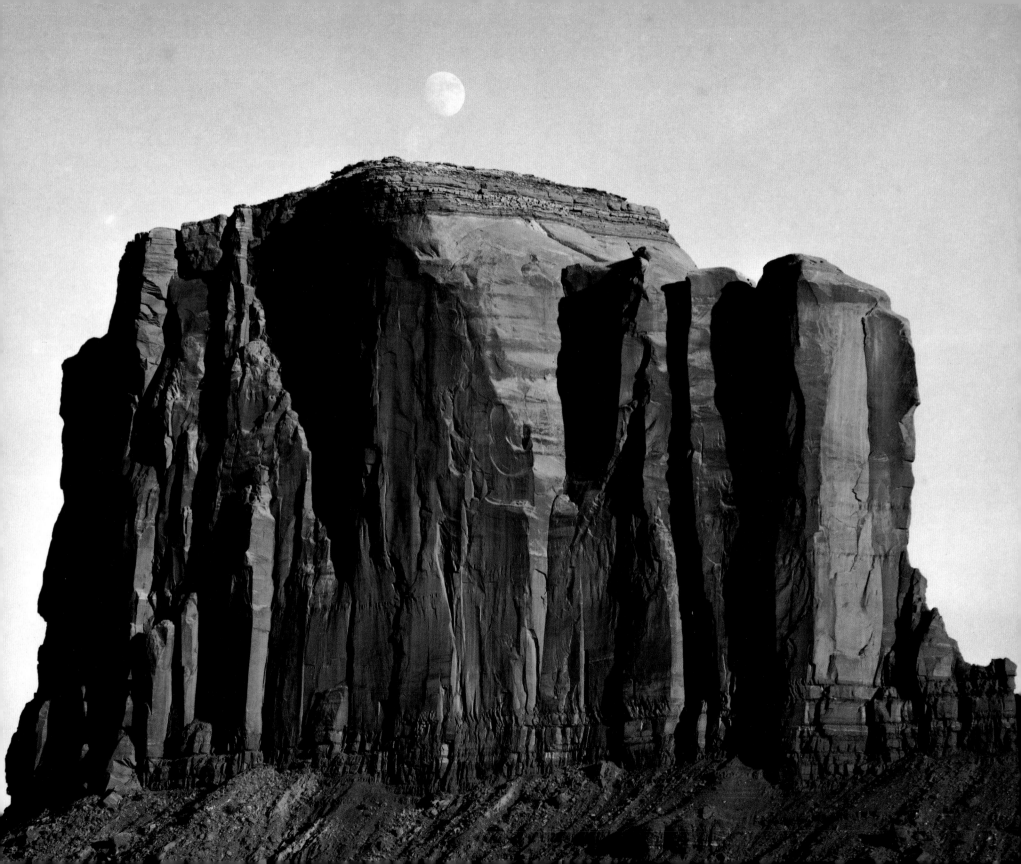

CLIFFDWELLER

MOONRISE OVER
ELEPHANT BUTTE

Monument Valley, Arizona

*This butte was in existence
long before the arrival of
the Cliffdweller in 700 B.C.,
and witnessed their
2000-year occupation and
eventual departure.*

NANA HOPIPAQÖ

from the east

QÖYANGWUNUKA KUYIVA

white dawn rising

NANA HOPIPAQÖ

from the east

SIKIANGWUNUKA KUYIVA

yellow dawn rising

ANGWU HUWAAM

be awakened

HAWIWOKIALYATA

ho! look on to us

CLIFFDWELLER

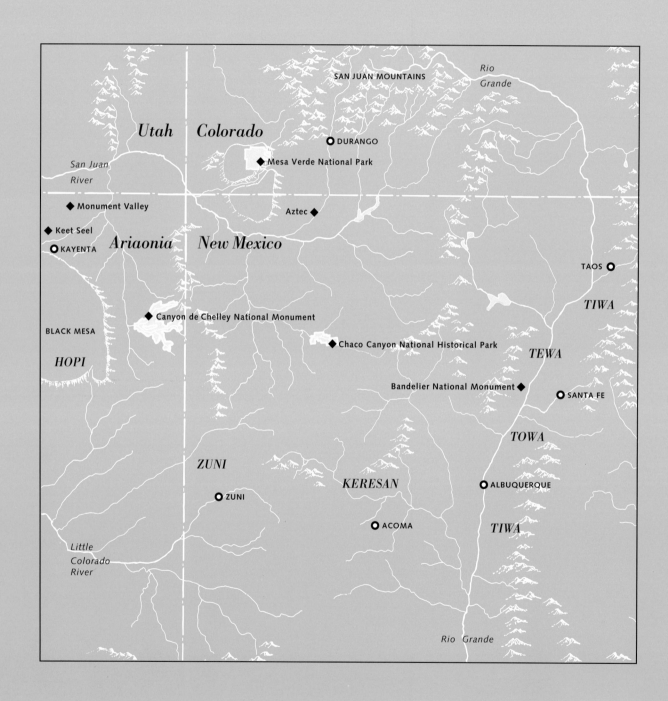

SAN JUAN MOUNTAINS

Rio Grande

Utah *Colorado*

○ DURANGO

◆ Mesa Verde National Park

San Juan River

◆ Monument Valley

Aztec ◆

◆ Keet Seel

Ariaonia *New Mexico*

○ KAYENTA

TAOS ○

TIWA

◆ Canyon de Chelley National Monument

BLACK MESA

◆ Chaco Canyon National Historical Park

TEWA

HOPI

Bandelier National Monument ◆

○ SANTA FE

TOWA

ZUNI

KERESAN

○ ALBUQUERQUE

○ ZUNI

○ ACOMA

TIWA

Little Colorado River

Rio Grande

CLIFFDWELLER refers to an ancient civilization in the North American South-West commonly known as Anasazi, a name meaning "Ancient Enemies" in the Navajo language. This translation has become unacceptable to the living decendents of the Anasazi, our modern day Hopi, Zuni, and Tiwa peoples, and the translation has been given a new meaning: "Those who have gone," "Ancient Ancestors," or "Ancient Ones." This book shall depart farther from the convention and replace the name Anasazi with CLIFFDWELLER, a term intended to evoke the spectacular vision of the cities built into cliff walls by these ancient people. This image, together with the unique configuration of the Kiva, forms the distinctive cultural signature of the Cliffdweller in the American South-West.

The story of the Cliffdweller began when their ancestors start migrating from Asia about 23,000 B.C., and for many centuries they continued to cross the glaciated land bridge at the Bering Strait. At first, these people were nomadic hunter-gatherers living in either caves or open sites near large lakes. By 5500 B.C., when most of these large lakes had dried up, they became a more desert-oriented culture. The technique of coiled and twined basketry was developed sometime in 2200 B.C. About 700 B.C., a branch of this archaic desert people, later known as the Cliffdweller, migrated towards an area known today as the Four Corners—the point where the states of New Mexico, Arizona, Utah, and Colorado meet. They lived in this general area as hunter-gatherers until A.D. 450, when the Cliffdweller became more settled and began farming maize, domesticating animals such as turkeys, and making pottery.

The Cliffdweller began building their pit houses around 270 B.C. These semi-subterranean, circular dwellings were twenty-five feet in diameter. They had cribbed roofs with entries that doubled as smoke vents. The earliest structures were fragile, often of pole-and-brush construction and plastered with adobe, while the later houses were of masonry and included adjoining rooms. These houses were built against the back of caves with Kivas in

front. The rock overhang provided shade from the sun, while it also protected the Cliffdweller from rain and frequent rock slides in the Canyon. The architecture of the Kiva derived from the pit-house form, it contains the following features: (1) The stone structure is subterranean and is circular in form with a rectangular opening in the cribbed log roof. The interior is accessed by means of a wooden ladder. (2) A fire pit is usually located directly below the roof opening, allowing the entry to act as a smoke vent. (3) A ventilator located outside the stone wall brings fresh air into the chamber. An air deflector was positioned between the opening of the air vent and the fire pit to prevent the incoming air from blowing out the fire.(4) A bench, usually running continuously along the inside circumference of the Kiva, acts as seating as well as storage for ceremonial artifacts. In later Kivas, pilasters were added on top of the benches to subdivide the seating and to provide additional support for the roof. (5) The sipapu, a circular opening in the ground about four inches in diameter, is located near the center of the

Kiva. This is the symbolic entry to the Underworld out of which the ancestors of the Cliffdweller emerged.

Although we do not have direct knowledge of the prehistoric Cliffdweller social system, experts have deduced from their descendants, the historic Hopi, that the Kivas belonged to men of the same clan, while the houses pertained to women, as in most primitive social systems throughout the world. The development of the early Pueblo (a Spanish word for town or village) began in A.D. 750, in the Chaco Canyon area. For the next two hundred and fifty years the Cliffdweller civilization built the great pueblos of Chaco, Mesa Verde, Kayenta, Keet Seel, and Canyon de Chelly.

The great pueblos of Chaco were built in the open. The largest settlement likely held a population of more than 2,500 dwellers within a building complex four stories high, containing over eight hundred rooms, and Kivas sixty-four feet in diameter. Water systems were developed to bring rainwater from the top of the cliffs to irrigate the corn fields in the valleys below, often over

intricate stone steps. More than 1,000 miles of highways were built over a 60,000 square mile area to connect towns, villages, and ceremonial centeres. In A.D. 1100, however, the population in Chaco Canyon began to migrate north and the canyon was empty by A.D. 1130. Some settled in Mesa Verde, others built the large Aztec Pueblo. Whatever caused the migration from Chaco seemed to haunt these later sites. Aztec Pueblo was short lived, the Chaco migrants left by A.D. 1120. The population in Mesa Verde disbanded, and by A.D. 1284, the majority had headed east toward the Rio Grande region. Evidence shows that Canyon de Chelly attempted to absorb some of the migrants from Mesa Verde, but it too became uninhabitable and was empty by A.D. 1299. The population migrated southwest toward the Hopi and Zuni mesas of today. Some experts have suggested that this exodus was due to the great drought of 1276–1299, at which point the land could no longer support the large populations of these cities. Others have suggested that the increasing conflicts with nomadic Navajo, Apache, and Shoshone tribes made these towns difficult to defend. These explanations for the abandonment of the pueblos are based on limited scientific evidence and are inconclusive. The exodus of the Cliffdweller from the Four Corners remains a mystery.

Archeological vestiges cannot preserve myths. The apparent continuity of the pueblo cultures in the South-West, however, implies that the sacred stories could have been kept alive through oral tradition for over a thousand years. Although the Cliffdweller had no written language, their life story can be reconstructed through the oral legends that have survived among their living descendants: the Hopi, Zuni, Keresan, Tewa, Towa, and Tiwa people.

It is said that if we allow ourselves to dream the Dream at the moment of each dawn and each sunset, in the places where the Ancient Ones lived, the wind, the rain, the light, and the stones will touch our souls, and we shall remember how life was for the Cliffdweller.

"I am going to take a picture of this," I said. My companion, Wilson, a Navajo guide, waited patiently while I selected my camera and framed the shot. Writing in my notebook, I murmured — Panoramic exposure four: Canyon del Muerto. "Canyon of the Dead," I said aloud. "The dead... the Navajo?"

He looked at me, then back down along the winding canyon. "This land has been home to many peoples," he said. He looked west and squinted against the low slanting light of the setting sun. There were wrinkles around his eyes, although he was not very old. "There were the Old Ones, the Cliffdweller," he said. "They were the first. That was a long time ago." He grinned. "So long ago that no one remembers where they came from, or how they went." He pulled down the bent brim of his hat to shade his eyes and we walked along the edge of the canyon. "Then came the Dine, the Navajo. Even the Hopi lived here once."

We walked in silence for some time; I watched the rocks, the dirt, and the canyon walls change colors, as the shadows grew long and indistinct.

He asked quietly, "Do you want to hear the story? An old man — he was Hopi — told me."

We stopped, and I asked him to tell the story. As we sat on the edge of the canyon he told me the story as he had heard it.

"In the beginning," he said, "there was the endless space of Tokpela. And there was the Creator, Tawa, the Sun. The space had no beginning and no end — not like this," he pointed to the canyon and its walls, growing dim with the coming night. "It was just a big space that had a rhythm and a time in the mind of Tawa, the Creator.

"Then the Creator, Tawa, conceived Sótuknang, and he said to him, 'I have created you to carry out my design for life in immeasurable space. You are my nephew. Go and set order, rhythm, and time in the universe.'

"Sótuknang did as he was told. From the far reaches of endless space, he gathered the materials to give the formlessness a form." Wilson looked at the horizon where the sun had gone, then over his shoulder where the moon would rise. He put out his hand and made a fist as though to grasp something from the air. He did this nine times.

"Sótuknang shaped the materials into nine universes: one for Tawa the Creator, one for himself, and seven for all the many forms of life that were still to come. He gathered all that was to become the waters and placed it on the surfaces of the nine universes. Then he separated the waters from the land. Then Tawa told him, 'I want you to set the forces of the air in motion all around.' So Sótuknang

...page one hundred-four

Two slender geological formations rise from the bottom of the canyon. This natural monument may have inspired the story of the Spider Grandmother, who created the twins in the Hopi creation myth.

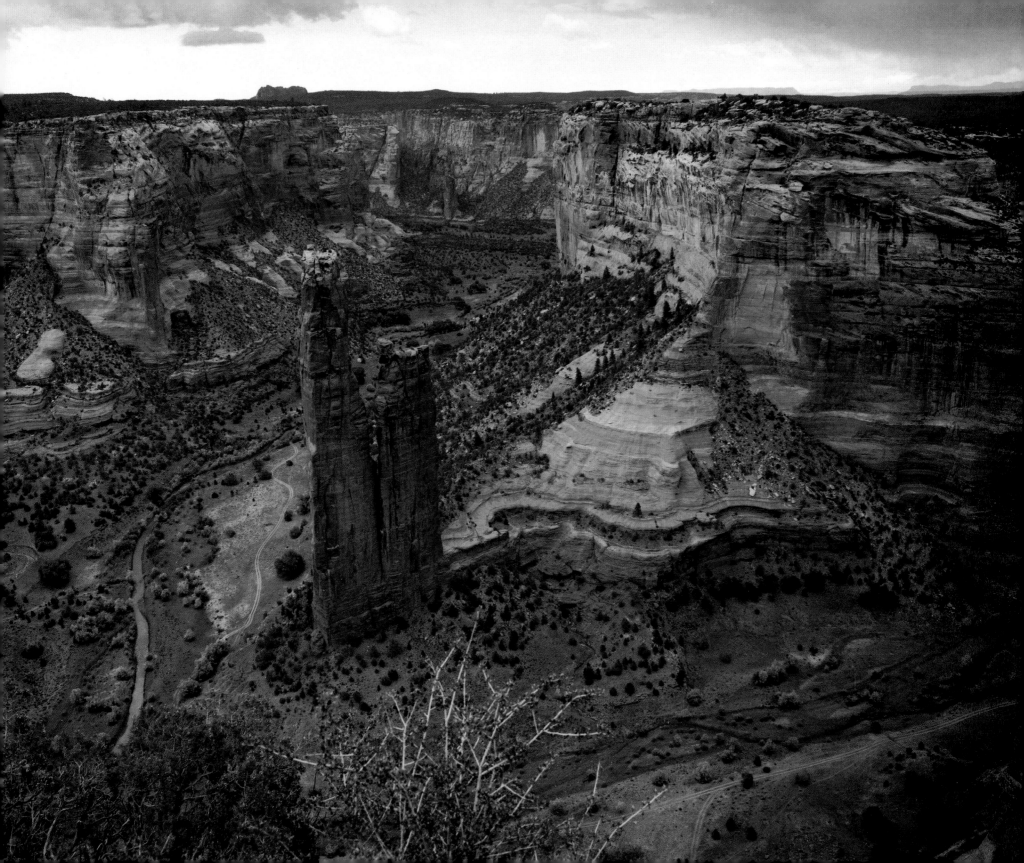

STORM PASSING OVER
MONUMENT VALLEY

Arizona

The forces of nature often
express themselves dramati-
cally in the Four Corners.
Such animated conditions may
arouse our ancient memory
of the destruction of the three
worlds in the myth of creation.

gathered all that was to become the air and made it into great winds, storms, and gentle breezes. Thus, Sótuknang brought order to each of the universes."

Wilson turned his head toward me and smiled. It was growing dark and I could see the first stars appearing dimly behind his head. "Tawa the Creator was pleased. He said, 'You have made great works according to my designs, Nephew. You have shaped the waters, the lands, and the airs. But now you must bring forth life, and with it joy and song and dance, to complete my design.' So Sótuknang returned to Tokpela, the endless place, and created a companion to help him complete his work. Her name was Spider Grandmother. It was she who took some earth, mixed it with saliva, and molded it into two beings."

Wilson held out his hand, palm up, as though the twins lay there. As he passed his other hand over the imaginary beings, he said, "She covered them with her robe which was made of wisdom, and sang the creation song over them. When she took away the robe the twins sat up and asked, 'Why are we here?' And Spider Grandmother explained that the twins were here to maintain order in the world once life was put on it. She then told the twins to touch the earth so that it would become solid, and to sing the creation song so that it could be heard through-out the new world.

"And the twins traveled throughout the new world. They made the high mountains solid. They left the valleys soft and supple. They sang the creation song so that the world and the universe quivered like the string of a bow, carrying the song, their prayer, to the ear of Tawa.

"'This is your song, Uncle,' said the twins. And Tawa the Creator was very pleased.

"And Spider Grandmother continued her work. She created the fruit-bearing trees, the nut-bearing trees, the bushes, the flowers, the pine, the pinion, and gave each its name. Then she created the birds and all of the animals. Just as she had made the twins, she molded the birds and all of the animals from earth and saliva, covered them with her robe, and sang the creation song to them. Then she placed them in the north, the south, the east, and the west.

"Finally, she gathered earth of all four colors — red, yellow, white, and black. She took the red earth, and with her saliva molded it into the image of Sótuknang. She did this again to the yellow earth, the white earth and the black earth. She covered the figures with her robe and sang the song of creation. As they came to life she said, 'Look there to the east. There is the Sun, your Father, the Creator.'

"The first people multiplied and populated the First World. Sótuknang gave them the ability to under-

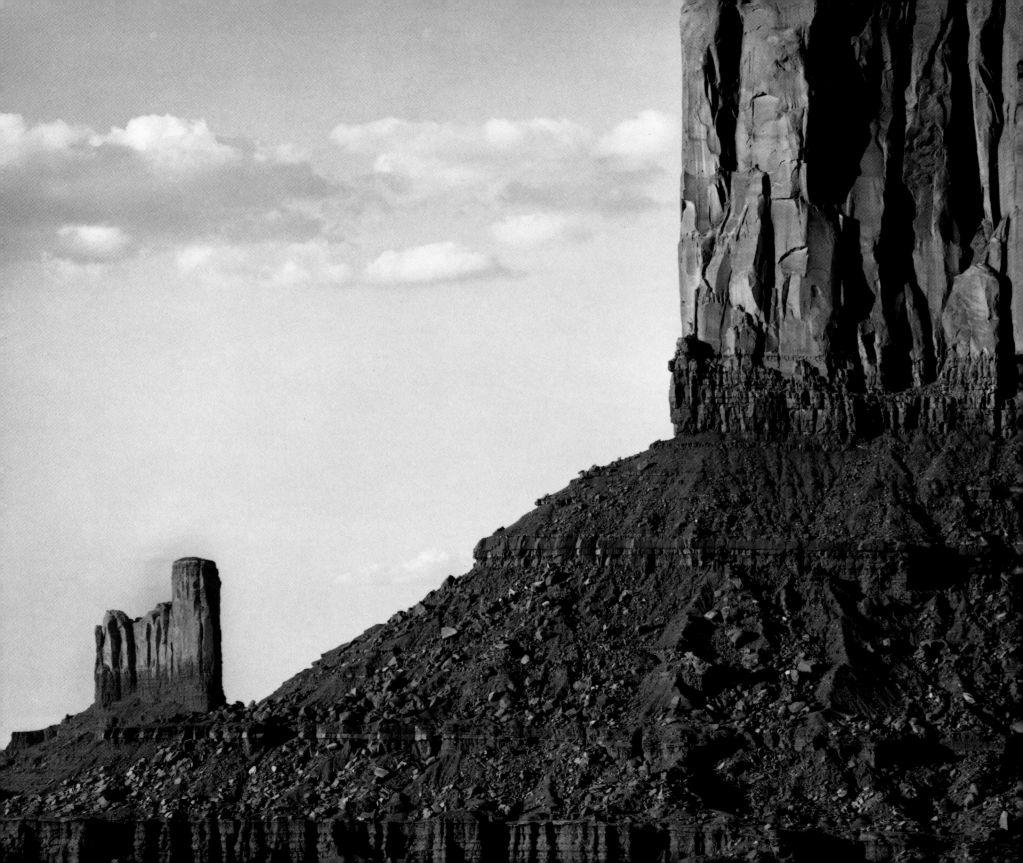

stand all living things. But after a while many of them forgot their creator and began to argue and fight. Sótuknang led those who still remembered Tawa to safety by taking them to the Kiva home of the Ant People. Those people who had forgotten their creator were left in Tokpela to be burned alive by fire during the destruction of the First World.

"After the world cooled down, Sótuknang said, 'Go and make your emergence into Tokpa, the Second World.' But there were wicked people who caused much fighting. Sótuknang sent the good people to safety in the Kiva of the Ant People and destroyed the Second World with ice. The world tipped off balance and rolled over on its side: what was north became south, and the mountain toppled into the sea.

"The Third World, Kuskurza, was corrupted by evil, too, and was destroyed by water. This time, it was Spider Grandmother who saved our grandmothers and grandfathers. She showed the people how to make small boats of reeds and to let the wind carry them to a great island in the direction of the rising Sun.

"Finally, Sótuknang made the Fourth World. It was not as beautiful as the other three. It was not perfect. There were low places and high places, and it was sometimes hot and sometimes cold. But there is everything in it that we need to be happy if we make the right choices." Wilson nodded a couple

of times and took a moment to look around the winding canyon.

"And that is what happened at the Dawn of Creation," he concluded, and pulled up the frayed collar of his jean jacket and buttoned it up the front.

We made our way down into the canyon by the light of the moon that night. We slept. The next morning we broke camp and began hiking before the sun had crested the eastern ridge. We watched the morning sunlight creep orange and crimson down the western wall of the canyon. Following a small stream in silence, we walked for miles. Then Wilson took a sharp turn, a few willow trees concealed a ruin.

"There's the Antelope House," he said.

"Why the Antelope House?" I asked.

As we walked towards the ruins he pointed at a partially restored Kiva, and said, "The word Kiva means 'the world below.' See that hole in the center, it is called 'sipapu,' the navel of mother earth. This whole structure helps us remember our being born from the world below, the place of the beginning. The sunken fire pit represents the First World, for life begins with fire. The altar represents the Second World, and the ladder is the Third World, a bridge to the world outside the Kiva. The world we live in now is the Fourth World."

ANTELOPE RUINS

Canyon del Muerto, Arizona

A community, once protected by the curvature of a cliff, stands in ruins today. These ruins were occupied during the 1200s and abandoned about 1270, possibly because of flooding. Beneath the structures are ruins dating back to A.D. 693.

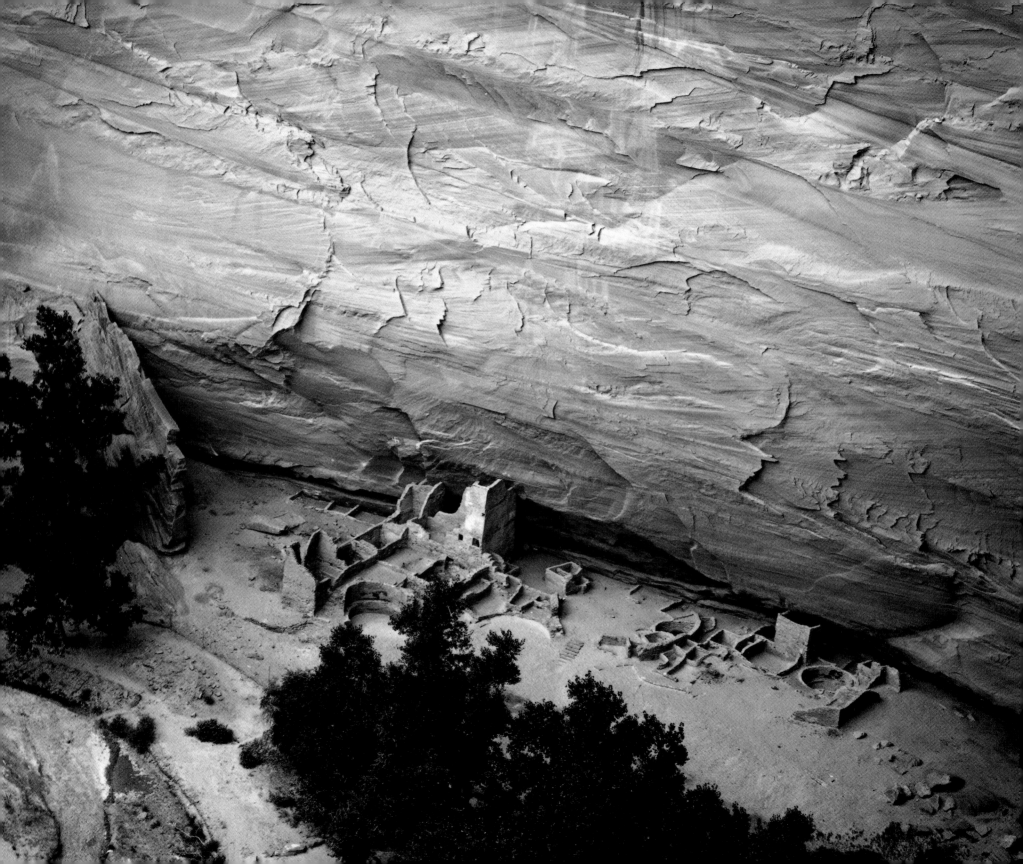

CLIFFDWELLER

Wilson's description of the Kiva reminded me of a series of images I saw on one cool night, when the stars were shining bright over the nearby Mummy Cave. As I pulled out my journal, I turned to Wilson, "Let me read you a poem that came to me when I was meditating in front of the Mummy Cave a year ago...":

Ho Ancient Ones!

You are the eyes that saw the dawning of time.

Talk to us!

Help us remember our ancient dreams,

Our ancient thoughts.

Remind us of our world under,

The time before light.

Bring us back to the place of emergence,

Guide us along the path of life.

There was silence in the dark,

without day, without night.

We have eyes that do not see,

mouths that do speak.

We have ears that do not hear,

hands that do not write.

But we felt the softness in our feet,

and the earth was warm,

and the soil was wet.

In the womb of the Mother we dwell,

in the song of silence we wait.

Bird songs, earth songs,

news of a greater world above.

Follow the sweet smell we climb,

follow the earth rhythms we emerge.

The earth was dry,

and the land was without light.

Buffalo and coyote roaming aimlessly,

while the blind bats fly.

In the world of darkness we dwell,

with the promise of emergence we wait.

ANTELOPE HOUSE TOWER

Canyon del Muerto, Arizona

The Cliffdweller took their building materials from the immediate environment; thus, their structures blended into their natural surroundings.

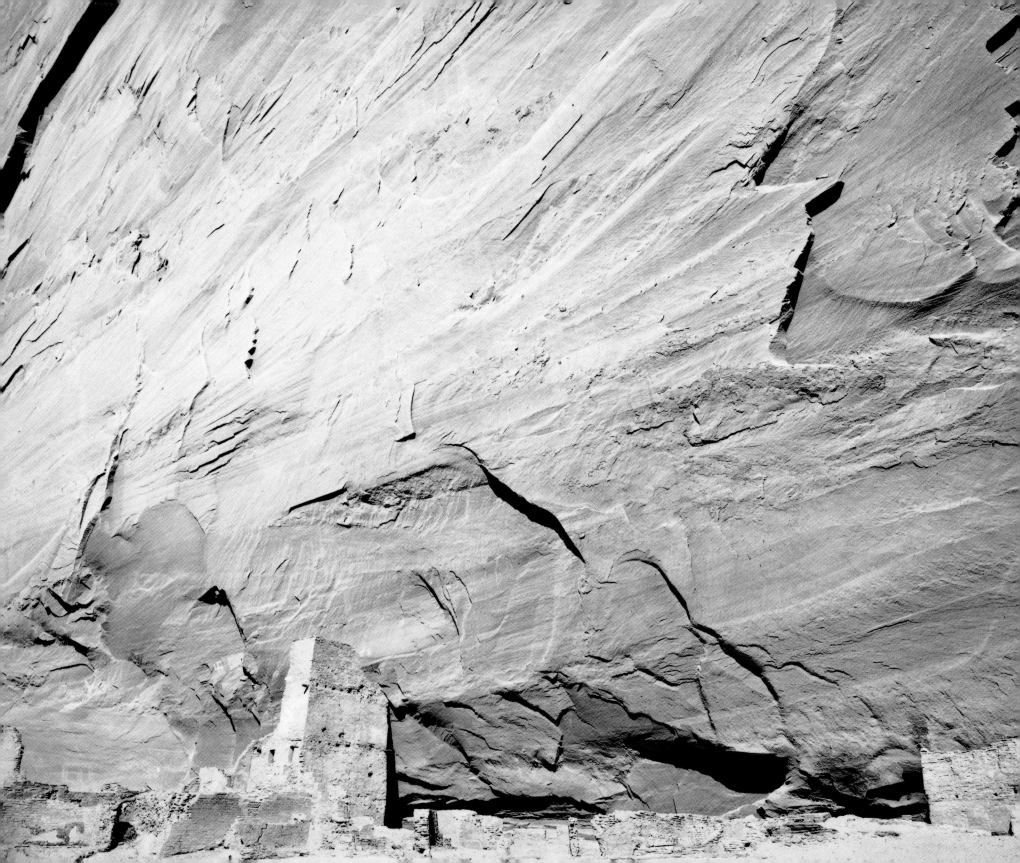

Wilson grinned at me, "So you have invoked the Ancient Ones to speak to you about the old ways, about the time from before the white man came, who did not know the dance, the prayers and the songs. But there is a prophecy that says that the old ways will return, 'When the white man steps on the Grandmother, this will mark the return of the buffalo. When the white man stands on Grandmother Moon, this will signal the beginning of the return of our ways.'"

"Standing on Grandmother Moon? Do you mean the astronauts lunar landing?" I asked innocently.

He grinned again and never answered my question. I pushed myself up, and we continued our walk along the deep canyon bed.

I spent three more days in the canyon where he had guided me, Canyon del Muerto. On the last day, before we walked out of the canyon, we stopped by the Standing Cow Ruins and looked at the Navajo petroglyphs. The skins of the rock seemed to have pealed off to reveal events of time past. The soldiers and missionaries on horseback refer to the arrival of the Spanish cavalry in the Narbona expedition, in 1804. This signified the new era of european cultural infiltration into a seemingly untouched land.

I spent some time photographing the petroglyphs on the canyon wall, then we went on. Soon we came to a place where three trails intersected. We took a sharp left and entered a new canyon. An hour had passed since Wilson had spoken.

"This is where Captain Pfeiffer and his men camped one hundred years ago, when they tried to wipe out our people. They burned the cornfields, poisoned the water holes, set the hogans on fire. It lasted for a long time. The army killed all that they could and took many prisoners too.

"My grandfather was a prisoner. He made the Long Walk from this place to Fort Sumner. It was three hundred miles away, and old men and women with their babies had to walk without food or water. Sometimes the young boys would sneak away to where the army mules were corralled at night. They would pick through the manure to find undigested kernels of corn to roast in hot ashes and eat. The water was bad. They became very sick. They said,

'Where did we go wrong?

We were peaceful people.

We loved the land

Given to us by the Holy Ones.

We did no harm.

Why are we made to suffer so?'

...*page one hundred-sixteen*

RUNOFF AT CANYON
DE CHELLY

Arizona

Runoffs are rare in Canyon de Chelly, appearing only after a great rainstorm.

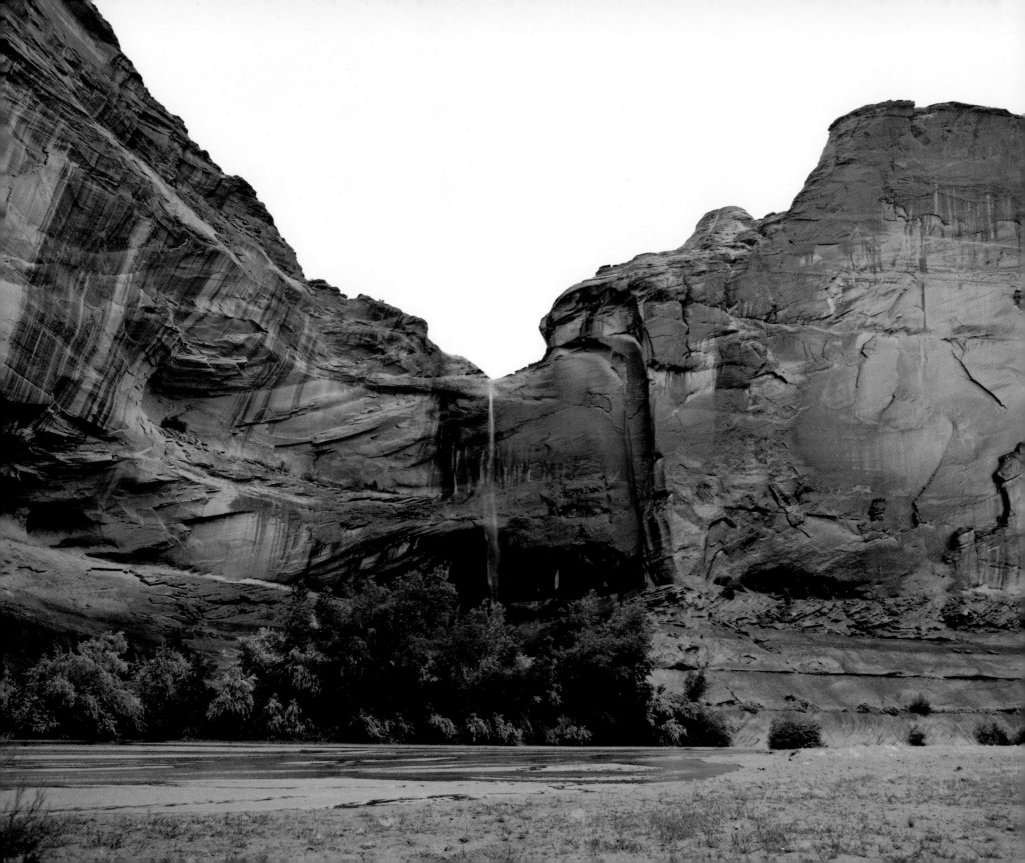

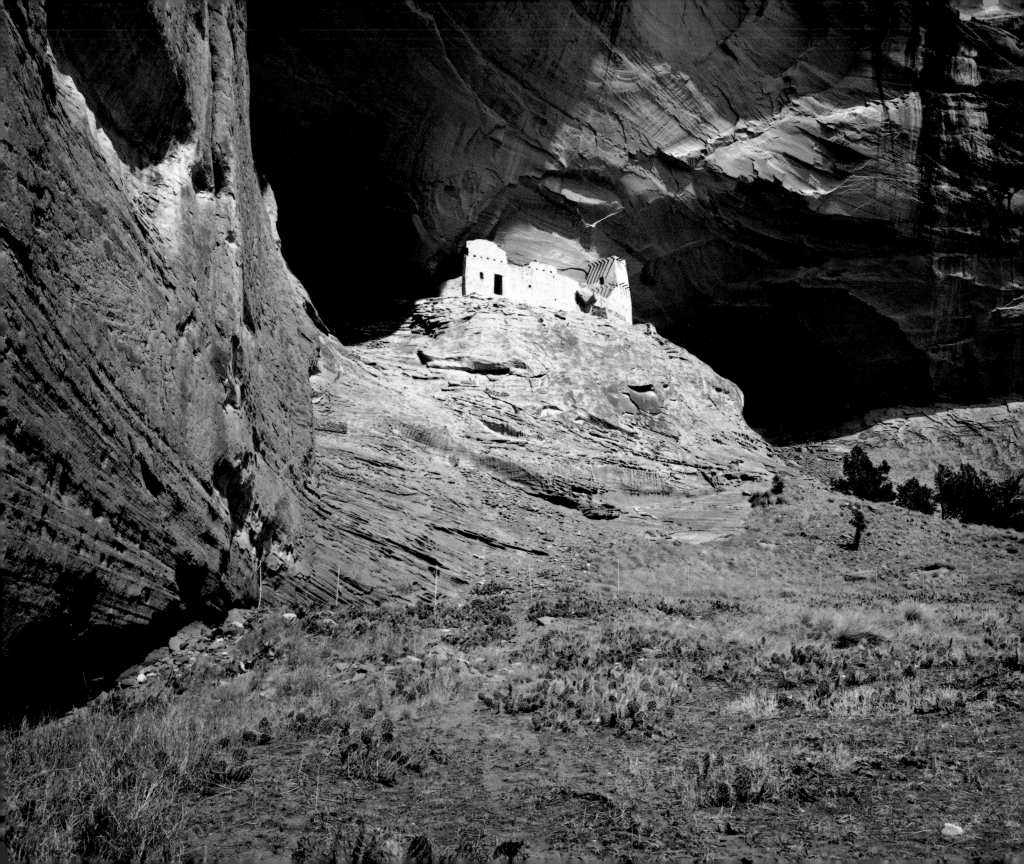

THE MUMMY CAVE

Canyon del Muerto, Arizona

Nestled on a ledge in a large cave, a fortress-like building guards the entrance to two alcoves. A beam from the talus of the east alcove, dated to A.D. 306, suggests that the earliest dwellers may have lived here.

DETAIL

Tree-ring dating of the wooden beams in the tower's uppermost story date this dwelling to 1284. This suggests that the building may have been the last one built by the Cliffdweller in the Canyon de Chelly area.

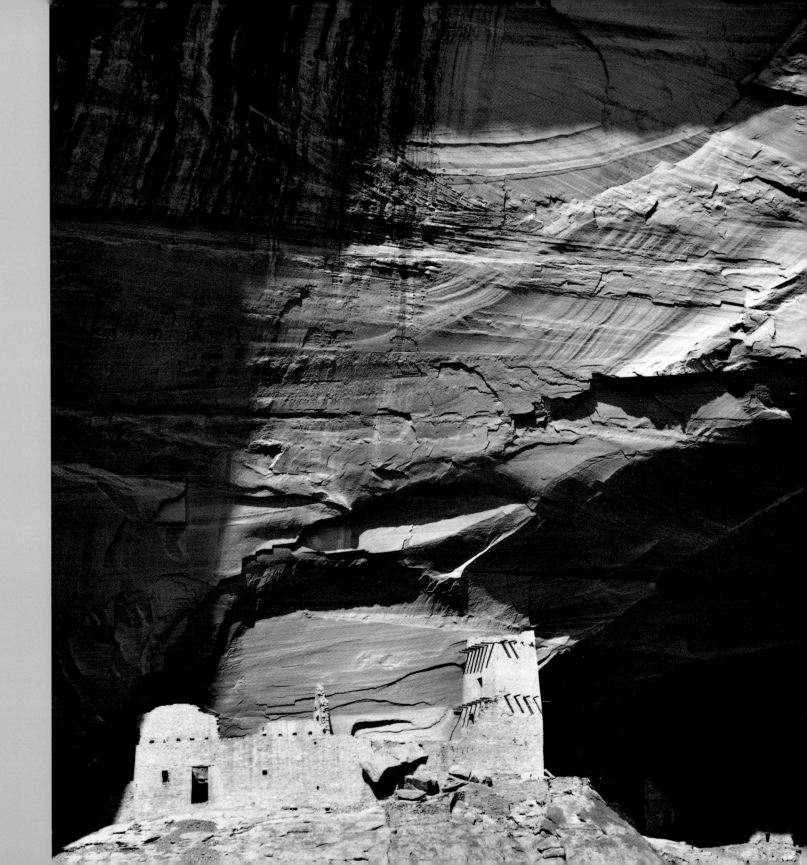

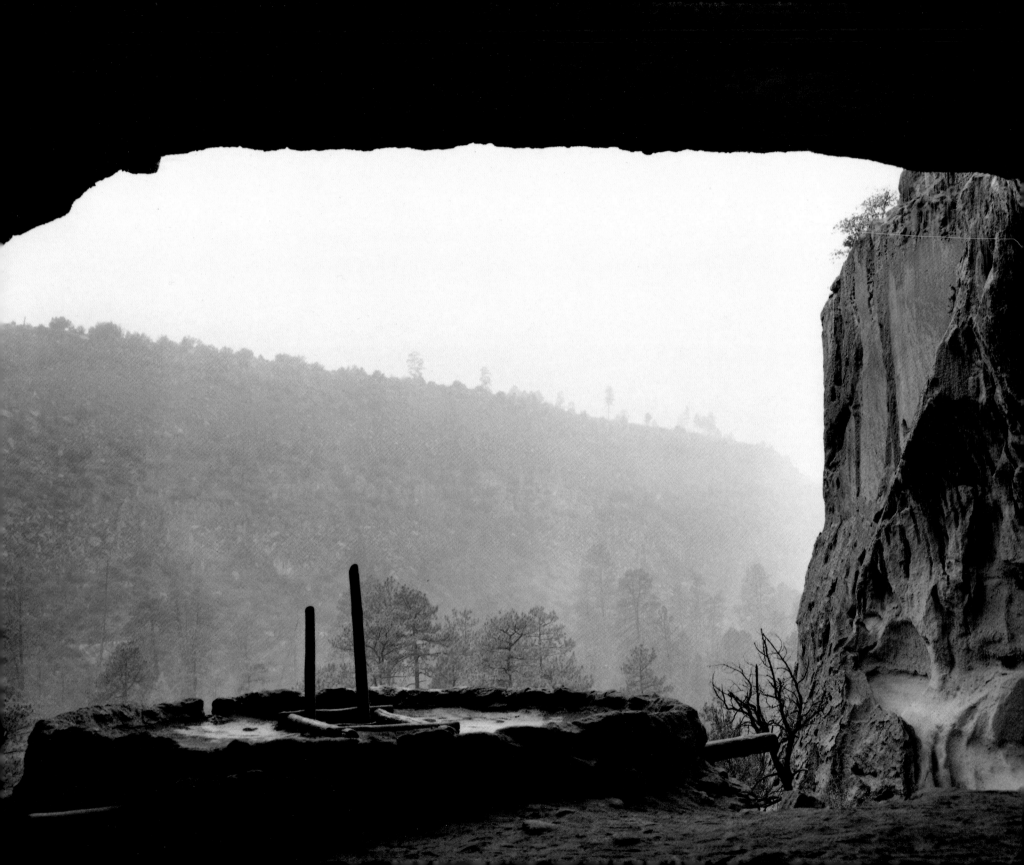

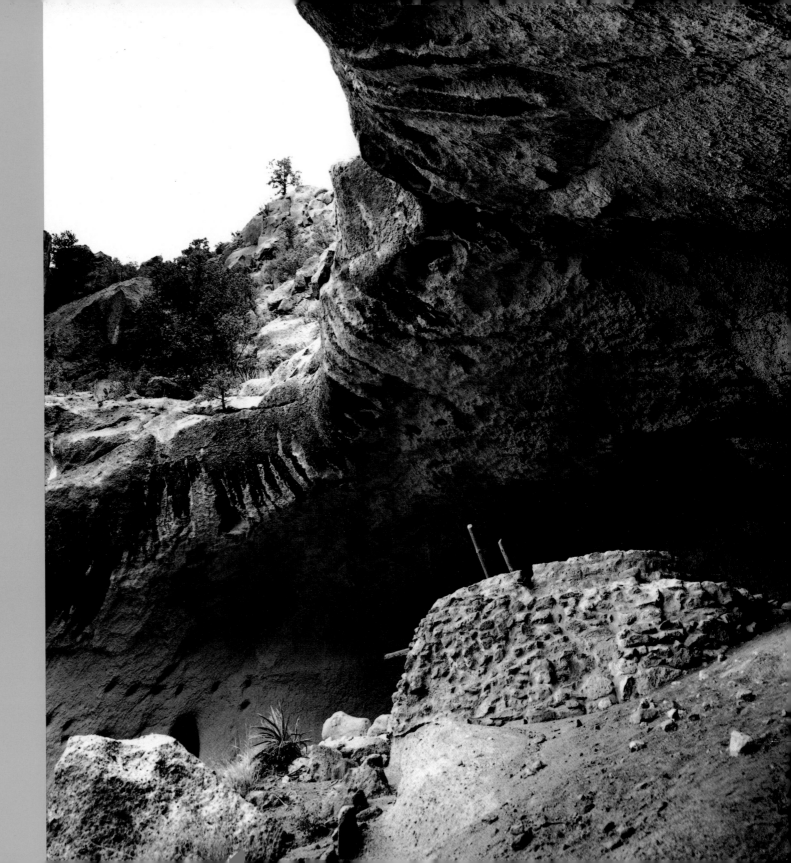

VIEW OF KIVA AND
FRIJOLES CANYON FROM
CEREMONIAL CAVE

Bandelier, New Mexico

The top view of this Kiva,
shows a rectangular open-
ing with two ladder posts
extending from it, the only
entrance to the structure.
For the Cliffdweller, who
participated in Kiva cere-
monies, the descent down
the ladder was the first
step in the return to the
Underworld, from which
their ancestors emerged.

VIEW INTO CEREMONIAL
CAVE

Bandelier, New Mexico

The Kiva hugs the edge of
a volcanic cliff that over-
looks the Frijoles Canyon.

"And sometimes enemy tribes would attack the prison camps. But the wolves were the worst. It was winter, and they were hungry, too.

"And then our chief Daghaa'i performed the ceremony to return home. It is called Ma'ii Bizee naast'a. All the people gathered in a big circle and started to close in. And inside the circle was a coyote. Daghaa'i caught the coyote and put a white sea-shell with a small hole in it into the coyote's mouth. And the coyote, which was a wild female, was docile as a lamb. Daghaa'i then let her go free. The coyote turned in the sunrise direction, and then headed to the west. And Daghaa'i said: 'It is so. We will be free.' And we were.

"We signed treaties with the government, and we smoked many times the Sacred Pipe. But peace? Peace is difficult to come by. Even now man is still fighting for land, the so-called Joint Use-Area, where Navajo herders have lived on little-used Hopi land for many generations. The U.S. Congress has forced relocation of the Navajo even at the objections of the most traditionalist Hopi, under the pretext of solving a land dispute. In fact, the mining companies have lobbied heavily in Congress because they want the coal and uranium under this land. The Hopi and Navajo tribal councils were set up like puppets of your government to sign away our land.

"Who owned this land, anyway?" he sighed, "it was given to us by the Great Spirit, without boundaries, without exclusive rights."

We finally made our way to where Wilson's green truck was parked. We drove to his house that sits on top of a canyon rim, above the Mummy Cave. There, I thanked him and we shook hands.

He said to me that he had enjoyed telling me the stories, and that I should keep talking to the Ancient Ones. Then he pulled something from his back pocket. It was a piece of paper, soiled and deeply creased, curved in the shape of an old wallet, a letter that he had transcribed, written in 1854 to President Pierce:

The Great Chief in Washington sends word that he wishes to buy our land. But how can you buy or sell the Sky? The Land? The idea is strange to us. If we do not own the freshness of the air and the sparkle of the water, how can you buy them?

Every part of the earth is sacred to my people. Every shining pine needle, every sandy shore, every mist in the dark woods, every meadow, every humming insect. All are holy in the memory and experience of my people.

TOWER AT CLIFF PALACE

Mesa Verde, Colorado

Inserted in the mouth of the cave, this community of approximately two hundred rooms and twenty-three Kivas is the largest individual cliff dwelling in the Mesa Verde.

...page one hundred-twenty

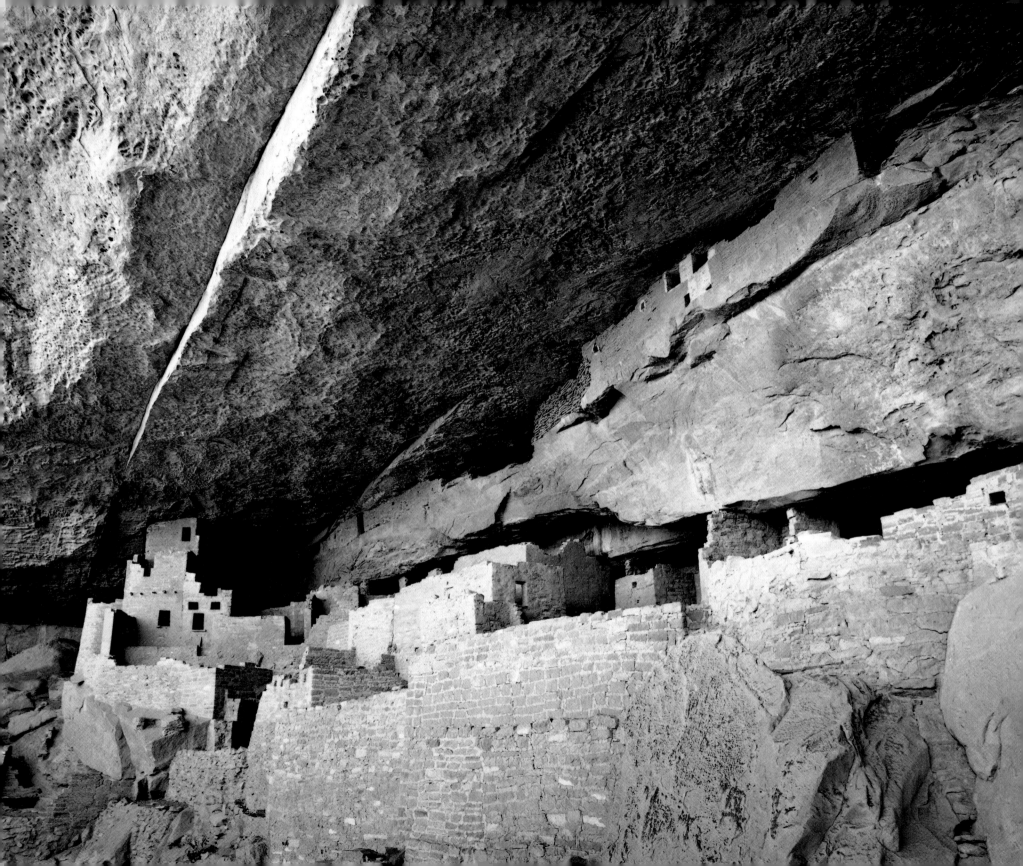

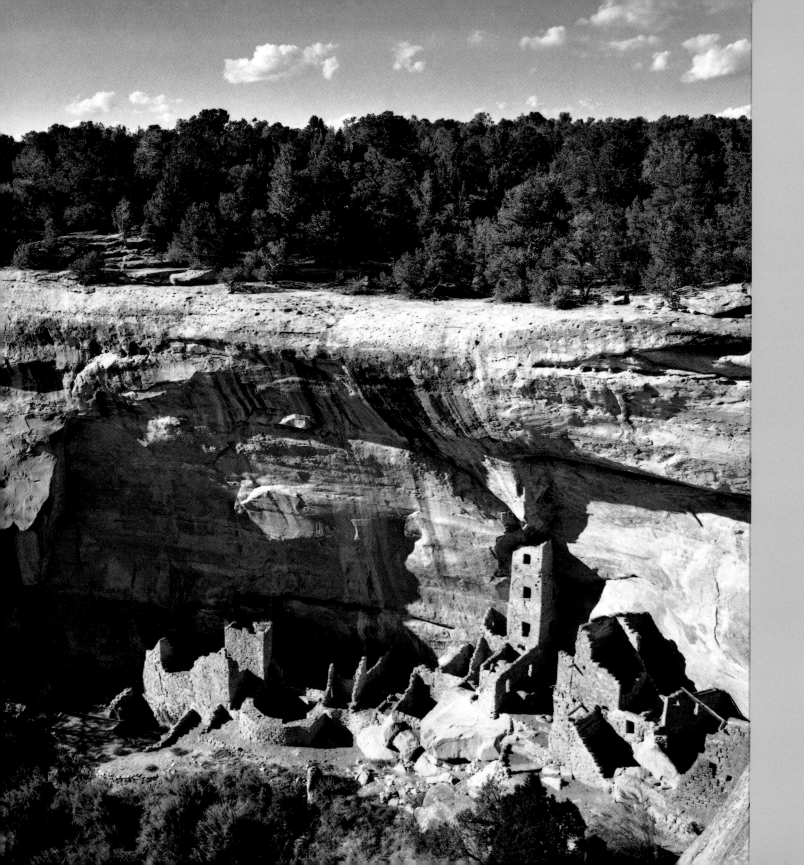

CHAPIN MESA AND NAVAJO
CANYON WITH SQUARE
TOWER HOUSE

Mesa Verde, Colorado

*In an ideal situation, the
Cliffdweller would build
their communities near
farmland. Here the Chapin
Mesa, once used as a tract
of agricultural land, is
located directly above the
inhabitants of the canyon.*

KIVA OF THE SUN TEMPLE

Mesa Verde, Colorado

*This Kiva is part of a cere-
monial complex that was
never completed. It stood
in a D-shaped courtyard
with another freestanding
Kiva. Together, the twin
Kivas might have been built
for seeking rain in times of
severe drought.*

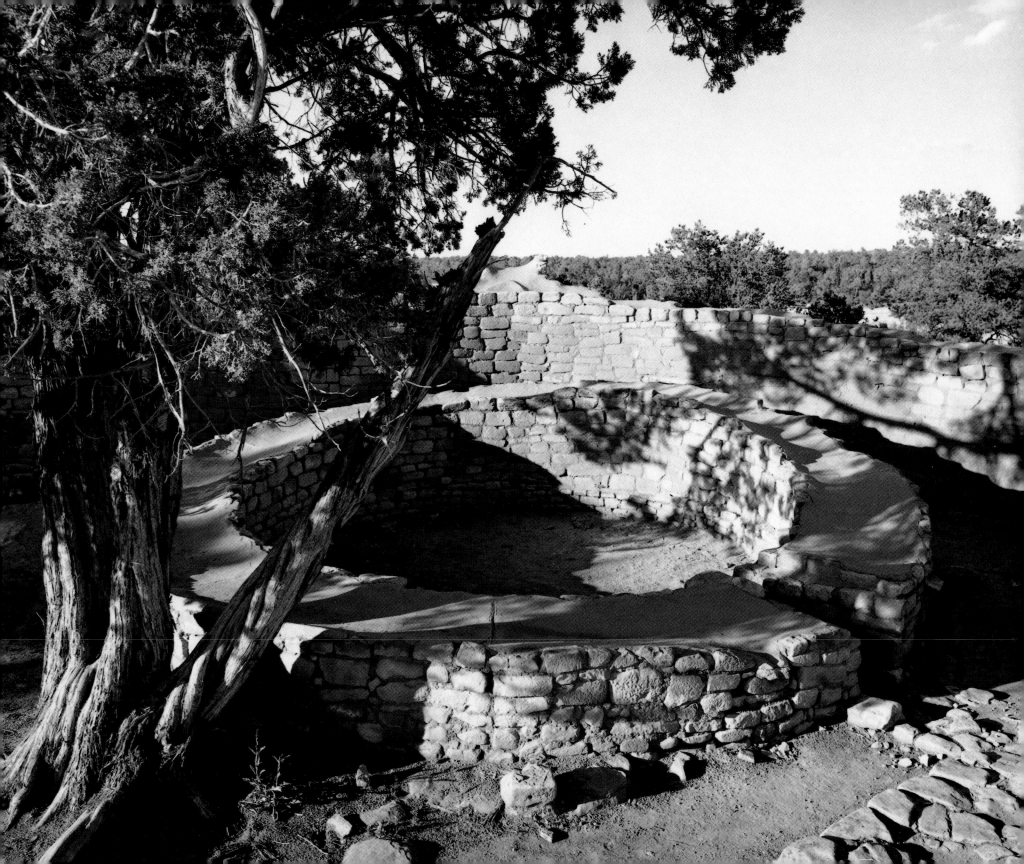

CLIFFDWELLER

We know the sap which courses through the trees as we know the blood that courses through our veins. We are part of the earth and it is part of us. The perfumed flowers are our sisters. The deer, the horse, the great eagle, these are our brothers. The rocky crests, the juices in the meadows, the body heat of the pony, and man, all belong to the same family.

The shining water that moves in the streams and rivers is not just water but the blood of our ancestors. Each ghostly reflection in the clear water of the lake tells of events and memories in the life of my people. The water's murmur is the voice of my father's father.

The rivers are our brothers. They quench our thirst. They carry our canoes and feed our children. So you must give to the rivers the kindness you would give to any brother.

If we sell you our land, remember that the air is precious to us, that the air shares its spirit with all the life it supports. The wind that gave our grandfather his first breath also received his last sigh. And the wind must also give our children the spirit of life. So if we sell you our land you must keep it

apart and sacred, as a place where man can go to taste the wind that is sweetened by the meadow flowers.

Will you teach your children what we have taught our children? That the earth is our mother? What befalls the earth befalls all the sons of the earth.

This we know. The earth does not belong to man; man belongs to the earth. All things are connected like the blood which unites all. Man did not weave the web of life, he is merely a strand in it. Whatever he does to the web, he does to himself.

One thing we know: our God is also your God. The earth is precious to him, and to harm the earth is to heap contempt on its Creator.

Your destiny is a mystery to us. What will happen when the animals are all slaughtered? The wild horses tamed? What will happen when the secret corners of the forest are heavy with the scent of many men? Where will the eagles be? Gone! And what is it to say good-bye to the swift pony and the hunt? The end of living and the beginning of survival.

KIVA AT CHETRO KETL

Chaco Canyon, New Mexico

Compared to Mesa Verde and Canyon de Chelly, the Chaco region has the most sophisticated masonry techniques of the Cliffdweller. The structures in this area were built in pueblo form and located on major routes. This location brought in active trade for the Chaco people and probably allowed them to have the resources for such refined construction.

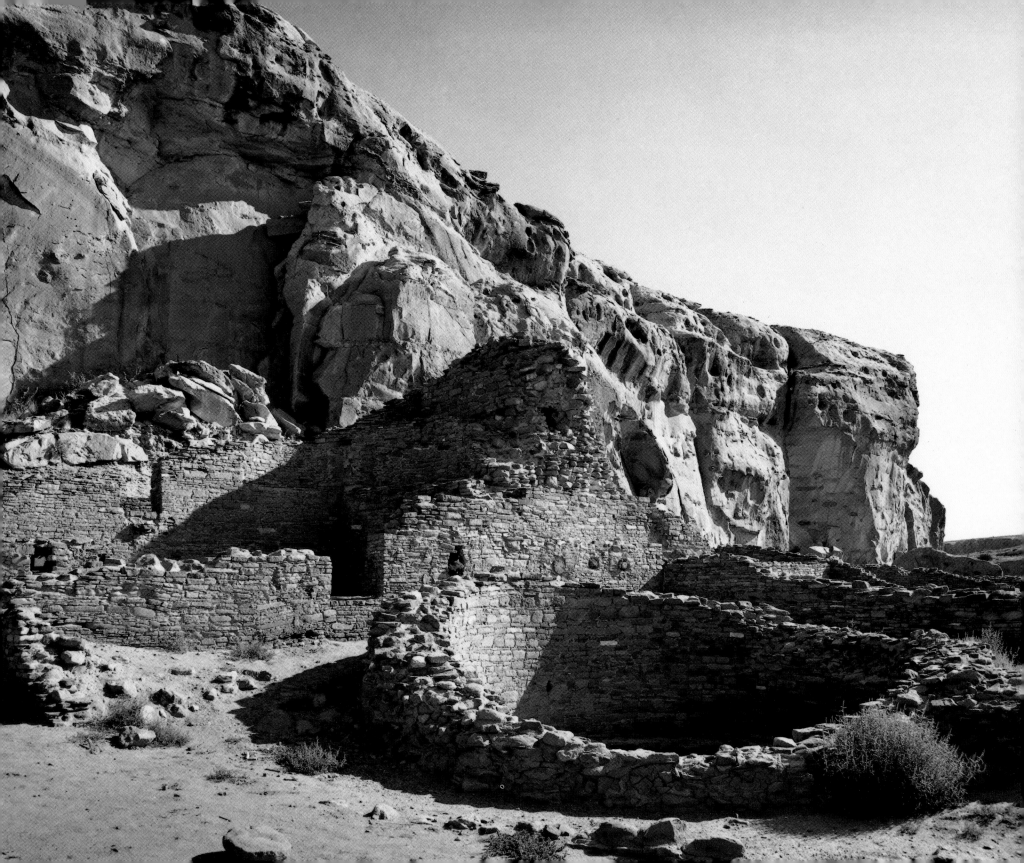

CLIFFDWELLER

When the last Red Man has vanished with his wilderness and his memory is only the shadow of a cloud moving across the prairie, these shores and forests will still hold the spirits of my people.

We love this earth as a newborn loves its mother's heart beat. So, if we sell you our land, love it as we have loved it. Care for it as we have cared for it. Preserve the land for all children and love it, as God loves us all.

As we are part of the land you too are part of the land. This earth is precious to us. It is also precious to you. One thing we know, there is only one God. No man, be he Red Man or White Man can be apart. We are brothers after all.

Chief Seattle

PUEBLO BONITO

Chaco Canyon, New Mexico

Once a horseshoe shaped metropolis that housed approximately 1,200 people in eight hundred rooms, Pueblo Bonito was likely the largest of the spiritual centers.

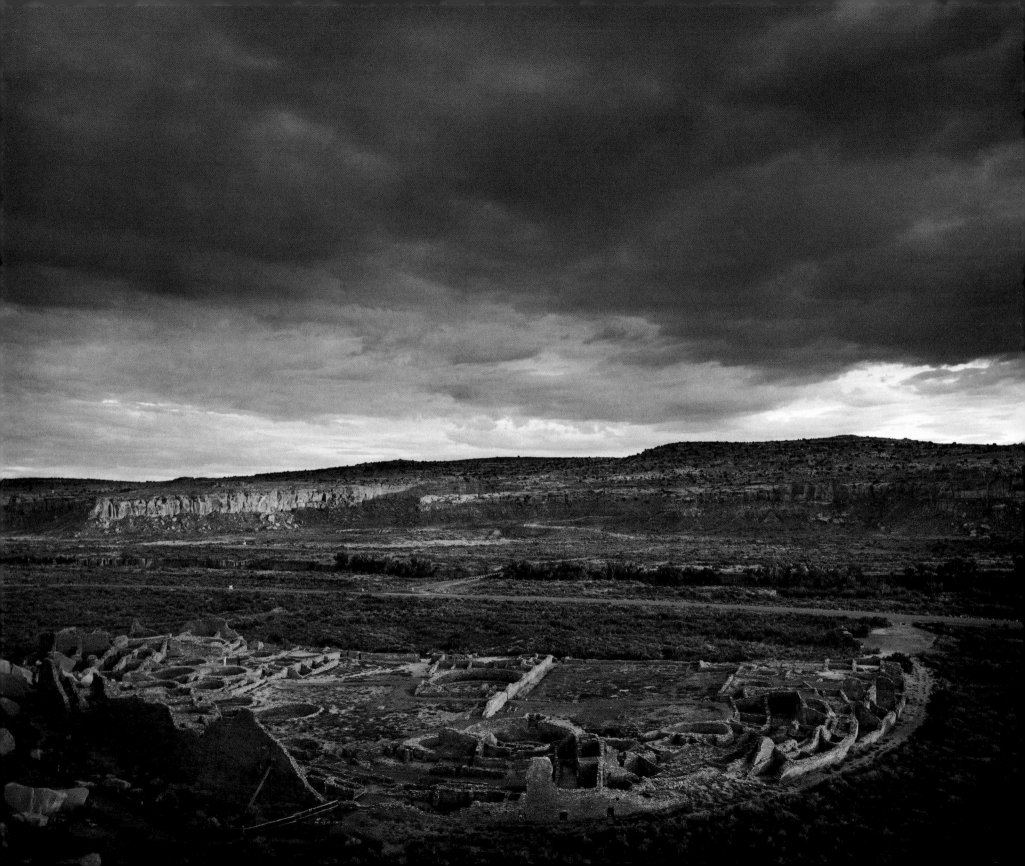

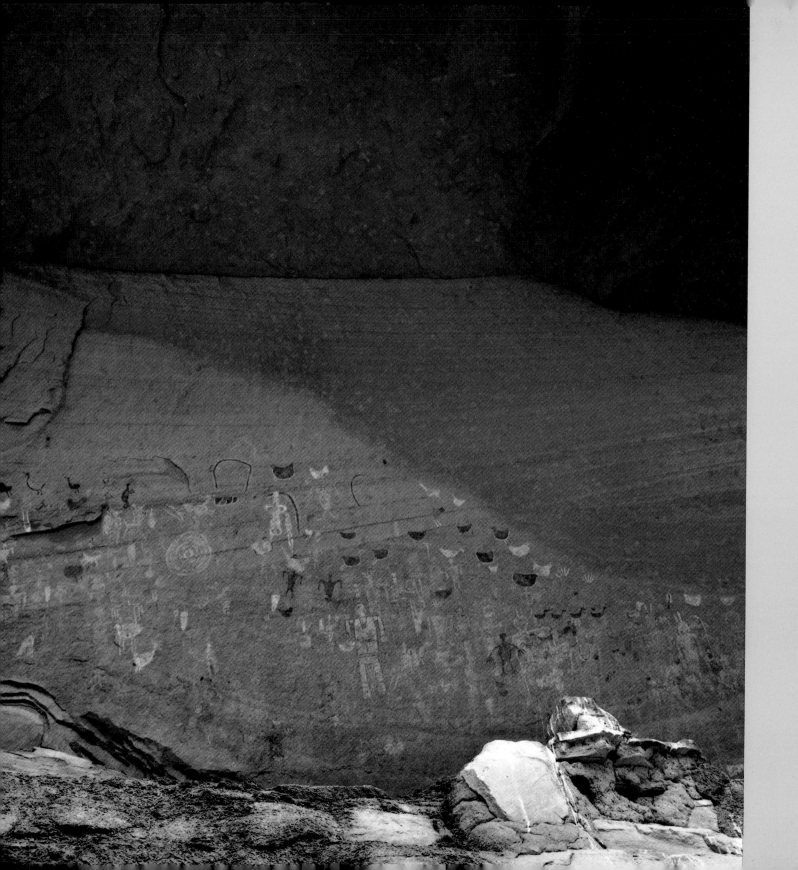

ROCK ART AT BLUE BULL CAVE

Canyon del Muerto, Arizona

Examples of rock art from the Cliffdweller and the Navajo are commonly found together. The Ancient Ones preferred rectangular-bodied figures ducks, and concentric circles (at left), while the Navajo painted the feathered Ye'i holding a feathered bow (at right).

NAVAJO PETROGLYPHS AT STANDING COW RUINS

Canyon del Muerto, Arizona

The Navajo continued the tradition of rock painting established by the Cliffdweller; however, they broke away from static images to introduce narrative. This painting documents the arrival of the Spanish cavalry into the canyon area (1804–1805).

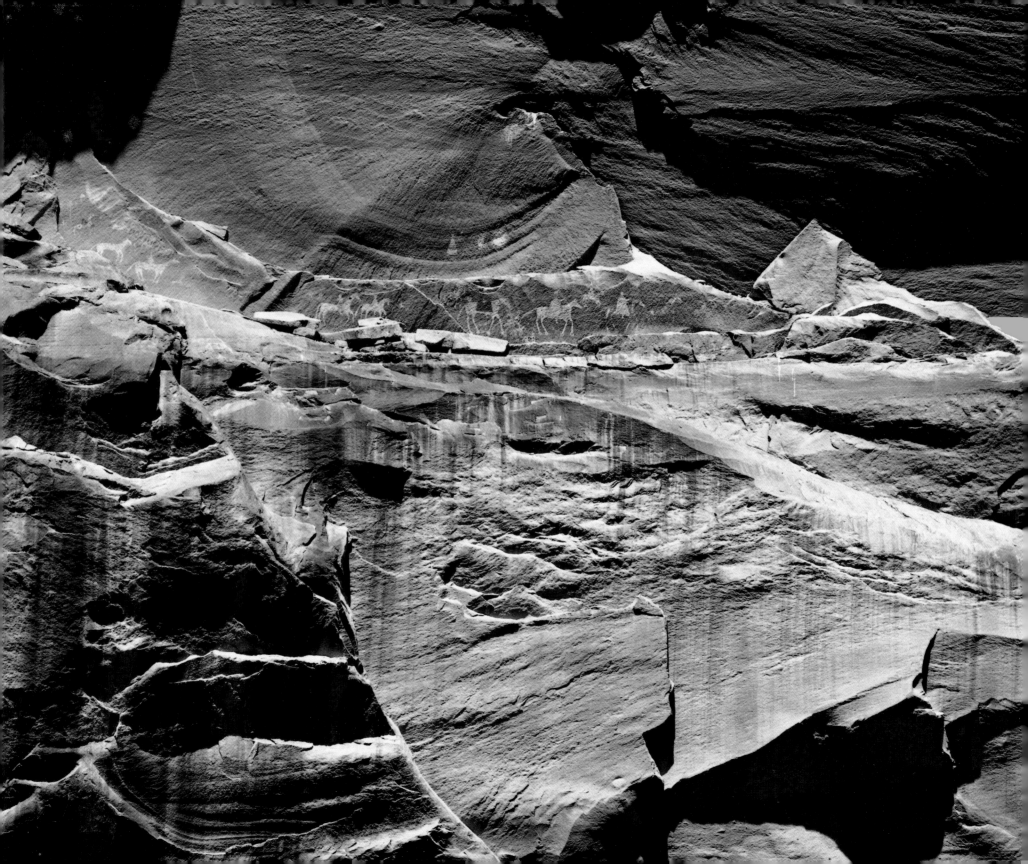

EPILOGUE

It was past midnight, and I was surrounded by the chullpas (burial towers) of Sillustani, near Lake Titikaka. By the light of the full moon, surrounded by these ancient stones, I quested for a vision for my book. I recalled the journeys that this project has taken me on in the past five years, through the canyons of the American South-West, to the jungles of the Yucatán, and the highlands of the Andes. At an altitude of 4,500 meters, where the air runs thin and crisp, I could no longer remember how or even why I started this project.

Perhaps it was a personal quest towards a better understanding of the American continent where I have lived for over twenty years. Perhaps it was that special night, now lost in time, when the shaman's songs made me feel very much at home among the ancient markings of the Nazca desert. Conceivably, my desire to relive that moment prompted my pilgrimage to the ancient sites represented in this book.

Photography has been the medium that disciplined my awareness of the subtle changes in light and shadow on the ruins. These monuments that stood in silence for eternity have spoken to me in a dance of shadow, light, and mist. The challenge lay in capturing that special moment when the image and the wind evoke a feeling of time-breaching—a distinct sensation of sharing a life and breath with these ancient peoples.

A herd of vicuñas rushed by me and broke my train of thought. As the echo of their hooves on the stones faded away, I heard a familiar whisper in the wind:

"We are the ancestors. Our first homes were of reeds, our last homes are of stone, for we have no faces to hide from the wind or turn away from the rain or snow. Our *chullpas* are the passages through which we die and are reborn into our world and yours. We know these things because we have been here since the beginning of time. And we remember the grandmothers and grandfathers that live within us. We remember every sunset, every story by the fire, for that is our medicine, to remember. Remembering is how we make *Ayni* to those who came before us, and this is how we are honored after we are gone. Time does fly like an arrow, but it also turns like a wheel, and the future rolls back upon the present evermore."

SELECT
BIBLIOGRAPHY

INKA

Aranibar, Lizardo Perez
1990 *Inkakunaq Mit'Anpi Qelqay: La Graficacion en la Epoca de los Gobernantes.* Cusco, Peru: Concytec.

Baptista, Mariano
1975 *Tiwanaku.* Switzerland: Plata Publishing Ltd.

Bauer, Brian S.
1992 *The Development of the Inca State.* Foreward by Gary Urton. Austin: University of Texas Press.

Bennett, Wendell C.
1954 *Ancient Arts of the Andes.* New York: The Museum of Modern Art.

Bernbaum, Edwin
1990 *Sacred Mountains of the World.* San Francisco: Sierra Club Books.

Bingham, Hiram
1976 *Lost City of the Incas: The Story of Machu Picchu and Its Builders.* New York: Atheneum.

Brundage, Burr Cartwright
1963 *Empire of the Inca.* Norman, Oklahoma: University of Oklahoma Press.

Cieza de Leon, Pedro de
1959 *The Incas,* trans. Harriet de Onis, ed. Victor Wolfgang von Hagen. Norman, Oklahoma: University of Oklahoma Press.

Cobo, Bernabe
1990 *Inca Religion and Customs.* Austin: University of Texas Press.
1991 *History of the Inca Empire.* Austin: University of Texas Press.

Conrad, Geoffrey, and Arthur A. Demarest
1984 *Religion and Empire: The Dynamics of Aztec and Inca Expansionism.* Cambridge: Cambridge University Press.

Demarest, Arthur A.
1981 *Viracocha: The Nature and Antiquity of the Andean High God.* Cambridge, England: Peabody Museum of Archaeology and Ethnology of Harvard University.

Hagen, Victor Wolfgang von
1975 *Highway of the Sun: A Search for the Royal Roads of the Incas.* Switzerland: Plata Publishing Ltd.

Hemming, John, and Edward Ranney
1982 *Monuments of the Incas.* Albuquerque: University of New Mexico Press.

Karsten, Rafael, Ph.D.
1926 *The Civilization of the South American Indians.* New York: Alfred A. Knopf.

Keatinge, Richard W.
1988 *Peruvian Prehistory: An Overview of pre-Inca and Inca Society.* Cambridge, England: Cambridge University Press.

Lechtman, Heather and Ana Maria Soldi
1981 *Runakunap Kawsayninkupag Rurasqanumaqu.* Mexico: Universidadt Nahua Autónome de Mexico

Macedo, Justo Caceres
1987 *Las Culturas Prehispanicas del Peru.* Lima, Peru: Perugraph Editores.

Markham, Sir Clements
1977 *The Incas of Peru.* Lima, Peru: ABC.

Mason, Alden J.
1975 *The Ancient Civilizations of Peru.* Switzerland: Plata Publishing Ltd.

Osborne, Harold
 1952 *Indians of the Andes: Aymaras and Quechas*. Cambridge: Harvard University Press.

Perez Aranibar, Lizardo
 1990 *La Gratificacion en la Epoca de los Gobernantes*. Cusco, Peru: Amercar.

Posnansky, Arthur
 1945 *Tihuanacu: The Cradle of American Man*, vol. I, trans. James F. Shearer. New York: J.J. Augustin Publisher.

Prescott, William H.
 1970 *The World of Incas*. Geneva: Editions Minerva.

Rowe, John Howland, and Dorothy Menzel
 1967 *Peruvian Archaeology*. Palo Alto, California: Peek Publications.

Salomon, Frank, and George L. Urioste, Trans.
 1991 *The Huarochiri Manuscript: A Testament of Ancient and Colonial Andean Religion*. Austin: University of Texas Press.

Townsend, Richard F.
 1992 *The Ancient Americas: Art from Sacred Landscapes*. Chicago: The Art Institute of Chicago.

Urton, Gary
 1990 *The History of a Myth: Pacariqtambo and the Origin of the Incas*. Austin: University of Texas Press.
 1988 *At the Crossroads of the Earth and Sky: An Andean Cosmology*. Austin: University of Texas Press.

Vega, Garcilaso de la (El Inca)
 1989 *Royal Commentaries of the Incas and General History of Peru*, part I, trans. Harold V. Livermore. Austin: University of Texas Press.

Zuidema, R. Tom
 1990 *Inca Civilization in Cuzco*. Austin: University of Texas Press.

MAYA

Arguelles, Jose
 1987 *The Mayan Factor: Path Beyond Technology*. Sante Fe, New Mexico: Bear & Company.

 Baudez, Claude, and Sydney Picasso
 1992 *Discoveries: Lost Cities of the Maya*. New York: Harry N. Abrams, Inc.

Bierhorst, John
 1990 *The Mythology of Mexico and Central America*. New York: William Morrow & Co., Inc.

Carrasco, David
 1992 *Quetzalcoatl and the Irony of Empire: Myths and Prophecies in the Aztec Tradition*. Chicago: University of Chicago Press.

Castillo, Ricardo Mimenza
 Encyclopedia Grafica de la Civilizacion Maya. Yucatán, Mexico.

Chan, Roman Pina
 1989 *The Olmec: Mother Culture of Mesoamerica*, ed. Laura Laurencich Minelli. New York: Rizzoli.

Chilam Balam of Chumayel.
 See: Roys, 1967, and Edmonson, 1986.

Chilam Balam of Tizimin.
 See: Edmonson, 1982.

Coe, Michael D.
 1987 *The Maya*. New York: Thames & Hudson.
 1992 *Breaking the Maya Code*. New York: Thames & Hudson, Inc.

Coe, William R.
 1967 *Tikal: A Handbook of the Ancient Maya Ruins*. Philadelphia: The University Museum, University of Pennsylvania.

Davila, Francisco Gonzales
 1979 *Ancient Cultures of Mexico: The Aztec Calendar*. Mexico: Museo National de Antropologia.

Diaz-Bolio, Jose
 1964 *La Serpiente Emplumada*. Merida, Mexico: Registro de Cultura Yucateca.
 1971 *Instructive Guide to the Ruins of Uxmal: The City of the Feathered Serpent*. Merida, Mexico: Area Maya.
 1980 *Origen de la Cronologia Maya*. Merida, Mexico: Revista de la Universidad de Yucatán.
 1982 *La Serpiente de Luz de Chichen Itza*. Merida, Mexico: Area Maya.
 1988 *Why the Rattlesnake in Mayan Civilization*. Merida, Mexico: Area Maya.

Dresden Codex:
 See: Tompson, 1972.

Edmonson, Munro S.
 1971 *The Book of the Council: The Popol Vuh of the Quiché Maya of Guatemala*. New Orleans: Middle American Research Institute, Tulane University.
 1982 *The Ancient Future of the Itza: The Book of Chilam Balam of Tizimin*. Austin: University of Texas Press.
 1986 *Heavenborn Merida and its Destiny: The Book of Chilam Balam of Chumayel*. Austin: University of Texas Press.

SELECT
BIBLIOGRAPHY

MAYA (*continued*)

Fernandez, Adela
1984 *Pre-hispanic Gods of Mexico*. Mexico: Panorama Editorial, S.A.

Greene Robertson, Merle
1991 *The Sculpture of Palenque*, vol. IV. Princeton: Princeton University Press.

Gomez, Ermilo Abreu
1992 *The Popol Vuh*. Merida, Mexico: Produccion Editorial Dante.

Hagan, Victor Wolfgang von
1990 *Maya Explorer: John Lloyd Stephens and the Lost Cities of Central America and Yucatan*. San Francisco: Chronicle Books.

Healan, Dan M.
1989 *Tula of the Toltecs: Excavations and Survey*. Iowa City: University of Iowa Press.

Henderson, John S.
1981 *The World of the Ancient Maya*. Ithaca: Cornell University Press.

Houston, S.D.
1989 *Maya Glyphs*. Berkeley: The University of California Press / The British Museum.

Hunter, C. Bruce
1986 *A Guide to Ancient Maya Ruins*. Norman, Oklahoma; and London: University of Oklahoma Press.

Ivanoff, Pierre
1973 *Monuments of Civilization: Maya*. New York: Madison Square Press Grosset and Dunlap.

Lopez-Portillo Y Pacheco, Jose
1982 *Quetzalcoatl*. Mexico: Joaquin Porrúa, S.A. de C.V.

Michel, Genevieve
1991 *The Rulers of Tikal: A Historical Reconstruction and Field Guide to the Stelae*. Guatemala: Publications Vista.

Morley, Sylvanus Griswold
1975 *An Introduction to the Study of the Maya Hieroglyphs*. New York: Dover Publications.

Neuenswander, Helen L., and Dean E. Arnold
1981 *Cognitive Studies of Southern Mesoamerica*. Dallas: Sil Museum of Anthropology.

Orellana, Sandra L.
1987 *Indian Medicine in Highland Guatemala*. Albuquerque, New Mexico: University of New Mexico Press.

Popol Vuh:
See: Recinos, 1950; Edmonson, 1971; Tedlock, 1985; and Gomez, 1992

Proskouriakoff, Tatiana
1993 *Maya History*. Austin: University of Texas Press.

Recinos, Adrian, Delia Goetz and Sylvanus G. Morley
1950 *Popol Vuh: The Sacred Book of the Quiché Maya*. Norman, Oklahoma: University of Oklahoma Press.

Robertson, Merle Greene
1991 *The Sculpture of Palenque: The Cross Group, the North Group, the Olvidado, and Other Pieces*. Princeton, New Jersey: Princeton University Press.

Roys, Ralph L.
1967 *The Book of Chilam Balam of Chumayel*. Norman, Oklahoma: University of Oklahoma Press.

Sabloff, Jeremy A.
1989 *The Cities of Ancient Mexico: Reconstructing a Lost World*. New York: Thames & Hudson, Inc.

Scarborough, Vernon L., and David R. Wilcox
1991 *The Mesoamerican Ballgame*. Tucson: University of Arizona Press.

Schele, Linda
1982 *Maya Glyphs: The Verbs*. Austin: University of Texas Press.

Schele, Linda, and David Freidel
1990 *A Forest of Kings: The Untold Story of the Ancient Maya*. New York: William Morrow & Company, Inc.

Schele, Linda, and Mary Ellen Miller
1986 *The Blood of Kings: Dynasty and Ritual in Maya Art*. New York: George Braziller, Inc., and Fort Worth: Kimbell Art Museum.

Soustelle, Jacques
1985 *The Olmecs: The Oldest Civilization in Mexico*, trans. Helen R. Lane. Norman, Oklahoma: University of Oklahoma Press.

Stuart, Gene S., and George E. Stuart
1993 *Lost Kingdoms of the Maya*. Washington D.C.: The National Geographic Society.

Tate, Carolyn E.
1992 *Yaxchilan: The Design of a Maya Ceremonial City*. Austin: University of Texas Press.

Tedlock, Barbara
1992 *Time and the Highland Maya*. Albuquerque, New Mexico: University of New Mexico Press.

Tedlock, Dennis
1985 *Popol Vuh*. New York: Simon and Schuster, Inc.

1992 "The Popol Vuh as a Hieroglyphic Book," *New Theories on the Ancient Maya*, ed. Elin C. Danieu and Robert J. Sharer.

Thompson, J. Eric S.
1972 *Dresden Codex: A Maya Hieroglyphic Book*. Philadelphia: American Philosophical Society.

1990 *Maya History and Religion*. Norman, Oklahoma; and London: University of Oklahoma Press.

Valliant, George C.
1962 *Aztecs of Mexico: Origin, Rise and Fall of the Aztec Nation*. New York: Doubleday & Company, Inc.

CLIFFDWELLER

Bahti, Mark
1988 *Pueblo Stories and Storytellers*. Tucson, Arizona: Treasure Chest Publications, Inc.

Berry, Michael S.
1982 *Time, Space, and Transition in Anasazi Prehistory*. Salt Lake City, Utah: University of Utah Press.

Braun, David P. and Stephen Plog
1982 "Evolution of 'Tribal' Social Networks: Theory and Prehistoric North American Evidence," *American Antiquity*, 47 (3), pp. 504-525.

Bradley, Zorro A.
1973 *Canyon de Chelly: The Story of its Ruins and People*. Washington, D.C.: Office of Publications, National Park Service, U.S. Department of the Interior.

Buge, David
1980 "Big Kivas and Tewa Prehistory," *The Masterkey*, 54 (1), pp. 24-29.

Campbell, Grant
1978 *Canyon de Chelly: Its People and Rock Art*. Tucson, Arizona: University of Arizona Press.

Canby, Thomas Y.
1982 "The Anasazi Riddles in the Ruins," *National Geographic*, 162 (5), pp. 554-592.

Courlander, Harold
1971 *The Fourth World of the Hopis*. Albuquerque, New Mexico: University of New Mexico Press.

Cushing, Frank Hamilton
1988 *The Mythic World of the Zuni*, edited & illustrated by Barton Wright. Albuquerque, New Mexico: University of New Mexico Press.

Ferguson, William, and Arthur H. Rohn
1987 *Anasazi Ruins of the Southwest in Color*. Albuquerque, New Mexico: University of New Mexico Press.

Fewkes, Jesse Walter
1898 "Archaeological Expidition to Arizona in 1895," *Annual Report of the Bureau of American Ethnology*, 17, pp. 519-744.

Frazier, Kendrick
1986 *People of Chaco: A Canyon and Its Culture*. New York: W.W. Norton & Co.

Grant, Campbell
1987 *Canyon de Chelly: Its People and Rock Art*. Tucson, Arizona: University of Arizona Press.

Lekson, Stephen H.
1988 "The Idea of the Kiva in Anasazi Archaeology," *The Kiva*, 53 (3), 213-232.

King, Patrick
1975 *Pueblo Indian Religious Architecture*. Salt Lake City, Utah: Patrick King.

Pike, Donald G.
1974 *Anasazi: Ancient People of the Rock*. New York: Crown Publishers, Inc.

Roberts, Elizabeth, and Elias Amidan
1991 *Earth Prayers*. San Francisco: Marpen.

Rothenberg, Jerome
1991 *Shaking the Pumpkin: Traditional Poetry of the Indian North Americas*. Albuquerque, New Mexico: University of New Mexico Press.

Schaafsma, Polly, and Curtis F.
1974 "Evidence for the Origins of the Pueblo Katchina Cultas Suggested by South-western Rock Art," *American Antiquity*, 39 (4), pp. 535-545.

1991 *Rock Art in New Mexico*. Principle photography by Karl Kernberger and Curtis F. Schaafsma. Santa Fe, New Mexico: Museum of New Mexico Press.

Smith, Watson
1990 *When is a Kiva? And Other Questions About Archaeology*. Tucson, Arizona: University of Arizona Press.

Supplee, Charles, and Barbara Anderson
1971 *Canyon de Chelly: The Story Behind the Scenery*. Las Vegas: KC Publications, Inc.

Waters, Frank
1953 *Book of the Hopi*. New York: Penguin Books.

Wheelright, Mary C.
1988 *The Myth and Prayers of the Great Star Chant*. Tsaile, Arizona: Navajo Community College Press.

ACKNOWLEDGEMENTS

Many people have contributed to the creation of this book:

Alberto Villoldo assisted me with developing the concept and introduced me to many of the sacred sites in this volume.

Sharon Gallagher saw me through the entire publishing process for which I am deeply grateful. Adrienne Atwell, my research assistant and map maker, did many hours of work at the Robert Goldwater Library at the Metropolitan Museum of Art, with the help of their courteous staff. Stephen Vincent's expertise in book packaging was instrumental to the success of this book, as were Mira Kamdar's creative ideas and her showing me the possibilities to which this project could lead.

During my photographic journeys in Central and South America, José Luis Herrera took care of all the logistics, Harjit Bajaj and Raghu Sud of Shopper's Travel, in New York, planned my travels with patience and flexibility.

Erik Jendersen, Molly McBride, Adrienne Atwell, Fausta Daldini, Scott Edward Anderson, Kelly Reardon-Tagore, and Liza Wolsky were the text editors. Dr. Angel Avendaño Farfan and Americo Yábar of Peru provided me with correct Kechua phonetics.

The following experts reviewed my manuscript and contributed their insightful advice: For the Inka section: Prof. Gary Urton of Colgate University, and Dr. Craig Morris of the American Museum of Natural History in New York. For the Maya section: Prof. Dennis Tedlock of the State University of New York, whose poetic translation of the Popol Vuh has been an inspiration for the making of the Maya photographs. For the Cliffdweller section: Dr. Polly Schaafsma of the Museum of Indian Arts and Culture in Santa Fe, New Mexico, contributed her vigorous criticisms.

Joseph Guglietti designed this book. I am grateful for his elegant execution and patience during the entire process.

Special thanks to my mother for her love and support while I was conducting my field work, Lorca Simons for her assistance while I was writing in New York, Nancy Royal and Stanford Anderson for years of loyal friendship and for providing me with a nurturing environment during the printing of the photographs.

Finally, I would like to thank the Men and Women of High Knowledge in the Andes for pointing out to me that the Ancient Ones are still with us today, for they are the mountains, the valleys, the streams, and the lakes. If we allow ourselves to listen, they will tell us their true story.

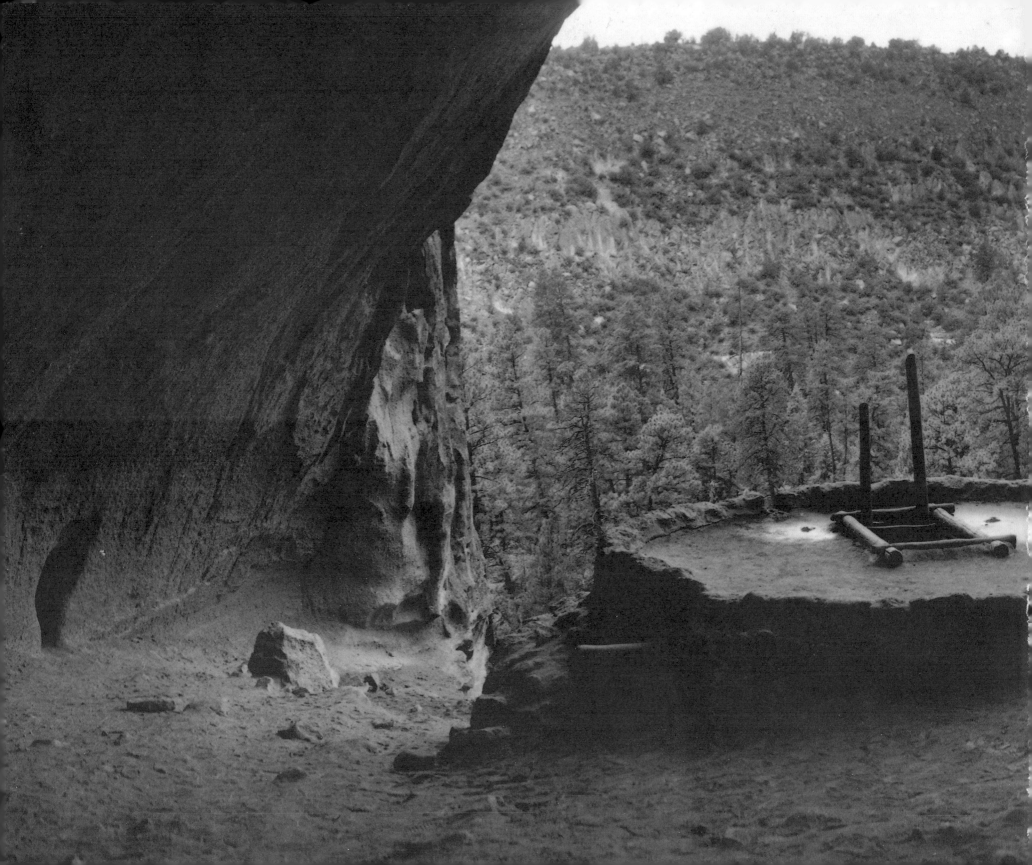